T0259695

Convergenze

a cura di
G. Anzellotti, L. Giacardi, B. Lazzari

Laura Catastini
Franco Ghione (a cura di)

Matematica e Arte
Forme del pensiero artistico

 Springer

LAURA CATASTINI
Centro Interdipartimentale di Ricerca e Formazione Permanente
per l'Insegnamento delle Discipline Scientifiche
Università di Roma Tor Vergata

FRANCO GHIONE
Dipartimento di Matematica
Università di Roma Tor Vergata

Additional material to this book can be downloaded from http://extras.springer.com

ISBN 978-88-470-1728-3 ISBN 978-88-470-1729-0 (eBook)
DOI 10.10077978-88-470-1729-0

Layout copertina: Valentina Greco, Milano

Progetto grafico e impaginazione: Valentina Greco, Milano
Stampa: Grafiche Porpora, Segrate (MI)

Springer-Verlag Italia S.r.l., Via Decembrio 28, I-20137 Milano
Springer fa parte di Springer Science+Business Media (www.springer.com)

Prefazione

Questo libro raccoglie alcune esperienze realizzate in varie scuole italiane negli anni 2005-2007 all'interno del Progetto Lauree Scientifiche. Una particolarità importante del Progetto è stata quella di avere accomunato professori universitari e professori delle superiori intorno a tematiche matematiche nuove, generalmente extracurriculari, con lo scopo di realizzare nelle scuole, insieme, dei laboratori di matematica. L'esperienza ha avuto molto successo sia tra gli studenti che hanno partecipato direttamente all'attività laboratoriale sia tra i professori che hanno trovato in questo nuove occasioni di crescita professionale: gli universitari entrando nel vivo della problematica realtà scolastica, gli insegnanti in una nuova forma di aggiornamento disciplinare e metodologico. Tra i tantissimi temi proposti e sviluppati in tutta Italia abbiamo raccolto, in questo libro, quelle esperienze particolarmente centrate sul binomio matematica-arte con un duplice obiettivo: da un lato avvicinare le menti curiose a quella matematica, spesso tutt'altro che banale, che ha profondamente interagito con l'espressione artistica e, dall'altro, di offrire agli insegnanti tutto il materiale prodotto nelle effettive esperienze laboratoriali, presentandolo come un nuovo strumento didattico proponibile, in toto o in parte, in varie forme e a vari livelli, nella loro diretta attività con gli allievi. Per facilitare questo lavoro, al libro è allegato un CD nel quale il materiale didattico che è stato prodotto e utilizzato nella nostra esperienza (animazioni, film, tavole di lavoro, presentazioni in power point, fogli dinamici ecc.), può essere utilizzato direttamente dagli insegnanti che se ne vogliano servire o da chi intenda, per gioco o per interesse, ripercorrere, in forma autodidatta, alcune tappe di questo percorso.

Abbiamo cercato quindi di saldare didattica e divulgazione su un tema di grande fascino come quello dei rapporti tra la matematica e l'espressione artistica, cercando di andare oltre alle ovvietà che spesso circondano quest'argomento, alle facili metafore e a esoterici misteri, con l'obiettivo di fornire un quadro concettuale matematico per quanto possibile rigoroso, accessibile a una cultura liceale, isolando quei temi per i quali non sia pretestuoso l'intreccio tra matematica e arte. Ciò che più ci è parso interessante esplicitare è come una disciplina possa influenzare un'altra così apparentemente diversa, attraverso quali meccanismi e su quali precise tematiche. Ovviamente, al di là di una consonanza cognitiva, che Catastini analizza nella sua introduzione, tra l'attività creatrice del matematico e quella dell'artista, non tutta la matematica si presta allo stesso modo a esplicitare i nostri intenti e non tutta l'attività artistica. Ci siamo quindi ristretti al campo delle arti visive e dell'architettura, con una piccolissima escursione nella musica, perché in questi settori ci pare più chiaro il rapporto con la matematica.

Particolare attenzione abbiamo riservato alla parte iconografica del libro. Riteniamo, infatti, che le nuove tecnologie permettano una ridefinizione del ruolo delle figure (fisse o animate) in un testo di matematica. Oggi è possibile realizzare facilmente figure a colori molto espressive che facilitino la comprensione del testo e permettano al pensiero di formare appropriate immagini mentali. In questo libro abbiamo cercato di recuperare una tradizione antica che si è persa con la comparsa della stampa: quella dei testi manoscritti a colori. Lo stile delle figure e soprattutto i colori sono i colori leonardeschi che abbiamo ricavato dal manoscritto di Luca Pacioli, illustrato da Leonardo da Vinci, *De divina proportione*, di cui ampiamente parliamo nel libro.

La ricerca di forme armoniche di *bellezza visiva*, tipiche dell'architettura, della pittura e della scultura, si lega intrinsecamente all'indagine geometrica delle forme dagli albori pitagorici fino ai nostri giorni. Tale bellezza sembra risiedere per alcuni nell'armonia dei rapporti, nell'equilibrio delle tensioni, tra le simmetrie delle parti. Ecco che, da questo punto di vista, appare naturale pensare a un reciproco influsso tra la ricerca estetica e quella matematica. È questa scienza, infatti, che è riuscita a elaborare un linguaggio attraverso il quale l'equilibrio, la proporzione, la simmetria, per fare solo degli esempi, da vaghe idee diventano concetti precisi intorno ai quali diventa possibile articolare ragionamenti sensati, formulare nuove idee, analizzare e classificare le diverse possibilità.

In quest'unità tra scienza e arte risiede certamente parte importante della nostra identità culturale, ereditata inizialmente dal pensiero greco e dall'ellenismo, e ripresa nel nostro Rinascimento. Dice Nicco-Fasola nella sua introduzione all'edizione critica del *De prospectiva pingendi* di Piero della Francesca: "E che si debbano ad artisti i fondamenti di molte scienze ha influito per dare loro quella fisionomia, quell'esigenza di simmetria che durò abbastanza a lungo o forse ancora dura". Da questo punto di vista riteniamo importante riproporre nella nostra scuola i temi che danno spessore a queste idee calandoli nel loro sviluppo storico, facendo riferimento alle fonti iniziali, in vista di una didattica nuova, maggiormente contestualizzata e vivace.

Il Progetto Lauree Scientifiche, all'interno del quale si collocano le esperienze che qui riproponiamo, ci ha permesso di riflettere sul piano teorico e pratico su cosa possa essere un laboratorio matematico. Non si tratta solo di scegliere una metodologia didattica di tipo non frontale, di servirsi del computer o di altri artefatti, si tratta anche, e soprattutto, di rivedere il rapporto astratto-concreto, senza confinare, come tradizionalmente viene fatto, i concetti matematici in un ambito puramente teorico, ma senza neanche svilire la natura di questa disciplina che ha, nell'astrazione e nel metodo dimostrativo, la sua essenza. Le esperienze che qui proponiamo, già realizzate nella scuola, se pure in contesti diversissimi, dall'estremo sud del paese all'estremo nord, offrono uno stesso modo per sciogliere questo nodo: legare la matematica alle sue applicazioni. Tra le applicazioni non pensiamo solo a quelle più banalmente legate alla vita del cittadino, o alla tecnologia corrente, ma a tutto ciò che di significativo la matematica, in tutto il suo lungo cammino, può dire ed

è riuscita a dire, su questioni non matematiche. Scindere la matematica dal suo ambito applicativo è un'operazione arbitraria che inaridisce la materia levandole molto del suo interesse e delle sue motivazioni. La geometria euclidea nasce come linguaggio iniziale col quale poter affrontare problemi esterni alla geometria stessa, problemi di meccanica, di geografia, di astronomia, di ottica, di scenografia che all'epoca di Euclide convivevano in un unico humus culturale. Aver staccato la geometria da questi ambiti, chiudendola su se stessa, ha certamente contribuito a un diffuso disamore per questa disciplina fino a farla quasi sparire dai nostri programmi d'insegnamento. Un esempio più vicino a noi, l'analisi infinitesimale, ha le stesse caratteristiche: da un lato viene elaborato un nuovo linguaggio, un *calcolo sublime*, e dall'altro tale calcolo diventa strumento essenziale per lo studio di problemi fisici e geometrici.

Il primo laboratorio che proponiamo, realizzato a Trieste, racconta questo intreccio tra teoria e pratica mediante lo studio della *Catenaria*. Questa curva è quella che assume una catena o una fune sospesa ai suoi estremi sotto l'effetto della gravità. Essa fu considerata e studiata da Galileo Galilei che, attraverso un'ardita analogia col moto di caduta di una palla lanciata da un cannone, pensò, sbagliando, dovesse assumere, come quella, una forma parabolica. In realtà le cose sono molto più complicate e a Galileo mancavano gli strumenti matematici per risolvere il problema e riuscire a descrivere con una formula questa curva. Lo strumento matematico che a Galilei mancava è proprio il calcolo differenziale. Qui abbiamo una pratica che chiede risposte e una teoria che manca, un "concreto" che osserviamo, ma non riusciamo a descrivere, e un "astratto" da costruire. Questo "astratto" viene costruito nel laboratorio seguendo le idee rivoluzionarie di un filosofo-matematico, Leibnitz, che sarebbe bene presentare nella sua doppia veste e non solo come filosofo. Abbiamo scelto questa via per presentare nel laboratorio qualche elemento di calcolo differenziale perché le idee, il linguaggio, le notazioni di Leibnitz ci sono parse più intuitive e più vicine storicamente alle effettive tecniche utilizzate dai matematici del primo Settecento per risolvere quello e altri problemi fisico-matematici. Così, in modo non rigoroso ma completo, possiamo indicare tutti i passaggi che portano all'equazione della catenaria. Fin qui la matematica interagisce con la fisica fornendo gli strumenti concettuali necessari per risolvere questo come molti altri problemi che la fisica si pone. Ma, come spesso avviene, dall'interazione tra la matematica e le applicazioni nasce nuova matematica, spesso interessante in sé. I matematici si accorgono che la traccia lasciata dal fuoco di una parabola che rotola senza strisciare è una catenaria. Ora siamo nel campo puramente geometrico, c'è un salto di astrazione, questa curva si sgancia dalla fisica e diventa oggetto di speculazione e di ricerca in sé, al di fuori d'immediate applicazioni. La funzione che la descrive, il coseno iperbolico, appare per certi versi simile al coseno di un angolo e la corrispondenza tra le due funzioni si esplicita attraverso la radice di meno uno! Ma altre imponenti applicazioni sono riservate a questo coseno iperbolico. Un architetto catalano, Gaudì, resta affascinato dalle caratteristiche statiche ed estetiche di questa curva e la userà, sia negli esterni che negli interni,

facendola oggetto di un vero e proprio personale lavoro di ricerca estetica. Il rapporto tra matematica e architettura è chiaro e non pretestuoso: le realizzazioni di Gaudì, per la loro bellezza e armoniosità vanno ben oltre le capacità immaginative della matematica. Altre strutture architettoniche, come per esempio ponti, cupole o archi, fanno uso di questa curva e il laboratorio, attraverso anche l'attività di ricerca in internet dei ragazzi, documenta la vastità di queste realizzazioni.

Ma le sorprese non sono finite. Ricerche matematiche avanzate di Eulero e altri, ricerche nel calcolo delle variazioni, delle quali non è possibile riferire in dettaglio nel laboratorio, dimostrano che una catenaria che ruota genera una superficie minima: la superficie che assume una lamina saponata compresa tra due anelli uguali e paralleli. Un film che si trova nel CD allegato al libro, riprende una ragazza che esegue questo esperimento con l'acqua saponata. La superficie che si genera stupisce per la sua misteriosa bellezza: l'economia di spazio, l'equilibrio, la simmetria, la naturalezza di questa superficie fanno senza dubbio di questa forma un oggetto di ricerca interessante anche in un campo lontano dalla matematica e dalla fisica quale è l'estetica.

Che storia! Un problema molto concreto di carattere fisico posto da uno scienziato italiano, per risolverlo una matematica nuova ideata da un filosofo tedesco, un architetto catalano che due secoli dopo si serve di tutto questo nella sua ricerca di nuove forme di equilibrio e bellezza, la matematica che, ancora oggi, ricerca queste forme servendosi del calcolo della variazioni inventato da un matematico svizzero.

Idee che s'intrecciano in tempi e luoghi diversi.

Nello stesso tempo invece e nello stesso luogo un grandissimo artista e un matematico lavorano gomito a gomito. Sono gli ultimi anni del XV secolo a Milano, Luca Pacioli compone il suo capolavoro il *De divina proportione* mentre Leonardo dipinge il *Cenacolo*. Le reciproche influenze sono evidenti: Pacioli darà significato matematico ai dodici apostoli introducendo nel suo libro dodici effetti della divina proporzione, mentre Leonardo contribuirà al libro di Pacioli disegnando in prospettiva solidi di tutti i tipi in 60 meravigliose tavole a colori e farà per il suo Cenacolo un grande studio sui rapporti e sulla divina proporzione in particolare. La ricerca della proporzione e dell'armonia tra le diverse parti di una composizione caratterizza il primo Rinascimento ed è una ricerca insieme matematica e artistica. La divina proporzione, che oggi chiamiamo sezione aurea, è il punto di arrivo di questo percorso: essa pervade non solo l'estetica, ma anche la geometria, perché rende possibile la costruzione dei poliedri regolari, e, infine, la filosofia platonica, che interpreta questi oggetti come gli elementi costitutivi dell'universo: acqua, terra, fuoco, aria e quinta essenza che tutto comprende come il dodecaedro che, solo, riesce a circoscrivere gli altri quattro poliedri.

Il laboratorio *La sezione aurea, la spirale logaritmica e i numeri di Fibonacci* che si è tenuto in varie scuole del Friuli Venezia Giulia, introduce la sezione aurea a partire dal suo ruolo nel Rinascimento e dal suo rapporto con l'armonia e la bellezza estetica. Ricerche di psicologia sperimentale iniziate da

Gustav Fechner nella seconda metà dell'Ottocento e verificate da numerosi altri sperimentatori, dimostrano come il rettangolo aureo, quello cioè i cui lati sono in quel rapporto, sia quello che appare più piacevole alla vista come se il nostro cervello avesse una particolare struttura capace di riconoscerlo più armonico. Ipotesi e studi, anche di carattere neurologico, sono stati proposti per spiegare il fenomeno e un'ampia letteratura divulgativa fornisce esempi di ogni tipo sulla presunta presenza della sezione aurea nelle situazioni più disparate. A questo si aggiunge un legame del tutto inaspettato che lega la sezione aurea ai numeri di Fibonacci i quali pure trovano frequenti applicazioni in natura. Tale legame è esplicitamente trattato nel laboratorio con tutti i dettagli dimostrativi e l'approccio proposto permette, servendosi di una calcolatrice tascabile, di calcolare rapidamente il valore della sezione aurea con un'approssimazione arbitraria servendosi proprio dei numeri di Fibonacci. Anche le spirali in un qualche modo sono parenti di queste idee e il loro ruolo, non solo in matematica, ma anche nelle scienze naturali, come per esempio nella disposizione dei semi di girasole, è ben evidenziato in questo laboratorio con vario materiale didattico disponibile nel CD allegato.

Anche la musica si è servita spesso della sequenza di Fibonacci. Un esempio è il pezzo di Debussy *Cathédrale Engloutie,* tratta dal primo libro dei Préludes. Attraverso una simpatica interazione, che il Progetto Lauree Scientifiche ha reso possibile, tra il Conservatorio Tartini di Trieste e l'Università il preludio è stato appositamente eseguito per noi al pianoforte da Luca Trabucco, che ringrazio, nella versione di Debussy e la registrazione, effettuata grazie alla collaborazione della Scuola di Musica e Nuove Tecnologie del Conservatorio, è inserita nel CD allegato al libro.

Il tema della simmetria è stato sviluppato a Palermo nel laboratorio *Le tassellazioni del piano nelle arti figurative* proponendo i diciassette gruppi di tassellazioni del piano senza appesantire la trattazione col linguaggio della teoria dei gruppi, ma passando in rassegna la casistica e arricchendo la trattazione con l'analisi dettagliata di alcuni disegni dell'Alhambra a Granada. Nel CD allegato al libro, per ognuno dei diciassette tipi di tassellazione vi è una bellissima animazione interattiva che descrive le diverse simmetrie che generano il gruppo in esame e che, alla fine, produce il parallelogramma minimo, il quale, doppiamente traslato lungo i suoi lati, produce l'intera tassellazione. Anche questo è un esempio non banale di come la ricerca matematica e quella estetica si siano incrociate e vicendevolmente influenzate. Il concetto di simmetria viene pienamente compreso e studiato dai matematici in tutta generalità all'interno della teoria dei gruppi, mentre la ricerca estetica, astratta come è stata quella araba, è tesa verso l'identificazione di motivi ornamentali periodici riproducibili all'infinito la cui bellezza risiede spesso in un indecifrabile intreccio di simmetrie. Con Escher quei motivi si riempiono di significati figurativi: dove prima, nella pittura araba, vi erano forme astratte variamente combinate, appaiono ora uccelli, diavoli, rane e cavalieri che s'incastrano tra loro in modi misteriosi ma periodici in uno sviluppo che, nella nostra immaginazione, non ha fine. La matematica

definisce, classifica, dimostra e l'indecifrabile si svela. Il laboratorio, con il suo taglio fattivo, insegna a realizzare con geogebra, un software di geometria dinamica open source, varie tassellazioni a partire dal disegno minimo. Il risultato di questa esperienza è di grande soddisfazione per gli allievi perché li mette in grado, direttamente e con la guida dell'insegnante, non solo di ridurre ai minimi termini il problema e discernerne la logica interna, ma anche di realizzare di fatto, con il computer, la tassellazione proposta dall'insegnante e di inventarne di nuove. È questo un esempio di un buon uso del computer, strumento essenziale in una didattica laboratoriale che, in questo caso, ci permette di fare cose che altrimenti non potremmo fare, amplificando le nostre potenzialità realizzative e nel contempo acuendo la nostra capacità di comprendere il problema.

Gli ultimi due laboratori che proponiamo sono legati a uno stesso tema che viene guardato da due punti di vista differenti. Il tema è quello del rapporto tra la rappresentazione pittorica della profondità spaziale (da qui all'infinito) e la geometria proiettiva. È il tema che, forse, meglio esemplifica il rapporto tra la matematica e le arti figurative ancor più perché i primi studi matematici su questo tema sono opera di un grande pittore, Piero della Francesca, che unisce nella sua persona le due anime. La scienza di cui Piero pone i fondamenti è la Geometria Proiettiva oggi alla base di tutta la geometria moderna. Un'idea molto importante in questo settore è quella di "punto all'infinito", idea che variamente e più spesso malamente è presente in varia divulgazione scientifica. L'affermazione, infatti, che in un piano rette parallele s'incontrano in un punto all'infinito risulta contraddittoria in sé poiché nel piano euclideo, parallele vuol dire proprio che non s'incontrano da nessuna parte, che la loro distanza è costante. Per dare senso a quest'affermazione si deve cambiare il concetto di piano, introducendo un nuovo oggetto, diverso dal piano euclideo, il cosiddetto piano completato, dove si aggiungono (ma in che modo?) questi punti all'infinito comuni alle rette parallele. La cosa appare in questi termini del tutto arbitraria e la trattazione di quest'argomento diventa o puramente formale o misteriosa (mistero spesso celato dietro l'aggettivo "intuitivo"). Anche qua il nodo si scioglie se pensiamo all'origine storica del concetto e al suo legame con le "applicazioni". Il pittore, quando disegna segmenti che sono paralleli come per esempio i lati di un viale o di un colonnato, li disegna convergenti a un punto sulla sua tela perchè così li vede. Disegna anche la linea dell'orizzonte alla quale vede avvicinarsi tutti i punti del paesaggio che sta guardando. La tela del pittore è una parte molto concreta (una *carta* in linguaggio tecnico) del piano proiettivo nel quale si vedono i punti all'infinito disposti sulla retta dell'orizzonte.

Anche in questo caso, questa scienza nasce da un'analisi critica della scienza antica e da un problema molto concreto. Piero della Francesca recupera la tradizione classica ellenistica e, a partire dall'*Ottica* di Euclide, sviluppa, da un punto di vista teorico e pratico, l'arte della prospettiva introducendo in modo esplicito quella trasformazione del piano in sé che oggi chiamiamo omologia.

Anche noi abbiamo scelto, nel presentare questa materia, l'ordine storico e siamo partiti da Euclide. Nel laboratorio *Dalla geometria della visione alla trasformazione prospettica* che si è tenuto in alcuni licei classici del Lazio, s'inizia lo studio della geometria della visione, quella geometria che analizza il mutare della forma apparente di un oggetto al variare del punto di vista. Qui è essenziale il dualismo tra l'essere di un oggetto (la sua reale forma geometrica) e il suo apparire che dipende strettamente dalla posizione dell'osservatore. Oggetti uguali appaiono diversi e oggetti diversi appaiono uguali secondo regole geometriche che possono essere esplicitate. Anche in questo caso, per poter sviluppare con chiarezza la geometria della visione, occorre partire da assunzioni iniziali che permettano di dare precise definizioni e sviluppare una teoria nella quale la geometria euclidea diventa uno strumento essenziale di lavoro. Il laboratorio diventa così il luogo nel quale gli studenti, con la guida degli insegnanti, costruiscono, da zero, una nuova teoria matematica con i suoi postulati, definizioni e teoremi. In questo percorso diventa possibile esplicitare, nel concreto, cosa questo significhi e in cosa consista il metodo scientifico. Naturalmente non si tratta di una pretestuosa invenzione ma al contrario si segue, in questa prima parte del laboratorio, la strada indicata da Euclide nella sua *Ottica* che, visto il significato che ha assunto oggi questo termine, sarebbe meglio chiamare *Teoria della visione diretta*. Il concetto base è quello di raggio visivo, una semiretta che ha origine nell'occhio e si prolunga all'infinito, e si postula che la visione avvenga per angoli: oggetti visti sotto angoli uguali appaiono uguali. L'ampiezza dell'angolo visivo dà la dimensione apparente di un oggetto e in questo modo la visione diventa quantitativa. Come la lunghezza di un segmento misura l'essere di un oggetto così l'ampiezza dell'angolo visivo il suo apparire.

La geometria dei raggi visivi e della loro disposizione nello spazio tridimensionale è ovviamente fondamentale in questo contesto e, come tutta la geometria solida, non facilmente immaginabile dagli studenti e poco trattata nella scuola. Si tratta di costruire immagini mentali tridimensionali che guidino il pensiero e permettano, come per la geometria piana, di sviluppare l'intuizione e immaginare procedimenti dimostrativi. Per questo nel laboratorio si utilizza uno strumento nuovo, un artefatto appositamente progettato e costruito a questo scopo, chiamato *prospettimetro*, che permette di fare effettive misure di angoli e lunghezze, di visualizzare i raggi visivi e i vari piani: quello di profondità e quello dell'orizzonte, che sono fondamentali per comprendere le prime nozioni di geometra della visione. Il prospettimetro è uno strumento di legno e plexiglas facilmente realizzabile del quale, nel CD allegato al libro, si fornisce una scheda tecnica che permette la sua realizzazione.

Questa geometria, che si basa sul principio che punti posti sullo stesso raggio visivo sono visti nella stessa posizione da un occhio posto in O, si applica anche alla prospettiva. Infatti, la visione (monoculare) di un oggetto rappresentato su un quadro è equivalente alla visione dell'oggetto reale se ogni punto P dell'oggetto reale è proiettato in un punto P' sul piano del quadro, da un raggio visivo in modo che i due punti, P e P', trovandosi su uno stesso raggio visi-

vo siano visti nello stesso modo. Riuscendo a fare questo per ogni punto dell'oggetto reale, tenendo fissa la posizione O dell'occhio, abbiamo realizzato un'immagine sul piano del quadro che, vista da O, appare come l'oggetto reale. Tutto questo introduce una relazione di equivalenza tra i punti dello spazio secondo la quale due punti sullo stesso raggio visivo sono ugualmente visti. Le classi di equivalenza sono i raggi visivi, cioè le rette che passano per O. È l'insieme di queste rette, pensate come "punti", che definisce il piano proiettivo reale. In questo modo si arriva naturalmente alla moderna definizione di piano proiettivo reale i cui "punti" sono appunto le rette uscenti da un punto fisso O dello spazio. Questa strada è anche quella generalmente seguita nei corsi universitari perché è più facilmente generalizzabile alle varietà di Grassmann definite come l'insieme dei sottospazi vettoriali di data dimensione di uno spazio vettoriale fissato. Essa inoltre permette di introdurre, anche a livello scolastico, le coordinate omogenee [x,y,z] di un "punto" del piano proiettivo come la classe di equivalenza delle terne non tutte nulle (x,y,z) a meno di un comune fattore non nullo di proporzionalità. Tali terne, al variare del coefficiente di proporzionalità, rappresentano nello spazio ordinario punti di una stessa retta uscente da O, punti cioè di uno stesso raggio visivo.

Se la geometria della visione, che abbiamo ereditato da Euclide, produce un'idea di piano proiettivo come un insieme di raggi, l'impostazione che ricaviamo da Piero della Francesca ci suggerisce un modo completamente diverso per avvicinarci al piano proiettivo. Questo modo viene esposto nel laboratorio *L'omologia e Piero della Francesca*, che si è tenuto a Palermo. Seguendo l'impianto prospettico suggerito da Leon Battista Alberti nel *De pictura*, si comincia col proiettare sul piano del quadro il piano di terra opportunamente reticolato. Questa proiezione produce una trasformazione uno-uno tra i punti P del piano di terra e i punti P' del piano del quadro con alcune eccezioni. Queste eccezioni vengono risolte se introduciamo, sui due piani, dei nuovi punti che pensiamo infinitamente lontani, che chiamiamo "punti all'infinito" e che immaginiamo disposti su una nuova retta che chiamiamo "retta all'infinito". Con tali aggiunte la proiezione P → P' diventa uno-uno senza eccezioni. Ora, l'idea di Piero, probabilmente suggerita da esigenze pratiche legate alla necessità di realizzare il disegno dei due piani su uno stesso foglio, consiste nel ruotare il piano del quadro sovrapponendolo al piano di terra conservando però la corrispondenza P → P' che ora diventa una corrispondenza biunivoca di un piano in se stesso. Corrispondenza oggi nota col nome di *omologia*. Il laboratorio propone uno studio dettagliato di questa corrispondenza, dando per quanto possibile le dimostrazioni più importanti in modo da avere un quadro complessivo rigoroso e sufficiente a motivare gli enunciati proposti. L'ingrediente fondamentale per poter fare le dimostrazioni è il teorema di Desargues sui triangoli omologhi, teorema che viene proposto e dimostrato rigorosamente solo nel caso più semplice, quando i due triangoli stanno su piani diversi, dando, nel caso di piani sovrapposti, l'idea della dimostrazione. Questa trattazione, molto astratta, è un buon esempio di come si costruisce oggi la geometria proiettiva sintetica e permette di giustificare rigorosamente le costruzioni che vengono poi

proposte con l'uso di software di geometria dinamica. In quest'ambiente si possono realizzare delle macro con le quali è possibile disegnare l'immagine prospettica di una qualunque figura piana a partire dalla posizione del punto di vista. L'attività laboratoriale con l'uso del computer aiuta a capire e congetturare le diverse proprietà dell'omologia potendo visualizzare in tempo reale l'immagine di un punto che si muove su una determinata linea. Nel laboratorio sono proposte varie schede di lavoro da eseguire col computer e con l'aiuto dell'insegnante che permettono di disegnare in prospettiva, seguendo il metodo di Piero, figure anche tridimensionali.

Per concludere questo studio sui rapporti tra la matematica e le arti, abbiamo voluto inserire un interessante lavoro museale, realizzato in un liceo di Carpi in provincia di Modena, all'interno del Progetto Lauree Scientifiche. Si tratta della mostra *Matematica: anima segreta dell'arte* e di un CD che raccoglie in forma interattiva il materiale della mostra. Questo capitolo racconta i vari momenti espositivi realizzati dagli insegnanti e dai ragazzi, in collaborazione con l'Università di Modena, dove si passa dalla divina proporzione, alle bolle di sapone, dalla forma delle nuvole ai fumetti e a tante altri argomenti che allargano l'interazione tra la matematica e l'arte in campi insospettabili.

Il CD allegato al libro contiene, per ogni laboratorio, una cartella con tutto il materiale didattico che è stato realizzato attraverso una proficua collaborazione Scuola-Università basata sul riconoscimento della pari dignità professionale, in vista di uno stesso obiettivo: qualificare maggiormente l'insegnamento della matematica nelle nostre scuole superiori.

Ringrazio Gabriele Anzellotti che mi ha aiutato e incoraggiato, Laura Catastini che ha curato con me l'edizione di questo libro e tutti i colleghi che hanno reso possibile questo difficile lavoro collettivo e in particolare gli insegnanti che con amore, interesse e intelligenza hanno dato il loro insostituibile contributo.

Giugno 2010 *Franco Ghione*

Indice

Introduzione

di *Laura Catastini*

Nella percezione della forma sta il germe
della formazione dei concetti
Rudolph Arnheim

Tra chi si affida ai sensi e li educa – gli artisti per primi – molti diffidano della rigidità del ragionamento astratto, mentre chi fa matematica sul piano del pensiero teorico suppone che le proprie operazioni si svolgano lontano dalla concretezza delle esperienze sensoriali.

"Matematica e Arte" è un connubio di grande effetto proprio per la percezione comune di contrasto tra questi due ambiti. L'arte è calda, la matematica fredda, si sa. Sono tutti d'accordo, tranne i matematici: "Un matematico il quale non abbia in sé nulla di poetico non sarà mai un matematico completo" diceva Weierstrass.

In realtà, tra l'attività matematica e quella artistica si possono trovare corrispondenze intime, meno ineffabili e più convincenti di un comune sentire poetico, se si porta la questione sul piano neurocognitivo, cioè se si studiano in tal senso i processi di pensiero sottesi a tali attività. Si troverà che in entrambi i casi l'attività mentale fa un uso importante di pensiero immaginativo[1] e che le simulazioni[2] che si possono compiere con le immagini o con i modelli mentali – importanti nella formazione di pensieri produttivi – trovano le loro radici nella concretezza dei processi percettivi.

Studi recenti hanno consolidato l'idea che le facoltà cognitive più raffinate e astratte si sono sviluppate grazie alla possibilità di movimento dell'organismo, secondo criteri evolutivi che hanno premiato processi percettivi dinami-

[1] Il pensiero immaginativo è stato ammesso nella scienza cognitiva piuttosto tardi, anche perché veniva rifiutato il metodo introspettivo con cui s'indagava su di esso. Negli anni Settanta del Novecento Shepard [1], tra i primi contestatori di un approccio esclusivamente proposizionale al pensiero, dimostrò la capacità dell'uomo di formare immagini mentali. Negli stessi anni Paivio [2] dimostrava che le immagini sono in grado di facilitare le prestazioni della memoria: per esempio, parole immagazzinate con doppio registro, verbale e immaginativo, sono meglio memorizzabili rispetto a quelle immagazzinate con modalità solo verbali. I lavori di Kosslyn [3] e di Johnson-Laird [4] infine hanno portato al riconoscimento delle immagini e dei modelli mentali come forma di conoscenza non riconducibile a nessun'altra modalità e alla costruzione di un'apprezzabile teoria dell'immaginazione mentale. Il modello mentale è la rappresentazione analogica di un determinato stato di cose, cioè, secondo la definizione di Johnson-Laird, è "una copia mentale interna che possiede la stessa struttura di rapporti del fenomeno che rappresenta".

[2] Sulla simulazione e sul rapporto tra astratto e concreto nella pratica laboratoriale si veda Catastini [5].

ci e anticipatori, capaci di adattare il comportamento a un ambiente altrettanto dinamico. La percezione oggi non è più vista come un mero momento statico di ingresso dati, ma come simulazione di eventi e anticipazione dinamica i cui sensi insieme sono capaci di escogitare ipotesi, creare modelli e inventare soluzioni che proiettano sul mondo.

L'imporsi dell'idea che "percepire" sia già "pensare" ha cambiato anche le metafore usate: il nostro cervello, già nella fase percettiva, non è più analogo a un calcolatore che computando si adatta al mondo esterno, ma piuttosto è un simulatore[3] biologico che prevede comportamenti, attingendo dalla memoria e formulando delle ipotesi. Percepire un oggetto è immaginare le azioni implicate dal suo uso, ed è anche astrarre, selezionare tratti particolari e ignorarne altri. Supponiamo per esempio di voler prendere una tazza da un tavolo pieno di altre stoviglie ma che, mentre stiamo per afferrarla, siamo distratti e prendiamo al suo posto un boccale. L'esperienza comune ci dice che individuiamo immediatamente l'errore, che ce ne accorgiamo prima ancora di guardare. Su quali basi fisiologiche è possibile riconoscere l'errore e correggerlo? Questo è possibile se esiste, già prima che il movimento inizi, una configurazione neurale di "aspettative" con la quale l'azione viene confrontata e corretta nel caso in cui se ne discosti in maniera significativa. Ancora: localizzare un oggetto vuol dire rappresentarsi i movimenti da fare per raggiungerlo, e non si tratta necessariamente di rappresentarsi i movimenti stessi nello spazio, ma solo le sensazioni muscolari che accompagnano questi movimenti.

L'importanza di questi processi, chiamati *percettivo-motori*, è stata confermata di recente dalla scoperta dei "neuroni specchio", emersa dalle ricerche di Rizzolatti [8]. Questi neuroni scaricano quando la scimmia sottoposta a esperimento fa un gesto particolare, per esempio girare una maniglia, prendere una nocciolina ecc. Ma scaricano anche, gli stessi neuroni, quando l'animale vede lo sperimentatore compiere lo stesso gesto.

Rizzolatti fa emergere nel suo libro come il sistema percettivo-motorio si sia negli anni trasformato, nella concezione scientifica, da semplice esecutore di singole azioni decise in altre sedi cerebrali, prive di alcuna valenza cognitiva, a pianificatore di azioni, di atti completi:

> Lo stesso rigido confine tra processi percettivi, cognitivi e motori finisce per rivelarsi in gran parte artificioso: non solo la percezione appare immersa nella dinamica dell'azione, risultando più articolata e composita di come in passato è stata pensata, ma il cervello che agisce è anche e innanzitutto un cervello che comprende. Si tratta, come vedremo, di una

[3] Negli ultimi anni sono stati presentati modelli teorici di rappresentazioni interne come "simulazioni" (Barsalou [6]) o saggi sul senso del movimento (Berthoz [7]). Il pensiero rappresentativo appare capace di concepire in modo endogeno ciò che non è immediatamente percepibile, o ancora di ricostruire ambienti percettivi memorizzati e di compiervi simulazioni creative, come nel caso della *visual imagery* di Kosslyn.

comprensione pragmatica, preconcettuale e prelinguistica, e tuttavia non meno importante, poiché su di essa poggiano molte delle nostre tanto celebrate capacità cognitive. [8, p. 3]

Il rapporto e la frattura tra l'astratto delle "nostre tanto celebrate capacità cognitive" care ai matematici e il concreto dei sensi che ispirano gli artisti, è stato anticipato e ricomposto nel secolo scorso con spirito modernissimo da uno psicologo della percezione e dell'arte, Rudolph Arnheim. La connessione tra percezione e pensiero si mostrò chiarissima ad Arnheim, non solo specifica alle arti ma anche alle operazioni generali del pensiero, in ogni campo conoscitivo. Il matematico abile riesce a usare la propria immaginazione e la propria capacità simulatoria educandole e facendosi guidare da esse nell'attività razionale del suo mestiere, così come l'artista può potenziare attraverso un reale contatto con il metodo scientifico la razionalità matura e consapevole che arricchisce le sue opere:

La mancanza di tirocinio visuale nelle scienze e nella tecnica, da un lato, e la trascuratezza, e persino il disprezzo, che gli artisti nutrono per il bellissimo e vitale compito di rendere visibile il mondo dei fatti alla mente ricercatrice, mi appare, fra l'altro, una minaccia assai più seria della nostra civiltà, delle "due culture" sulle quali C.P. Snow ha attirato tanto l'attenzione pubblica qualche tempo fa. Egli lamenta che gli scienziati non leggano buona letteratura, e gli scrittori non sappiano della scienza. Forse è così, ma la lagnanza è superficiale. Una persona è "a tutto tondo" non semplicemente quando possiede un poco di ogni cosa ma quando applica a ogni cosa che fa l'insieme integrato di tutte le sue potenzialità mentali. Il suggerimento di Snow che "il punto di incontro" fra scienza e arte "dovrebbe produrre possibilità creative" sembra ignorare la parentela fondamentale che esiste tra le due. Uno scienziato può essere un conoscitore di Wallace Stevens o di Samuel Beckett, ma può darsi che il suo tirocinio gli abbia comunque impedito di usare, nel suo stesso pensiero professionale al più alto livello, l'immagine percettiva a cui si affidano quegli scrittori. E un pittore può leggere libri di biologia o di fisica con profitto, eppure non impiegare la propria intelligenza quando dipinge. L'estraniazione è qui di natura assai più fondamentale. [9, p. 360]

Nella pratica didattica l'apprendimento verso l'astrazione percettiva va guidato mediante illustrazioni opportune – continua Arheim – cercando di mantenere un ricco contesto concreto. Nel tentativo di guidare gli studenti ad astrazioni percettive si usano costrutti semplificati come fossero loro stessi la realtà, ma spesso tale concretizzazione scientifica "necessariamente e quasi per definizione costituisce un caso modificato, astratto, semplificato, omogeneizzato, rinsecchito" che non riesce a dare agli allievi neppure un barlume della situazione concreta in se stessa e che finisce per essere una falsa facilitazione. Il fenomeno viene estratto dal contesto, come fosse un evento indi-

pendente, e lo si mostra "contro uno sfondo vuoto" che elimina "la parte gra-
nulosa e rumorosa della situazione concreta". L'educazione alla scienza – con-
clude Arnheim – esattamente quanto l'arte, funziona al meglio se abbraccia
l'intero processo che va dalla percezione diretta ed empirica fino alle costru-
zioni formalizzate, e se assicura uno scambio continuo tra di esse. Separate
dai propri referenti percettivi, i concetti stereotipi conducono a un vuoto
gioco di forme, proprio come la semplice esposizione sensoriale all'esperien-
za personale non assicura all'artista la comprensione profonda e la trasmis-
sione di significati di spessore.

Nel campo dell'arte gli enti geometrici smettono di essere casi astratti e "rin-
secchiti" e diventano elementi essenziali di espressione – e spesso anche di atti-
vità di indagine teorica e di ricerca – e una volta materializzati, graficamente o
in altre forme, acquistano una loro particolare personalità, funzione di molti
fattori. La percezione li compone gestalticamente togliendo loro la natura di
entità geometriche autoreferenti, mettendoli in relazione tra loro e con l'intero
campo che li contiene. L'interpretazione gestaltica del percepire muove in qual-
che misura anche i campi più statici: punti sparsi su un piano, raggruppati o
lontani, sono in grado di generare una gran varietà di sensazioni dinamiche,
sembreranno avvicinarsi tra loro, o allontanarsi, avere una direzione centrifu-
ga o centripeta e ubbidire a direzioni comuni. Lo stesso si può dire delle linee,
che acquisteranno caratteri cinetici intrecciati a leggerezza, armonia e pesan-
tezza, in funzione dell'intero percepito[4]. Queste sensazioni sono legate non solo
al tipo di organizzazione formale determinato dalla semplice disposizione degli
elementi tra loro, ma anche all'attività interpretativa del nostro sistema percet-
tivo che organizza, interpreta ed elabora cognitivamente gli stimoli visivi.

La dimensione e la forma dei punti e delle linee, per esempio, variano a
seconda che s'impieghi una penna, un punteruolo, pennarello, e che si agi-
sca su carta ruvida, su pietra o lastre metalliche, dalla pressione della mano
che guida il disegno. Le forme, i segni stessi, come tutti i percetti, vengono cor-
relati ad altri stati percettivi ed emotivi, a volte importanti, a volte sottili.
Questo semplice test sperimentale parla da solo: si danno due nomi senza
significato – *tàkete* e *malùma* – a due forme chiuse e si chiede quale sia il più
appropriato per ognuna di esse:

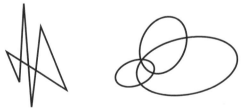

[4] Si veda Kandisky [10].

Qual è *tàkete* e qual è *malùma*? La maggioranza abbina la prima figura piena di spigoli al suono duro e pungente di *tàkete* e la seconda, più rotonda, al suono morbido di *malùma*.

La sollecitazione emotiva nel lavoro intellettuale rafforza e sostiene l'interesse e la partecipazione, facilita la pratica intelligente di concentrarsi su determinati punti di interesse e di trascurare quanto è estraneo agli elementi che formano l'oggetto di attenzione, porta ad assumere un atteggiamento di ricerca verso ciò che il messaggio visivo propone e a ricercarne le varie fasi processuali che lo hanno composto, insieme all'interesse verso strumenti e conoscenze di base che permettano di riprodurlo. Per esempio, dà soddisfazione disegnare ricreando questo coinvolgente movimento[5].

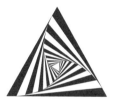

È possibile se s'individuano le semplici e ricorsive operazioni geometriche di base: dato un triangolo equilatero ABC, stacchiamo sui suoi lati, a partire da ogni vertice, uno stesso sottomultiplo della lunghezza del lato, per esempio un decimo. Unendo tra loro i punti A', B', C' così ottenuti si ottiene un nuovo triangolo equilatero, ruotato rispetto al primo.

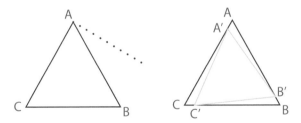

Ripetendo l'operazione sul triangolo A'B'C' si determinano altri tre punti che formano un terzo triangolo, e così via.

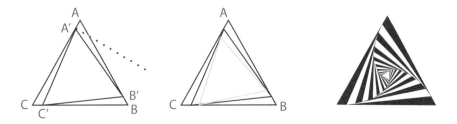

[5] Costruzione di F. Grignani: si veda [11].

Il risultato è dato da una successione di triangoli equilateri che, ruotando, diventano sempre più piccoli, dando luogo a quelle *curve di inseguimento* i cui intensi effetti dinamici sono immediatamente evidenti.

Grazie a un'azione educativa di questo tipo del suo pensiero visivo, lo studente sarà presto portato a poter individuare, per esempio, il "disegno minimo" di una tassellazione e a concettualizzare così in modo integrato la teoria matematica sottesa a queste operazioni.

Cogliere la struttura generale di una situazione è esercizio primario dell'intelligenza, che spesso vi si applica in maniera inconscia.

Quando la mente opera al modo dello scienziato cerca l'unica immagine corretta che si cela tra i fenomeni dell'esperienza. [9]

Racconta Arnheim [9] di una paziente alla quale, durante un test clinico, erano stati dati tre gruppi di forme geometriche: sedici triangoli, sedici quadrati, sedici dischi, e in ogni gruppo quattro figure erano rosse, quattro blu, quattro gialle e quattro verdi. La richiesta del test era alquanto generica: mettere insieme gli elementi che potessero essere in qualche modo correlati. La paziente scelse le figure rosse e le compose come mostra la figura, a sinistra, ma non trovava il quarto disco, accidentalmente caduto per terra, per cui, non soddisfatta, cambiò spontaneamente la struttura finale della sua composizione come in figura, a destra:

"È il caso tipico di una ristrutturazione intelligente", osserva Arnheim: la persona, nella situazione in cui le manca un disco, inventa una disposizione totalmente nuova, che comporta *pattern* nuovi e relazioni nuove, per poter soddisfare un proprio istintivo desiderio di simmetria.

La simmetria è innanzitutto una proprietà estetica derivante da un'universale legge organizzativa dei dati percettivi, e il termine che la designa era anticamente usato con i significati di "ordine", "armonia", "equilibrio", "proporzione", principi considerati essenziali nelle scienze umane e in quelle scientifiche. Questa spinta primordiale alla "ristrutturazione intelligente" ha portato successivamente a coinvolgere nelle ricerche di simmetrie situazioni geometriche – si pensi per esempio a Leonardo e ai suoi studi sulle piante delle basiliche – e algebriche – vedi Galois – e ha infine prodotto una definizione e una formalizzazione matematica del concetto stesso di simmetria[6].

A proposito di matematica, Hilbert si chiedeva:

Possono i pensieri sulle cose essere così differenti dalle cose? Possono i processi del pensiero essere così dissimili da come gli oggetti procedono? In poche parole, può il pensiero allontanarsi così tanto dalla realtà? [13]

Più che il pensiero a volte sono le parole che allontanano la matematica dalla realtà. Ciò che l'occhio e l'anima vedono nelle due immagini seguenti, per esempio, difficilmente si ritrova nell'espressione *invarianza rispetto a un gruppo di trasformazioni*, con la quale i matematici indicano la simmetria.

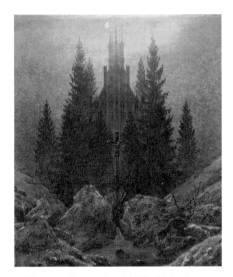 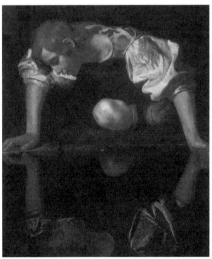

▲ **Figura 1** Kaspar David Friedrich, *Croce e cattedrale fra le montagne*, 1812, olio su tela, 46x38,5 cm, Museum Kunst Palast Düsseldorf (NRW), su gentile concessione di Kunstmuseum/The Bridgeman Art Library

▲ **Figura 2** Caravaggio, *Narciso*, 1546, olio su tela, 113x95 cm, Galleria Nazionale d'Arte Antica, Roma, su gentile concessione di Galleria Nazionale d'Arte Antica

[6] Si veda Weyl [12].

La parola matematica e ciò che essa rappresenta restano apprezzabilmente uniti nella fase in cui il pensiero matematico non è ancora completamente formalizzato, quando cioè è ancora "pensiero vivo", come lo chiamava Enriques rammaricandosi del suo divenire successivamente "pensiero morto". L'accettazione e l'uso della teoria matematica portano infatti a un processo di rigorosa formalizzazione che ne ottimizza l'efficacia ma che, da un punto di vista educativo, rende difficile guidare su di essa l'esercizio di pensiero che ne colga le strutture essenziali.

Le difficoltà di lavorare su un "pensiero morto" si superano resuscitandolo. Le pratiche laboratoriali mirano a questo: le tecniche usate sono molteplici e convergenti, sollecitano quanto più è possibile i processi percettivo-motori nel pensiero degli studenti e restituiscono significazione e interesse all'argomento affrontato reinserendolo nell'ambientazione storica in cui è nato.

In questo scenario l'insegnante copre un ruolo essenziale. Interagendo attivamente con gli studenti, guidandoli nell'attività esplorativa e nelle discussioni collettive opera come uno strumento di facilitazione per l'apprendimento e per lo sviluppo di capacità cognitive. Nello sviluppo cognitivo ha grande importanza l'apprendimento formale che procede attraverso attività condivise di ricerca di significati, dialogo, argomentazione, discussione e confronto. Attraverso il dialogo si realizza infatti una funzione di comunicazione e di aiuto tra le menti che porta alla conseguente interiorizzazione di significati. Questa pratica restituisce inoltre un ruolo fondamentale alla parola matematica, che viene cercata e usata dagli studenti stessi con ruolo comunicativo e che, così, "svolge la funzione di mezzo nella formazione di un concetto, poi ne diventa il simbolo" [14, p. 137]. L'interazione con i compagni e con l'insegnante, mediata da un sistema complesso di segni e di strumenti culturali, contribuisce a costruire nello studente conoscenze e concetti, secondo una teoria dell'insegnamento e dell'apprendimento della matematica che s'ispira a una visione antropologica e storico-culturale del sapere.

> L'insegnamento della matematica è tematizzato come l'acquisizione da parte della comunità di una forma di riflessione sul mondo guidata da modi epistemici-culturali storicamente formati. [15, p. 103]

Radford vede l'apprendimento come il processo di trasformazione attiva degli oggetti concettuali culturali in oggetti interiori. La trasformazione avviene tramite il processo di *oggettificazione*, inteso nella sua accezione etimologica di "rendere concreto, evidente, percepibile".

Tra i mezzi di oggettivazione troviamo gli strumenti[7], concreti oggetti, anche sofisticati, con i quali si possono sviluppare interazioni pratiche, linguistiche, concettuali che, sotto la guida dell'insegnante, trasmettano i significati culturali voluti. L'attività laboratoriale, praticata come costruzione di significati matematici, non è infine contraddittoria con il carattere deduttivo della materia: le attività pro-

[7] Per approfondimenti su questo argomento, si veda Bartolini Bussi, Maschietto [16].

poste, le interazioni strumentali e personali, la significazione storica che rende cognitivamente importanti i concetti mirano alla costruzione di un rigoroso atteggiamento deduttivo, formalmente rispettoso di assiomi e di definizioni iniziali.

Il ruolo della storia della matematica in questo contesto è fondamentale:

L'analisi storico-epistemologica può fornirci interessanti informazioni riguardanti lo sviluppo della conoscenza matematica all'interno di una cultura e attraverso culture diverse e anche fornire informazioni sul modo in cui i significati sono sorti e sono cambiati; è necessario comprendere le negoziazioni e le concezioni culturali che sottendono tali significati. Il modo in cui si è formata un'antica idea può aiutarci a trovare antichi significati che, mediante un lavoro di adattamento didattico, possono probabilmente essere ridisegnati e resi compatibili con i moderni programmi nel contesto dell'elaborazione delle sequenze d'insegnamento. [17, p. 32]

Essere in grado di usare la storia della matematica non vuol dire solo saper dare notizie storiche ma soprattutto saper usare produttivamente *paradigmi storici* adatti alla situazione che ci troviamo in classe[8]. La libertà progettuale del docente, quindi, è direttamente proporzionale alla sua cultura matematica, storica, umanistica, intesa come il suo essere "a tutto tondo".

Il CD allegato a questo libro contiene parte del materiale che è servito nei vari laboratori, riportato esattamente nella forma in cui è stato utilizzato dagli studenti, affinché, come chiede Arnheim, "il frastuono dell'aula e del laboratorio e l'aroma dello studio dell'artista" non restino remoti agli argomenti di questo lavoro ma siano percepibili in tutta la loro freschezza e incisività.

Bibliografia

[1] Shepard, R.N., Metzler, J. (1971) Mental rotation of three-dimensional objects, *Science* 171, 701-703.

[2] Paivio, A. (1971) *Imagery and verbal processes*, Holt, Rinehart and Winston, New York.

[3] Kosslyn, S. (1983) *Ghosts in the mind's machine*, W. W. Norton and Co., New York. Traduzione italiana: *Le immagini nella mente*, Giunti Barbèra, Firenze (1989).

[4] Johnson Laird, P. (1983) *Mental Models. Towards a Cognitive Science of Language, Inference, and Conciousness*, Cambridge University Press, Cambridge. Traduzione italiana: *Modelli mentali*, Il Mulino, Bologna (1988).

[8] Per un'esemplificazione vedere Catastini [5].

▶ [5] Catastini, L. (2009) Concretamente astratto, anzi, simulabile, *La Matematica nella Società e nella Cultura*, Rivista della Unione Matematica Italiana, serie I, vol. 2, 31-69.

[6] Barsalou, L.W. (1999) Perceptual symbol systems, *Behavioral and Brain Sciences* 22, 577-609.

[7] Berthoz, A. (1997) *The Brain's Sense of Movement*, Harvard University Press, Cambridge Mass. Traduzione italiana: *Il senso del movimento*. McGraw-Hill, Milano (1998).

[8] Rizzolatti, G., Sinigaglia, C. (2006) *So quel che fai. Il cervello che agisce e i neuroni specchio*, Cortina, Milano.

[9] Arnheim, R. (1969) *Visual Thinking*, Regents of the University of California, Berkeley – Los Angeles. Traduzione italiana: *Il pensiero visivo*, Einaudi, Torino (1974).

[10] Kandisky, V. (1968) *Punto linea superficie*, Adelphi, Milano.

[11] Valeri, V. (1999) *Corso di disegno*, La Nuova Italia, Scandicci.

[12] Weyl, H. (1962) *La Simmetria*, Feltrinelli, Milano.

[13] Hilbert, D. (1926) Über das Unendliche, *Acta Matematica* 48, 91-122.

[14] Vygotskij, L.S. (1992) *Pensiero e linguaggio*, Laterza, Roma-Bari.

[15] Radford, L. (2006) Elementos de una teoría cultural de la objetiva-ción, *Revista Latinoamericana de Investigación en Matemática Educativa, Special Issue on Semiotics, Culture and Mathematical Thinking*, Numero speciale, 103-129.

[16] Bartolini Bussi, M.G., Maschietto M. (2006) *Macchine matemati-che*, Springer, Milano.

[17] Radford, L. (1997) On Psychology, Historical Epistemology and the Teaching of Mathematics: Towards a Socio-Cultural History of Mathematics, *Forthe Learning of Mathematics* 17(1), 26-33.

Capitolo 1
La Catenaria

di *Emilia Mezzetti* e *Maura Ughi*

1. Introduzione e contesto didattico

Vi sono delle curve molto interessanti che nascono da problemi fisici e da sviluppi interni al pensiero matematico, che hanno segnato per lungo tempo la storia della fisica e della matematica. Da questa constatazione hanno avuto origine le nostre motivazioni nel proporre "Curve celebri" come tema per un laboratorio di matematica nell'ambito del Progetto Lauree Scientifiche, tenendo conto dei nostri diversi interessi professionali (una fisica matematica, l'altra geometra). Avevamo in mente la catenaria, la cicloide, le spirali, ma anche la cissoide, la trattrice, le figure di Lissajous e altre, curve diverse dalle "solite" coniche, ma comprensibili a studenti degli ultimi anni delle scuole superiori. Poi la scelta da parte degli insegnanti è caduta sulle prime tre curve, anche perché i problemi da cui nascono, pur essendo classici, non vengono dall'antichità greca. In questo capitolo presentiamo il lavoro che è stato fatto sulla Catenaria, la curva che ha più applicazioni all'arte e in particolare all'architettura. A grandi linee, sono curve studiate da Galileo in poi, coinvolgendo nomi meno noti fuori dall'ambiente accademico, quali i Bernoulli, Fibonacci, Beltrami. Particolarmente interessante per gli studenti ci sembrava far notare che la soluzione dei problemi viene da un lungo processo che coinvolge persone diverse, che porta a costruire strumenti nuovi d'indagine scientifica, in assenza dei quali l'intuizione e l'empiria possono

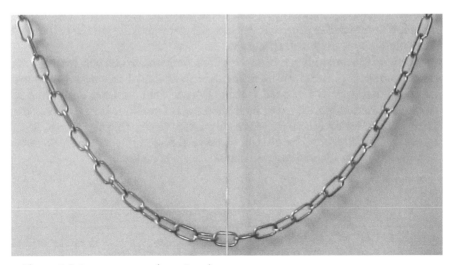

▲ **Figura 1** Catena sospesa a due estremi

condurre in errore e non possono bastare per risolvere problemi anche sem-plici che vengono dal mondo naturale. La catenaria è la curva descritta da una catena omogenea sospesa a due estremi.

Galileo Galilei, che sembra sia stato il primo a porsi il problema di una descri-zione matematica di questa curva, aveva pensato a una parabola[1] non tanto per la forma molto simile a quella parabolica che poteva sperimentalmente osservare, quanto piuttosto sulla base di un'analogia col moto di un proiettile. Galileo pensò che, come il proiettile in moto in ogni istante è sottoposto a due azioni (una naturale che lo spinge verso il basso per effetto del suo peso e l'al-tra "equabile" che ha la direzione del movimento), così anche nella catena ogni anello è sottoposto alle stesse due azioni. Per il moto del proiettile Galileo era riuscito a dimostrare la natura parabolica dell'orbita, e nello stesso modo pensò si potesse fare per la catena. Più tardi fu Joachim Jungius a evidenziare l'errore di Galileo e Jacob Bernoulli, nel 1690, lanciò ai matematici più illustri la sfida: determinare l'equazione che descrive la catenaria. Nel CD allegato al libro, *Capitolo I/La catenaria.ppt.: Le curve nella storia*, si trova una breve sin-tesi storica degli eventi legati a questo problema (si vedano anche Boyer [2] e Kline [3]).

Jacob Bernoulli aveva ben compreso che il problema non poteva essere risolto senza servirsi dei nuovi metodi infinitesimali e sapeva bene che chiun-que avesse tentato di venirne a capo con i metodi tradizionali, i soli disponibi-li a Galileo, avrebbe sbattuto la testa contro un muro. Questa considerazione è essenziale per motivare l'importanza del nuovo calcolo e vale la pena di insi-stere sulla novità che questo comporta per lo sviluppo della scienza parago-nando il prima (Galileo) col dopo (Leibnitz e Newton). La nascente analisi infi-nitesimale e i metodi analitici introdotti da Cartesio renderanno possibili, a partire dalla seconda metà del XVII secolo, conquiste prima impensabili. Il problema della catenaria si presta bene a illustrare la forza di questi nuovi metodi d'indagine che preludono ai successi clamorosi di Newton e di tutta la fisica matematica dei secoli successivi.

Lo studio proposto si presta anche a essere affrontato con vari metodi: ana-litico-geometrici, laboratorio sperimentale di fisica, laboratorio informatico (sia per l'uso di software quali Qbasic, Derive, Cabri, sia per l'aspetto della ricerca in Internet, vista la quantità di materiale disponibile in rete). Ma la cosa forse più interessante è la rilevanza di queste curve nell'arte in tutte le sue forme, dall'architettura alla pittura, come se vi fosse un legame diretto anche se non esplicito tra la costruzione matematica e la bellezza.

[1] Nella seconda giornata dei *Discorsi intorno a due nuove scienze*, Galileo allude esplicitamen-te alla forma parabolica della catena sospesa (p. 161), mentre nella quarta giornata (p. 293) sem-bra essere più cauto e parla di "adattamento" di quella alla forma parabolica.

Il laboratorio sulla catenaria è stato progettato nel 2005/06 da un gruppo d'insegnanti coordinati dai proff. Emilia Mezzetti, Maura Ughi e Marino Zennaro dell'Università di Trieste. È stato realizzato nel periodo gennaio-aprile 2006 in due istituti scolastici: il Liceo scientifico "G. Oberdan" di Trieste, con l'insegnante Giulialba Pagani, e l'ISIS "Dante Alighieri" di Gorizia (nelle due sedi del Liceo scientifico "Duca degli Abruzzi" e dell'Istituto magistrale "S. Slataper") con gli insegnanti Marina Altran, Giuliano De Biasio ed Emanuela Fabris. Hanno partecipato al laboratorio complessivamente cinquanta studenti provenienti da tutte le classi del triennio.

L'obiettivo del laboratorio "Curve celebri" era di far conoscere agli studenti l'evoluzione di alcuni temi della matematica, con la presentazione di problemi fisici che hanno portato all'introduzione e allo studio di curve importanti nella storia della matematica, in particolare il problema della configurazione di equilibrio di una catena omogenea, problema matematico semplice ma rilevante teoricamente, storicamente e per le applicazioni. Ci si proponeva di sviluppare le capacità di osservazione e modellizzazione in senso matematico di problemi e contemporaneamente sviluppare competenze trasversali, linguistiche, storiche, informatiche. Inoltre, come obiettivi secondari, si voleva familiarizzare gli studenti al lavoro di gruppo, all'utilizzo della lingua inglese e all'elaborazione di testi e ipertesti su materiali tratti da libri o reperiti su Internet. A posteriori ci si è resi conto dell'enorme interesse suscitato negli studenti dalle applicazioni della catenaria all'arte, in particolar modo all'architettura.

Nella fase di progettazione, che si è articolata in cinque incontri della durata di circa due ore, si è studiata la letteratura sull'argomento, si sono individuati i temi su cui concentrarsi, la scansione degli argomenti. Fra i testi consultati ricordiamo Cresci 1998 [4], Cresci 2005 [5], Courant-Robbins [6] per l'aspetto della divulgazione, Levi Civita-Amaldi [7] per la trattazione matematica rigorosa, Loria [8], Kline [3], Boyer [2] per l'inquadramento storico. Per quanto riguarda i siti web, le fonti sono numerosissime e in continuo aumento, e purtroppo non tutte attendibili. Citiamo in bibliografia solo alcune, basandoci sul nostro gusto personale.

Il laboratorio si è articolato in venti ore, di cui le prime diciassette nell'istituto scolastico, in orario quasi tutto extra-scolastico, alla presenza dei docenti coinvolti, le ultime tre all'università con i gruppi riuniti e la partecipazione dei docenti universitari. Nell'ultimo incontro si è data la parola ai ragazzi che, con l'aiuto di computer e videoproiettore, hanno illustrato il lavoro svolto. Alla fine ciascun gruppo ha prodotto un CD-rom contenente la presentazione e altro materiale raccolto. Per maggiori dettagli sull'organizzazione didattica dei laboratori si veda Mezzetti [9].

Il presente capitolo contiene il materiale sulla catenaria, secondo lo schema emerso nella fase di progettazione con gli insegnanti. Vi abbiamo raccolto in modo autocontenuto argomenti che si trovano generalmente sparsi in testi di livello universitario (quindi con prerequisiti troppo elevati rispetto al livello di scuola superiore), oppure in testi classici ma ormai un po' antiquati come linguaggio, e anche in testi divulgativi e siti web, e in tal caso un po' troppo super-

ficiali. Il capitolo segue l'ordine di presentazione effettivamente seguito nei laboratori con gli studenti. S'inizia quindi con un'introduzione storica del problema e dell'atmosfera scientifica del periodo in cui il problema è stato posto. Questa parte di carattere storico è stata molto gradita agli studenti, che l'hanno ampliata anche andando a cercare informazioni sulle vite dei personaggi coinvolti e le loro relazioni e diatribe.

Sempre nella logica di una presentazione prima di tutto storica, abbiamo inserito il paragrafo sul "calcolo sublime" di Leibnitz, senza il quale non si fanno i conti, cioè non si può affrontare l'equazione differenziale che dà la catenaria come soluzione. Si è cercato di usare il linguaggio del tempo per presentare le regole del "calcolo", e non il linguaggio che si usa in una presentazione moderna degli stessi argomenti. Questa scelta è stata discussa con gli insegnanti e, nella pratica, è risultata efficace.

Successivamente (paragrafo 3.1), si è sviluppata una fase più pratica del laboratorio con l'osservazione e la determinazione sperimentale della curva. Si è passati poi a scrivere l'equazione differenziale della catenaria (paragrafo 3.2) e a trovare la sua soluzione (paragrafo 3.3). Questo ha portato a introdurre in modo naturale le funzioni seno e coseno iperbolico, facendo chiaramente vedere l'origine del loro nome per analogia con le funzioni seno e coseno (cambiando un segno nella relazione quadratica tra le due).

Si è ritenuto di fare un cenno ai ponti sospesi (paragrafo 3.4), perché in questo caso si ottiene proprio la parabola immaginata da Galileo.

Nel leggere le notizie e curiosità sulla catenaria raccolte nel classico libro di Gino Loria sulle curve, abbiamo trovato la proprietà della catenaria di essere il luogo dei fuochi di una parabola volvente su una retta. Questa caratteristica geometrica che lega la catenaria alla parabola (di Galileo) è sembrata significativa a tutti, e quindi è stata esaminata prima sperimentalmente poi con Cabri (per usare anche strumenti informatici), e poi ovviamente con gli strumenti della geometria analitica e differenziale. Questo è stato riportato nel paragrafo 3.4.

La realizzazione pratica del laboratorio, proprio perché lasciava spazio al gusto e alla curiosità degli studenti, ha seguito poi strade all'inizio non previste. Da ciò sono nati i paragrafi 5 e 6 e altri argomenti contenuti nel CD, quali la pseudosfera di Beltrami e la catenoide, su cui è stato anche filmato l'esperimento con le superfici saponate.

Il CD allegato al libro: *Capitolo I/La catenaria.ppt.*, realizzato dai due istituti, riflette bene gli aspetti che più hanno interessato gli studenti fra le molte cose che della Catenaria si possono dire. Ricordiamo di nuovo che i vari gruppi erano sì "guidati" dai docenti ma lasciando molto spazio al gusto e alle curiosità personali. Per esempio nel CD si accenna brevemente ad altri contesti nei quali la catenaria interviene tra cui la pseudosfera di Beltrami che fornisce un modello per il piano iperbolico non euclideo. Infine vedremo l'importanza e la presenza della catenaria nell'architettura di tutti i tempi e nell'arte per capirne la misteriosa bellezza che molti artisti hanno creduto di poter trovare nella purezza della sua forma.

2. Il *calcolo sublime* di Leibnitz

Noi seguiremo, nel trattare l'argomento, i metodi e le notazioni di Leibnitz che ci paiono più vicini alla geometria elementare e più facilmente comprensibili agli studenti delle scuole superiori. Ovviamente il linguaggio usato al giorno d'oggi per spiegare all'università gli stessi argomenti è diverso e più legato alla teoria delle equazioni differenziali.

Leibnitz introduce formalmente il calcolo differenziale introducendo l'operatore di differenziazione e dando delle regole per differenziare delle quantità variabili. Le regole sono quelle usuali:

- se a è costante $da = 0$;
- $d(x + y) = dx + dy$;
- $d(xy) = x \ dy + y \ dx$;
- $d\left(\dfrac{x}{y}\right) = \dfrac{x \ dy - y \ dx}{y^2}$.

Da queste relazioni si deduce che $d(x^n) = nx^{n-1}dx$ anche quando n è razionale; infatti, osservando che

$$y = x^{\frac{1}{n}} \quad \Rightarrow \quad y^n = x \ ,$$

differenziando si ottiene $ny^{n-1} \ dy = dx$ da cui segue:

$$dy = d(\ x^{\frac{1}{n}} \) = \frac{dx}{ny^{n-1}} = \frac{1}{n} x^{(\frac{1}{n}-1)} \ dx \ .$$

Questo "calcolo" risolve il problema di determinare la retta tangente a una curva di equazione cartesiana $F(x,y) = 0$. La tangente nel punto $P = (x,y)$ viene pensata come la retta che unisce (x,y) col punto $(x + dx, y + dx)$, e dunque la sua pendenza si ottiene calcolando il differenziale di F con le regole dette e scrivendo il rapporto

$$\frac{dy}{dx} \ .$$

Per esempio se la curva è definita dall'equazione

$$ay - x^n = 0$$

allora la tangente a questa curva nel punto P si trova nel modo seguente:

$$0 = d(ay - x^n) = d(ay) - d(x^n) = ady - nx^{n-1}dx$$

e quindi calcolando il rapporto abbiamo

$$\frac{dy}{dx} = \frac{nx^{n-1}}{a}$$

che fornisce la pendenza richiesta.

Se dx è l'incremento infinitesimo di una variabile x allora la somma di questi infiniti incrementi restituisce la variabile x e Leibnitz scrive

$$\int dx = x \ .$$

L'operatore inverso a quello di differenziazione è dunque l'integrazione che permette di passare da elementi infinitesimi a elementi finiti[2].

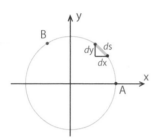

Questi metodi permettevano in moltissimi casi di calcolare aree, volumi e lunghezze di archi di curva. A titolo di esempio vediamo come si calcola, seguendo queste rivoluzionarie idee, la lunghezza di un arco di circonferenza.

Consideriamo la circonferenza di raggio r e centro nell'origine: la sua equazione è

$$x^2 + y^2 = r^2.$$

Supponiamo di voler calcolare la lunghezza dell'arco di circonferenza da A a B. Consideriamo l'arco come formato da elementi infinitesimi ds. La lunghezza totale l sarà la somma di questi elementi

$$l = \int_A^B ds \ .$$

L'arco infinitesimo ds è legato ai differenziali dx e dy dal teorema di Pitagora

$$ds^2 = dx^2 + dy^2$$

ma x e y sono legati dalla relazione $x^2 + y^2 = r^2$ e quindi differenziando abbiamo

$$2x \ dx + 2y \ dy = 0$$

$$dy = -\frac{x}{y} \ dx$$

che sostituito nel ds dà

$$ds = \sqrt{dx^2 + dy^2} = \sqrt{dx^2 + \frac{x^2}{y^2} dx^2} = \sqrt{\frac{x^2 + y^2}{y^2}} \ dx = \sqrt{\frac{r^2}{r^2 - x^2}} \ dx = \frac{r}{\sqrt{r^2 - x^2}} \ dx$$

e quindi il valore finito della lunghezza l si ottiene calcolando l'integrale

$$l = \int_A^B ds = \int_A^B \frac{r}{\sqrt{r^2 - x^2}} \ dx$$

[2] Si veda per esempio [10].

integrale che si risolve con ulteriori regole (come per esempio l'integrazione per parti) deducibili dal fatto che l'integrazione è l'operatore inverso a quello di differenziazione.

3. L'equazione cartesiana della catenaria: corde, catene e ponti

Consideriamo una catena o una corda omogenea in equilibrio, sospesa per due punti A e B e soggetta all'azione della gravità: la linea che si forma si chiama *catenaria*.

3.1. Osservazione sperimentale

Lo studio in classe, riportato nel CD allegato al libro: *Capitolo I/ La catenaria.ppt.: L'esperienza della catenella e altre*, inizia appendendo una catenella su un foglio quadrettato per riprodurne la forma (notiamo che questo era proprio il metodo della "fune branda" usato anticamente per costruire ponti ad arco catenario). Fatto questo si comincia un'attività congetturale di discussione confrontando questa curva con quella della parabola interpolando i due grafici. Si nota che la catenaria non è una parabola. Si nota anche che, cambiando il materiale della corda ma mantenendo invariata la lunghezza e la posizione dei due punti di sospensione, la curva rimane identica.

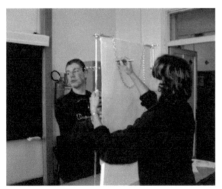

▲ **Figura 2** L'esperienza della catenella

3.2. Modello fisico-matematico

Se si conviene di designare con s la lunghezza dell'arco AP, misurato positivamente da A verso B, la tensione $\bar{T}(s)$ esercitata sull'arco in P per effetto della parte restante PB di fune è una funzione dell'arco, tangente alla fune (perché la fune è flessibile) e sempre diretta nel verso delle s crescenti (perché la fune

non è in grado di resistere alla compressione). Nel punto P d'altra parte il trat-
to AP esercita una tensione opposta $-\bar{T}(s)$ sull'arco PB.

Si può supporre la catena costituita da elementi materiali di lunghezza ds. Sia
\bar{F} il vettore peso specifico, costante per l'omogeneità della fune. Pertanto $\bar{F}ds$ è
la sollecitazione del campo gravitazionale cui è sottoposto l'intero tratto ds.

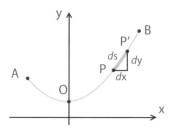

Equazioni di equilibrio

Considerato il tratto di fune di estremi P e P'=P+ds:

- all'estremo inferiore agisce la tensione $-\bar{T}(s)$;
- all'estremo superiore agisce $\bar{T}(s + ds)$;
- al centro del tratto agisce la forza peso $\vec{F}ds$.

Per avere l'equilibrio di ogni elemento di corda la somma delle tre forze pre-
cedenti deve essere zero, quindi:

$$-\vec{T}(s) + \vec{T}(s + ds) + \vec{F}ds = 0$$

quindi

$$\frac{d\vec{T}}{ds} + \vec{F} = 0.$$

Questa equazione deve essere soddisfatta in ogni punto della catena o della fune.

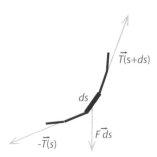

Fissato un verso di misura degli archi, se proiettiamo le forze su un sistema di
assi cartesiani tale che la forza peso risulti parallela all'asse y e di verso con-

trario, indicato con p il peso del tratto di lunghezza unitaria, si ottengono le seguenti equazioni di equilibrio:

$$\frac{d}{ds}\left(T(s)\frac{dx}{ds}\right) = 0 \quad , \quad \frac{d}{ds}\left(T(s)\frac{dy}{ds}\right) = p \quad ,$$

la prima in direzione orizzontale, la seconda in direzione verticale.

Da un punto di vista fisico e ingegneristico l'equazione di equilibrio e la figura corrispondente esprimono il fatto che il peso di ogni "elemento" di catena è equilibrato da due forze agenti all'estremità dell'elemento, dirette tangenzialmente alla curva di equilibrio verso l'esterno. Non sono necessarie all'equilibrio altre forze. Questo vuol dire che gli sforzi interni alla catena sono *solo di trazione*, questa è d'altra parte l'ipotesi da cui siamo partiti, cioè che un qualsiasi elemento di catena resta in equilibrio solo se è sottoposto a sforzi di trazione, mentre se è sottoposto a sforzi ortogonali (di taglio), a coppie che possono flettere la catena (momenti flettenti) o a sforzi di compressione si deforma. Questa ipotesi sulla natura della catena (che in gergo tecnico si dicono "equazioni costitutive") insieme al principio che tutte le forze agenti devono dare somma nulla, permette appunto di scrivere l'equazione di equilibrio.

Tornando ora alla fisica e alle sue applicazioni, immaginiamo di avere un arco solido (rigido) *a forma di catenaria* fissato alle estremità e soggetto solo al suo peso, per ogni suo elemento valgono le stesse equazioni di equilibrio e questo vuol dire che in esso si presenta *solo* sforzo di trazione in ogni punto. Se si riflette quest'arco rispetto all'orizzontale (catenaria riflessa) esso sarà soggetto *solo* a sforzo di compressione, così che l'arco si "sostiene da solo" o con termine inglese più usato è *self-supporting*.

Questo è il motivo statico dell'uso della catenaria riflessa in ingegneria e architettura. Mentre per un arco a tutto sesto (romano) o a sesto acuto (gotico) l'equilibrio del singolo elemento d'arco necessita di sforzi tangenti, ortogonali (di taglio) e momenti flettenti, per l'arco catenario sono sufficienti solo gli sforzi tangenziali.

3.3. Trattazione matematica

Integrando le due equazioni a partire da O (chiamando d'ora in poi per comodità *s* la lunghezza dell'arco OP), otteniamo

$$T(s)\frac{dx}{dy} = \text{cos tan te} \quad , \quad T(s)\frac{dy}{ds} = \int_0^P p\,ds \quad .$$

La prima equazione ci dice che la tensione orizzontale è costante per tutta la lunghezza della catenaria, mentre la seconda, supponendo che p sia costante (e in questo caso l'integrale è semplicemente ps) ci dice che la tensione verticale cresce, a partire dal punto più basso O, proporzionalmente alla lunghezza s dell'arco da O a P.

Facciamo ora, nel caso della catenaria (quando cioè p si suppone costante), il rapporto tra queste equazioni. La tensione sparisce (si semplifica) e, chiamando pc la costante relativa alla prima equazione, troviamo c $dy = s\, dx$ che, unita alla relazione $ds^2 = dx^2 + dy^2$, fornisce le relazioni

$$c\, dy = s\, dx$$
$$ds^2 = dx^2 + dy^2.$$

Queste equazioni legano tra loro i differenziali delle quantità x, y, s e il problema si riduce a quello di calcolare le funzioni che verificano queste relazioni.
Eliminando dy troviamo

$$c\, ds = \sqrt{c^2 + s^2}\ dx\ .$$

Questa relazione che lega x, s e i loro differenziali, se integrata, permette di trovare la dipendenza di x da s e viceversa.

$$x(s) - x(0) = x(s) = \int_0^P \frac{ds}{\sqrt{1 + \dfrac{s^2}{c^2}}} = c\int_0^P \frac{dt}{\sqrt{1 + t^2}} \quad , \quad t = \frac{s}{c}\ .$$

L'integrale può essere esplicitamente calcolato con un po' di astuzia tramite il logaritmo naturale:

$$\int_0^P \frac{dt}{\sqrt{1 + t^2}} = \log\!\left(t + \sqrt{1 + t^2}\right)\Big|_0^P = \log\!\left(\frac{s}{c} + \sqrt{1 + \frac{s^2}{c^2}}\right)\ .$$

Questo calcolo ci permette di trovare l'espressione esplicita della funzione incognita x(s):

$$\frac{x(s)}{c} = \log\!\left(\frac{s}{c} + \sqrt{1 + \frac{s^2}{c^2}}\right)\ .$$

Questa funzione ha un'espressione complicata, mentre la sua inversa, che esprime s in funzione di x, ha una forma più semplice. Si tratta di una nuova funzione di grande interesse e semplicità che nasce come funzione inversa di un integrale, situazione questa che si ripresenta nello studio degli integrali ellittici e non del tutto nuova se pensiamo che

$$\int \frac{dt}{\sqrt{1 - t^2}} = \text{arc}\ \sin(t)$$

è la funzione inversa della funzione sen(t).

Calcoliamo esplicitamente s in funzione di x. Cominciamo col "togliere" il logaritmo usando la sua funzione inversa: abbiamo

$$e^{\frac{x}{c}} = \frac{s}{c} + \sqrt{1 + \frac{s^2}{c^2}}$$

da cui, con facili calcoli,

$$\left(e^{\frac{x}{c}} - \frac{s}{c}\right)^2 = 1 + \frac{s^2}{c^2} \ , \qquad e^{2\frac{x}{c}} - 2\frac{s}{c}e^{\frac{x}{c}} = 1$$

e quindi, ricavando s, otteniamo la funzione cercata

$$s(x) = c \ \frac{e^{\frac{x}{c}} - e^{-\frac{x}{c}}}{2} \ .$$

Questa funzione è molto importante e le si dà un suo nome proprio. Per ragioni di strettissima parentela con la funzione seno, ragioni che vedremo più avanti, questa funzione si chiama *seno iperbolico* e si indica con sinh. Abbiamo quindi

$$s(x) = c \ \sinh(\frac{x}{c}) \qquad \text{dove} \qquad \sinh(t) = \frac{e^t - e^{-t}}{2}$$

Questa funzione esprime la lunghezza s dell'arco di catenaria che va da O al punto P di ascissa x.

Non è difficile vedere che la sua derivata, che chiamiamo *coseno iperbolico*, è data da

$$\cosh(t) = \frac{e^t + e^{-t}}{2} \ .$$

Ci sono molte analogie con le funzioni trigonometriche standard, tra cui

$$\cosh^2(t) - \sinh^2(t) = 1 \quad \text{per ogni t}$$

e quindi i punti di coordinate $(\cosh(t), \sinh(t))$ si trovano tutti sull'iperbole equilatera di equazione

$$X^2 - Y^2 = 1.$$

Altre analogie, introducendo per esempio la funzione tangente iperbolica $\tanh(t)$, possono essere trovate direttamente dagli studenti. La differenza

🔘 essenziale con le funzioni trigonometriche (dette anche circolari) è tutta in un segno! Nel CD allegato al libro: *Capitolo I/ Le funzioni iperboliche.pdf*, si trova una semplice trattazione di questo argomento.

Tornando alla catenaria, se vogliamo trovare l'espressione di y in funzione di x basta tener conto del fatto che c dy = s dx : sostituendo il valore di s che abbiamo trovato risulta

$$dy = \frac{s}{c}dx = \sinh\left(\frac{x}{c}\right)dx$$

da cui, integrando

$$y(x) - y(0) = \int_0^P \sinh\left(\frac{x}{c}\right)dx = c\int_0^P \sinh(t)dt = c\frac{e^t + e^{-t}}{2}\Big|_0^P = c\,\frac{e^{\frac{x}{c}} + e^{\frac{x}{c}}}{2} - c \quad .$$

In definitiva, se prendiamo l'origine del sistema di riferimento in modo che l'ordinata del punto O sia c, *l'equazione della catenaria è semplicemente un coseno iperbolico*:

$$y(x) = \; c\,\frac{e^{\frac{x}{c}} + e^{-\frac{x}{c}}}{2} = c\,\cosh(\frac{x}{c}) \quad .$$

Questa equazione può essere facilmente tabulata anche con un foglio elettronico e il suo grafico può essere tracciato per vari valori del parametro c.

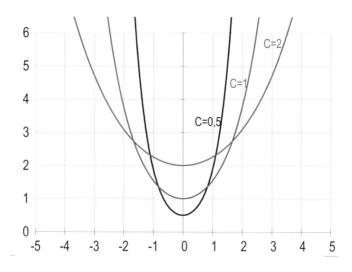

Si nota come man mano che il parametro c aumenta, la catenaria si allarga sempre più.

3.4. Ponti sospesi

Un altro problema interessante è quello dei cosiddetti "ponti sospesi".

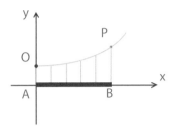

Nel caso descritto dalla figura, la curva OP sostiene, con dei tiranti verticali, una struttura orizzontale AB molto più pesante. Supponendo che i fili con cui sono fatti i tiranti e la linea OP siano molto più leggeri del tratto orizzontale AB, abbiamo che la forza specifica di carico agente sul tratto ds è pari al peso specifico del ponte per l'elemento orizzontale di ponte, cioè per dx. Quindi l'equazione di bilancio delle forze diventa adesso:

$$-\vec{T}(s) + \vec{T}(s + ds) + \vec{F}_{ponte}\,dx = 0 \ .$$

Procedendo come prima le due equazioni di equilibrio sono:

$$\frac{d}{ds}\!\left(T(s)\frac{dx}{ds}\right) = 0 \quad , \quad \frac{d}{ds}\!\left(T(s)\frac{dy}{ds}\right) = k\,\frac{dx}{ds} \qquad .$$

dove k è il peso specifico del ponte, che supporremo costante.

In questo caso integrando si ottiene:

$$T(s)\frac{dx}{ds} = \cos\tan te = ck \quad , \quad T(s)\frac{dy}{ds} = \int_{0}^{P} k\,\frac{dx}{ds}\ ds = kx$$

L'equazione della curva diventa

$$c\,dy = x\,dx$$

che, integrata, fornisce l'equazione di una parabola (come sosteneva Galileo Galilei):

$$y(x) \ = \ \frac{x^{2}}{2c} \ .$$

Molti ponti sono costruiti in questa maniera soprattutto quelli più primitivi fatti di liane e tavole.

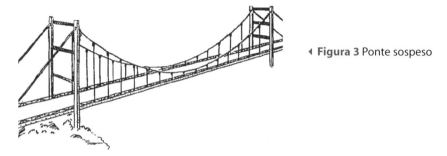

◄ **Figura 3** Ponte sospeso

Famoso è il ponte Golden Gate di San Francisco in California la cui curva sovrastante non è una catenaria ma una parabola!

4. Catenaria e parabole che rotolano

Esiste anche un modo completamente diverso, puramente geometrico, per trovare la catenaria. Il fuoco di una parabola che rotola senza strisciare su una retta descrive una curva che è proprio una catenaria, il cui parametro c è la distanza del fuoco della parabola dal suo vertice: miracolo!

Anche questa attività inizia in classe in modo sperimentale. Si costruiscono parabole di varia apertura in cartoncino e si fora il cartoncino nel punto dove si trova il fuoco della parabola (esercizio questo che permette di riprendere la teoria delle coniche e il modo concreto di tracciarle tramite una tabulazione o un movimento meccanico). Si fa infine rotolare la parabola su un foglio senza strisciare e si segna, facendo passare la mina della matita nel foro, la posizione del fuoco man mano che la parabola ruota. Ogni gruppo di studenti avrà un suo luogo, una sua catenaria. Nel CD allegato al libro: *Capitolo I/ Parabola che ruota.gif*, si trova un'animazione che mostra la catenaria che si forma dal rotolamento della parabola.

Fissiamo un sistema di riferimento come nella prima figura, col vertice V della parabola posto nell'origine O e il fuoco sull'asse delle ordinate a una distanza c dal vertice. In questa situazione l'equazione della parabola nella posizione iniziale è

$$4cy = x^2$$

e il suo fuoco si trova nella posizione (0,c). Facciamo ora rotolare la parabola senza strisciare sull'asse delle x. Se P è il punto di appoggio della parabola, l'asse delle x si sovrappone con la retta tangente alla parabola in P e l'ascissa di P è data dalla lunghezza s dell'arco di parabola VP. In questa posizione (vedi la terza figura della pagina precedente) il fuoco F della parabola avrà le coordinate

$$F=(X,Y) \text{ dove } X=s-HP \text{ e } Y = FH.$$

Le lunghezze dei segmenti FH e HP si calcolano usando la geometria della parabola, mentre per calcolare la lunghezza s dell'arco dobbiamo usare il calcolo integrale.

Consideriamo la parabola nella posizione iniziale e sia P un suo qualunque punto di coordinate (x,y).

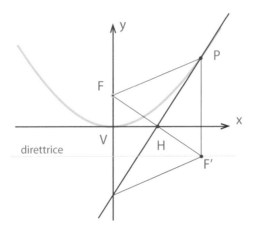

Calcolando esplicitamente la tangente, troviamo con semplici calcoli, che la retta tangente alla parabola per P è la diagonale del rombo di lato FP, dato che la retta per F' parallela all'asse delle ascisse è la direttrice della parabola. Dunque FH è perpendicolare alla tangente e H ha come ascissa x/2. Applicando il teorema di Pitagora troviamo, per valori positivi di x,

$$FH = \sqrt{\frac{x^2}{4} + c^2} = c\sqrt{1 + \frac{x^2}{4c^2}}, \quad PH = \sqrt{\frac{x^2}{4} + y^2} = \sqrt{\frac{x^2}{4} + \frac{x^4}{16c^2}} = \frac{x}{2}\sqrt{1 + \frac{x^2}{4c^2}}.$$

Calcoliamo ora la lunghezza dell'arco di parabola. Scriviamo l'elemento di linea

$$ds = \sqrt{dx^2 + dy^2}.$$

Sfruttando il fatto che $4cy=x^2$, differenziando troviamo $4c\, dy=2x\, dx$. Sostituendo nel ds otteniamo

$$ds = \sqrt{1 + \frac{x^2}{4c^2}}\; dx \cdot$$

L'integrale di questa funzione fornisce l'arco di parabola cercato

$$s = \int_0^P \sqrt{1 + \frac{x^2}{4c^2}}\; dx = 2c\int_0^P \sqrt{1 + t^2}\, dt \quad , \quad t = \frac{x}{2c} \cdot$$

È interessante osservare che la primitiva della semplicissima funzione $\sqrt{1 + t^2}$ è la lunghezza di un arco di parabola. Calcolando esplicitamente questa primitiva troviamo

$$\int \sqrt{1 + t^2}\, dt = \frac{1}{2}\left[\log\!\left(t + \sqrt{1 + t^2}\right) + t\sqrt{1 + t^2}\right]$$

e dunque

$$s = 2c\frac{1}{2}\left[\log\!\left(\frac{x}{2c} + \sqrt{1 + \frac{x^2}{4c^2}}\right) + \frac{x}{2c}\sqrt{1 + \frac{x^2}{4c^2}}\right] = c\; \log\!\left(\frac{x}{2c} + \sqrt{1 + \frac{x^2}{4c^2}}\right) + \frac{x}{2}\sqrt{1 + \frac{x^2}{4c^2}} \cdot$$

Abbiamo in questo modo trovato le coordinate del fuoco F in ogni posizione:

$$\begin{cases} X = s - HP \\ Y = FH \end{cases} \quad \text{cioé} \quad \begin{cases} X = c\; \log\!\left(\dfrac{x}{2c} + \sqrt{1 + \dfrac{x^2}{4c^2}}\right) \\[2em] Y = c\sqrt{1 + \dfrac{x^2}{4c^2}} \end{cases} \cdot$$

Come abbiamo visto, il logaritmo che abbiamo trovato è la funzione inversa del seno iperbolico e dunque la prima equazione ci dice che

$$\frac{X}{c} = \operatorname{arc\;sinh}\!\left(\frac{x}{2c}\right) \quad \text{invertendo} \quad \sinh\!\left(\frac{X}{c}\right) = \frac{x}{2c} \cdot$$

Sostituendo nella seconda equazione abbiamo

$$Y = c\sqrt{1 + \sinh^2\!\left(\frac{X}{c}\right)} = c\; \cosh\!\left(\frac{X}{c}\right) = c\; \frac{e^{\frac{X}{c}} + e^{\frac{X}{c}}}{2} \cdot$$

In definitiva, le coordinate (X,Y) del fuoco F verificano l'equazione della catenaria di parametro c.

Queste funzioni sono facilmente implementabili su un computer sia in un foglio elettronico, sia scrivendo un semplice programma. Nel CD allegato al libro si trovano i programmi compilati: *Capitolo I/ Excel, Derive, Pascal.pdf* e *Capitolo I/ Grafici funzioni.xls* e *Capitolo I/ Grafico catenaria.xls*.

5. Le catenarie tra noi

È molto frequente trovare nella nostra esperienza quotidiana esempi di catenaria o, che è lo stesso, di coseni iperbolici: le collane senza pendenti appese al collo delle signore, i cavi tra i piloni dell'elettricità, forme comuni che la matematica riesce a descrivere completamente svelandone l'essenza. Ma la cosa forse più interessante non è l'aspetto descrittivo della matematica quanto piuttosto la possibilità attraverso essa di inventare nuove cose, nuova tecnologia. La catenaria genera nuove forme che da lei derivano e a lei si legano, oggetti che è possibile studiare con i metodi della geometria differenziale dei quali abbiamo dato un cenno nei paragrafi precedenti.

Nel CD allegato al libro: *Capitolo I/ La catenaria.ppt.: Altre vie per arrivare alla catenaria*, sono brevemente trattate altre curve legate alla catenaria: la *Clinoide*, la *Velaria* e la *Trattrice*. A proposito della "Catenaria come evoluta della Trattrice" sono state messe in risalto le relazioni con la pseudosfera di Beltrami, che fornisce un modello dello spazio iperbolico non euclideo a dimostrare che le "relazioni pericolose" e "sotterranee" hanno un grande fascino anche per gli studenti.

La Velaria invece è il profilo che presenta una vela rettangolare gonfiata da un vento che ha la direzione perpendicolare alla vela. Jacob Bernoulli riuscì a dimostrare che questa linea non è altro che una catenaria ruotata di 90°.

Tuttavia, la scoperta forse più interessante avviene con Eulero in relazione alla *catenoide*, la superficie ottenuta ruotando la catenaria intorno all'asse delle x. Nel 1744 Eulero riuscì a dimostrare che questa superficie è quella di area minima tra tutte quelle che hanno come bordo due circonferenze parallele.

◀ **Figura 4** Catenoide

La dimostrazione matematica è molto più complicata e necessita di strumenti ancora nuovi, tra cui il calcolo delle variazioni ideato da Eulero, tuttavia possiamo fare l'esperimento con delle bolle di sapone. Nel CD allegato al libro: *Capitolo I/ Catenoide.mpg*, il filmato riprende direttamente questo esperimento che può anche essere facilmente replicato a scuola.

Per quanto riguarda le "applicazioni della catenaria alla vita quotidiana" è stato privilegiato il suo uso massivo in architettura, passata e recente, e naturalmente il focus dell'attenzione è andato a Gaudì, il grande spagnolo che ha utilizzato archi e superfici catenarie dovunque poteva. Notiamo che l'uso "artistico" della catenaria è risultato essere più interessante per gli studenti del suo utilizzo in molteplici applicazioni ingegneristiche.

Il lavoro con gli studenti termina con una domanda che non si sarebbero sicuramente mai posti prima di questo laboratorio: l'arco delle Olimpiadi di Torino è una catenaria?

6. La catenaria nell'arte

Accade spesso che la matematica abbia alcuni aspetti interni che il matematico considera belli. Anzi riteniamo che senza questa tensione verso la bellezza e l'armonia la matematica avrebbe potuto svilupparsi ben poco. Tra le cose belle in matematica vi è la sua capacità spesso geniale di trasformare una cosa molto complicata in una cosa semplice e ben chiara. Così la descrizione matematica della linea che assume una catena sospesa non viene data con una fotografia che fissa i punti uno a uno ma attraverso un'espressione, una formula che racchiude in sé implicitamente tutti gli infiniti punti della curva e che permette ulteriori manipolazioni e sviluppi matematici. Il fatto poi che la formula sia semplicissima e che si esprima misteriosamente attraverso il numero *e* di Nepero rende la cosa ancora più affascinante. A questo si aggiunge una componente visiva, non più intellettuale: la misteriosa bellezza della curva, la sua semplicità e purezza, bellezza che ha affascinato numerosi artisti. Questa purezza è forse legata al suo rendere minima l'area come ha dimostrato Eulero o a equilibrare perfettamente tutti gli anelli di una catena ognuno dei quali è influenzato oltre che dal suo peso anche da quello dei suoi vicini che lo tirano da una parte e dall'altra. Situazione questa comune a ogni lamina o struttura formata da tante parti interagenti tra loro. Da questo punto di vista una catenaria rovesciata dà la linea che meglio sopporta il peso di se stessa armonizzando tra loro tutte le sue parti. Questa "armonizzazione" è racchiusa nell'equazione di equilibrio di cui abbiamo parlato precedentemente (paragrafo 3.2), che esprime il fatto che le forze esercitate su ogni elemento di catena dalle altre parti della catena stessa sono utilizzate nel miglior modo possibile, cioè lungo la tangente, senza disperdersi in componenti che vorrebbero deformare la "bella forma" (le componenti di taglio e flettenti). In un certo senso la catenaria vuole intimamente restare come è, è contenta di sé e non ha alcuna intenzione di cambiarsi forma, di deformarsi.

Molti architetti si sono ispirati nelle opere a questa linea creando strutture molto belle.

Solo a Firenze troviamo il ponte di Santa Trìnita e la cupola di Santa Maria del Fiore di Brunelleschi, strutturate con delle catenarie.

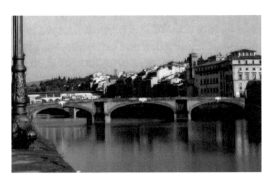

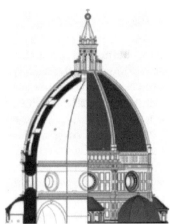

▲ ▶ **Figure 5 e 6** Ponte di S. Trìnita; Cupola di
S. Maria del Fiore del Brunelleschi, Firenze

La superficie ottenuta ruotando una catenaria ribaltata intorno all'asse delle
ordinate è spesso usata, per i motivi di staticità che abbiamo detto, per realiz-
zare delle grandi cupole. Per esempio la cattedrale di St. Paul a Londra.

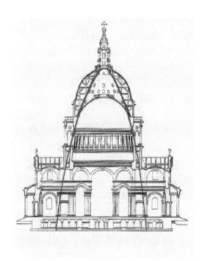

◀ **Figura 7** Cattedrale di St. Paul, Londra

Tra tutti gli artisti quello che più di tutti si è lasciato affascinare dalla bellezza
della catenaria è Gaudì, che usa questa forma sia negli esterni sia negli interni
attraverso un vero e proprio personale lavoro di ricerca estetica. Gaudì ritiene
che la forma più funzionale sia anche la più bella e trova nella matematica lo
strumento per scoprire la "funzionalità" delle strutture che possono essere
immaginate.

Ricordiamo qui che l'arco catenario riflesso è stato usato da molto prima
che si conoscessero le funzioni esponenziali, o che addirittura ci si ponesse il

problema della sua equazione, per la facilità con cui lo si ottiene. Bastava infatti prendere una catena o una fune, fissarla a due ganci alle estremità, farla pendere liberamente, prendere l'impronta della sua forma, rovesciarla ed ecco uno splendido arco catenario. Questo era in effetti il metodo detto in Toscana "della fune branda", usato per esempio per il ponte di Santa Trìnita a Firenze. Anche Gaudì otteneva le sue linee e superfici appendendo in giro catene finché non otteneva il risultato artistico che aveva in mente e seguendo poi le forme così ottenute nella costruzione materiale (con disperazione dei committenti che vedevano lievitare i costi di costruzione).

Nel CD allegato al libro: *Capitolo I/ La catenaria.ppt: La catenaria nella vita quotidiana*, si trova un'ampia rassegna dei lavori di Gaudì che può essere utilmente utilizzata per illustrare i rapporti non pretestuosi o formali tra la geometria, la sua bellezza e le opere, non solo tecnologiche, di grandi architetti e artisti.

Bibliografia

[1] Galilei, G. (1990) *Discorsi e dimostrazioni matematiche intorno a due nuove scienze*, a cura di E. Giusti, Einaudi, Torino.
[2] Boyer, C. (1982) *Storia della matematica*, Mondadori, Milano.
[3] Kline, M. (1991) *Storia del pensiero matematico*, Einaudi, Torino.
[4] Cresci, L. (1998) *Le curve celebri, invito alla storia della matematica attraverso le curve piane più affascinanti*, Muzzio, Padova.
[5] Cresci, L. (2005) *Le curve matematiche tra curiosità e divertimento*, Hoepli, Milano.
[6] Courant R., Robbins, H. (2000) *Che cos'è la matematica?*, Bollati Boringhieri, Torino.
[7] Levi-Civita T., Amaldi, L. (1974) *Lezioni di Meccanica razionale*, Zanichelli, Bologna.
[8] Loria, G. (1930) *Curve piane speciali, algebriche e trascendenti*, II, Hoepli, Milano.
[9] Mezzetti, E. (2009) *Con le mani e con la mente*, EUT, Trieste.
[10] Giusti, E. (2007) *Piccola storia del calcolo infinitesimale dall'antichità al Novecento*, Istituti editoriali e poligrafici internazionali, Pisa-Roma.

Siti web:

http://turnbull.mcs.st-and.ac.uk/history/Curves/Curves.html
http://www.imss.fi.it/index.html
http://web.math.unifi.it/archimede/archimede/index.html
http://www2.comune.roma.it/museomatematica/percorso05.htm
http://virtualmathmuseum.org/

Capitolo 2
La sezione aurea, la spirale logaritmica e i numeri di Fibonacci

di *Franco Ghione, Emilia Mezzetti* e *Maura Ughi*

Oggi siamo convinti che la Geometria sia una scienza arida, indegna della sensibilità di un'artista. Se la conoscessimo meglio, sapremmo invece che è pervasa di sensibilità e di intuizione. Penso che la geometria, capita come solo un'artista la può capire sia poesia suprema.
Gino Severini[1]

1. Introduzione e contesto didattico

Divina proporzione. Divina perché come Dio. Come Dio una e trina, come Dio ineffabile, come Dio ubiqua. Ubiqua perché si ritrova ovunque, nell'aria (icosaedro), nella virtù celeste (dodecaedro). Ineffabile perchè il numero che la rappresenta non può essere pronunciato con le parole, qualunque sia il numero di cifre che si riescano a calcolare ve ne sono infinite altre ignote, casuali, ineffabili. Una e trina perché coinvolge in un'unica proporzione tre grandezze. Così il frate Luca Pacioli predicava la geometria nel 1498 a Milano e, insieme a Leonardo da Vinci, componeva il suo capolavoro: *De Divina proportione*.

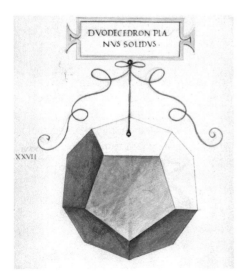

▲ **Figura 1** Il dodecaedro e il 72 basi disegnati da Leonardo da Vinci per illustrare il *De Divina proportione* di Luca Pacioli

[1] Gino Severini (1997) *Dal Cubismo al Classicismo*, Abscondita, Milano, p. 59.

Leonardo con la delicatezza e la poesia dei suoi colori dava corpo ai poliedri e fra' Luca accompagnava la divina proporzione con 12 *effetti*: 12, come gli apostoli che Leonardo andava genialmente immaginando per il Cenacolo, 12 proprietà di questa proporzione cui Pacioli, a dieci di queste, attribuisce un nome: essenziale, singolare, ineffabile, mirabile, innominabile, inextimabile, sopra gli altri eccessivo, supremo, excellentissimo, quasi incomprensibile. Nel CD allegato al libro *Capitolo I/12 Effetti.pdf*, sono riportate in una scheda queste 12 proprietà alcune delle quali saranno ripercorse in questo testo.

Come il nostro cervello è strutturato per avvertire, tramite l'udito, consonanze e dissonanze nei suoni, così tende a riconoscere, tramite la vista, come armonica la divina proporzione. Studi sperimentali di psicologia cognitiva, eseguiti inizialmente dallo psicologo tedesco Gustav Fechner nel 1876 hanno ampiamente dimostrato che il rettangolo considerato più piacevole alla vista è quello i cui lati sono in rapporto secondo la divina proporzione. Il grafico seguente riporta i dati riscontrati da Fechner.

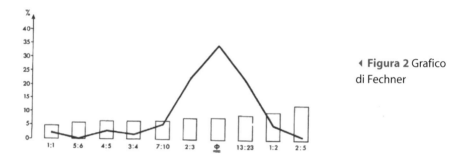

◀ **Figura 2** Grafico di Fechner

Questo fatto potrebbe spiegare come mai numerosi artisti, architetti, scultori, pittori e musicisti, a partire dall'antichità greca fino a tempi recentissimi si siano ispirati a questa proporzione come irraggiungibile aspirazione di bellezza e armonia. Irraggiungibile dal momento che qualunque sua materializzazione concreta ne rappresenta solo una rozza approssimazione, non per difetto di misura ma intrinsecamente, per il carattere irrazionale di questo rapporto.

◀ **Figura 3** La "divina proportione" nel Partenone

Un dato segmento u è diviso in due parti a e b (a>b) secondo la divina proporzione (o, come diceva Euclide, in media ed estrema ragione) se a è il medio proporzionale tra u e b, cioè se e

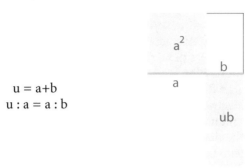

$$u = a+b$$
$$u : a = a : b$$

La parte maggiore a è detta anche la *sezione aurea* di u. Il rettangolo di lati a e b, e ogni altro rettangolo a lui simile, si chiama *rettangolo aureo*.

Nel CD allegato al libro *Capitolo II/Sezione Aurea.ppt/Rettangolo Aureo nella realtà*, è ampiamente documentato il ruolo che la sezione aurea ha giocato e continua a giocare nella Storia dell'Arte.

Ma oltre a un valore estetico diciamo oggettivo che si può ritrovare nella sezione aurea e che apparentemente nulla ha a che fare con il mondo fisico, emerge anche, con chiarezza, un inaspettato legame con alcuni processi di crescita che si ritrovano in natura, come per esempio la struttura di certe conchiglie o delle galassie, la fillotassi, la disposizione dei semi del girasole, la crescita di una popolazione di conigli che per primo Fibonacci ha esplorato. Nel CD allegato al libro *Capitolo II/Fibonacci.ppt* questi elementi sono ampiamente documentati anche nei loro aspetti legati alla pittura, all'architettura e alla musica. La stretta parentela tra questi fenomeni di crescita e la sezione aurea da un punto di vista matematico dipende dal fatto che la sezione aurea, la spirale logaritmica e i numeri di Fibonacci sono strettamente imparentati tra loro. È l'insieme di questi legami, che possono essere visti e compresi fino in fondo anche con gli strumenti che la scuola media superiore fornisce, che illustriamo in questo capitolo.

Sezione aurea, spirale logaritmica e numeri di Fibonacci sono i tre temi intorno a cui ruotava il laboratorio "Curve celebri" progettato e realizzato nel 2006/07. Proseguendo il discorso avviato l'anno precedente con la catenaria, il gruppo di lavoro coordinato da Emilia Mezzetti e Maura Ughi si proponeva di far compiere agli studenti un percorso storico avente come filo conduttore la spirale logaritmica e in particolare la spirale aurea. Gli istituti scolastici partecipanti sono stati il Liceo "G. Leopardi - E. Majorana" di Pordenone, con gli insegnanti Sergio La Malfa, Margherita Messina e Andrea Secomandi, e l'ISIS "Dante Alighieri" di Gorizia con gli insegnanti Marina Altran, Giuliano De Biasio e Emanuela Fabris. Hanno partecipato al laboratorio complessivamente 67 studenti provenienti quasi tutti da classi del triennio.

Accanto all'obiettivo di far conoscere agli studenti come la matematica si sia spesso evoluta a partire da problemi fisici molto naturali, il tema prescelto si prestava a illustrare le profonde connessioni fra la matematica e le varie forme d'arte, dalla musica alla pittura alla scultura all'architettura, e la capacità della matematica di descrivere e modellizzare la Natura. Gli studenti hanno avuto modo di attingere alla gran mole di materiale disponibile su Internet in varie lingue, e di proporre variazioni sul tema che andavano spesso molto al di là dell'idea iniziale degli insegnanti. Numerosi sono stati gli spunti per l'utilizzo di software quali Cabri, Excel e QBasic.

Alla fase di progettazione e ad alcuni degli incontri a scuola hanno preso parte anche tre insegnanti non ancora di ruolo, iscritte al corso di perfezionamento in Didattica della matematica ed orientamento universitario, attivato a Trieste nell'ambito del Progetto Lauree Scientifiche. Le due fasi hanno avuto scansione simile a quella del laboratorio dell'anno precedente: a partire da novembre si sono svolti gli incontri di progettazione, della durata di circa due ore, in cui si è esaminata la letteratura sull'argomento e si sono selezionati gli argomenti da sviluppare poi nei laboratori con gli studenti. Questi sono stati proposti in venti ore, quasi tutte a scuola, in orario pomeridiano alla presenza degli insegnanti, mentre l'incontro conclusivo si è svolto all'università con i gruppi riuniti e la partecipazione dei docenti universitari. I ragazzi hanno relazionato sulla loro attività con l'aiuto di Power Point. Alla fine ciascun gruppo ha prodotto un CD-rom contenente la presentazione e altro materiale pertinente al laboratorio. Per maggiori dettagli sull'organizzazione didattica dei laboratori si veda Mezzetti [1].

2. La geometria della divina proporzione

La prima cosa da stabilire è come si costruisce la divina proporzione. Vi sono due modi geometrici molto semplici che si trovano negli *Elementi* di Euclide [2], sicuramente noti, per lo meno nella cultura greca, ben prima della sistemazione euclidea della geometria. Il metodo più antico è legato al cosiddetto problema di applicazione delle aree di tipo iperbolico. Dato un segmento u e un'area S (che si può supporre quadrata: $S=y^2$) si tratta di costruire su u ("applicare", "alzare su u") un rettangolo di altezza x tale che questo rettangolo, aumentato di un quadrato con lo stesso lato x, sia equivalente all'area assegnata. Lo stesso problema nel caso in cui si debba togliere il quadrato è il problema di applicazione delle aree di tipo ellittico. Da qui l'etimologia di queste due fondamentali parole matematiche: iperbole = aggiungere, ellissi = togliere.

$$x\ \boxed{}\ \underset{u}{}\ x^2\ =\ y^2$$

Da un punto di vista algebrico interpretando u, x, y come le misure dei relativi segmenti, il problema si riduce a quello, dati u ed y, di determinare un numero incognito x tale che

$$ux \pm x^2 = y^2.$$

Il segno "più" è relativo al caso iperbolico e quello "meno" al caso ellittico.

L'equazione di secondo grado che ne risulta veniva, già dagli Egiziani, risolta correttamente attraverso una procedura esplicita. Euclide ([2], Libro II, Proposizione 6) indica un'identità da cui è facile determinare la costruzione con riga e compasso per trovare x a partire da u e y, costruzione che per molti secoli ha costituito la *dimostrazione* della correttezza della procedura. La costruzione è molto semplice e, tradotta in numeri, corrisponde al metodo del completamento del quadrato.

$$x \quad \boxed{} \; \underset{\frac{u}{2}}{\square}\,\underset{\frac{u}{2}}{\square}\,\square \quad = \quad y^2$$

Supponendo x "una cosa", si costruisce il rettangolo $ux+x^2$ e si divide in due parti uguali il segmento dato u. Si costruisce lo gnomone azzurro spostando uno dei due rettangoli di lato x e u/2.

$$2\left(\frac{u}{2}\right)x + x^2 = y^2$$

$$\left(\frac{u}{2}\right)^2 = y^2 + \left(\tfrac{u}{2}\right)^2$$

Si completa il quadrato contornato dallo gnomone aggiungendo il quadrato bruno.

$$\left(\frac{u}{2}\right)^2 + 2\left(\frac{u}{2}\right)x + x^2 = y^2 + \left(\frac{u}{2}\right)^2$$

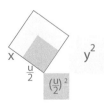

Si estrae la radice, cioè si costruisce col teorema di Pitagora l'ipotenusa del triangolo rettangolo di lati noti y e u/2.

$$\left(x+\frac{u}{2}\right)^2 = y^2 + \left(\frac{u}{2}\right)^2 .$$

Prendendo quindi la radice positiva abbiamo in definitiva

$$x = \sqrt{y^2 + \left(\frac{u}{2}\right)^2} - \frac{u}{2} .$$

Nel caso della sezione aurea, dato il segmento u, si tratta di trovare un segmento x che sia medio proporzionale tra u e u-x, cioè tale che

$$x^2 = u(u\text{-}x) \qquad \text{ovvero} \qquad x^2 + ux = u^2.$$

La costruzione di x in questo caso diventa molto semplice perché y = u ed Euclide la svolge esplicitamente nella proposizione 11 del secondo libro.

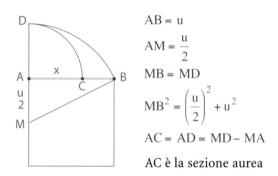

AB = u

$AM = \dfrac{u}{2}$

MB = MD

$MB^2 = \left(\dfrac{u}{2}\right)^2 + u^2$

AC = AD = MD − MA

AC è la sezione aurea

⬤ Nel CD allegato al libro *Capitolo II/Sezione Aurea 1.ggb*, si trova questa costruzione realizzata col software di geometria dinamica, open source, Geogebra.

L'estrazione della radice e il calcolo numerico della soluzione ci portano all'espressione:

$$x + \frac{u}{2} = \sqrt{\left(\frac{u}{2}\right)^2 + u^2} \quad \text{e quindi} \quad x = u\frac{\sqrt{5}-1}{2} .$$

Il rapporto

$$\varphi = \frac{x}{u} = \frac{\sqrt{5}-1}{2}$$

si chiama *sezione aurea* dell'unità. Spesso si chiama anche sezione aurea, o rapporto aureo, o costante di Fidia, il rapporto inverso, che noi per evitare ogni confusione indichiamo con la lettera Φ:

$$\frac{u}{x} = \phi = \frac{2}{\sqrt{5} - 1} = \frac{2(\sqrt{5} + 1)}{(\sqrt{5} - 1)(\sqrt{5} + 1)} = \frac{\sqrt{5} + 1}{2} \ .$$

È immediato vedere che $\varphi + 1 = \phi$ e quindi

$$\varphi + 1 = \frac{1}{\varphi} \quad \text{e} \quad \phi = 1 + \frac{1}{\phi}$$

$$\varphi^2 + \varphi = 1 \quad \text{e} \quad \phi^2 = 1 + \phi \ .$$

Un metodo geometrico forse più rapido per costruire la soluzione x di un'equazione di secondo grado, usato anche da Erone limitatamente alla sezione aurea e generalizzato da Cartesio nella sua geometria per l'equazione di secondo grado generale, si basa sul teorema della secante (Euclide, [2], Libro III, Proposizione 36)

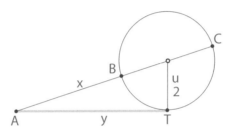

Data una qualunque secante ABC a una circonferenza, la tangente AT è media proporzionale tra AC e AB. Se u è il diametro della circonferenza questa proporzione si traduce nella relazione

$$x(x + u) = y^2$$

che, dato y, permette di costruire x. Nel caso della sezione aurea u = y e la figura diventa

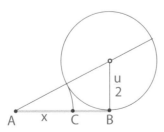

Questa seconda costruzione è apparentemente più semplice. Apparentemente, dato che il teorema della tangente è piuttosto difficile da dimostrare e si basa su molti risultati di geometria della circonferenza, mentre la prima costruzione si serve di pochissimi prerequisiti del tutto evidenti.

Nel CD allegato al libro *Capitolo II/Sezione Aurea 2.ggb*, si trova questa costruzione realizzata col software di geometria dinamica, open source, Geogebra.

In ogni caso la costruzione geometrica permette di costruire la sezione aurea con riga e compasso, con l'approssimazione implicita in questi strumenti, ma geometricamente esatta, mentre, dal punto di vista numerico, il rapporto è irrazionale, non può cioè scriversi come rapporto tra due numeri interi. Di questa proprietà, che Pacioli chiamava il *sesto innominabile effetto*, possiamo dare due dimostrazioni: una di tipo aristotelico analoga a quella relativa alla irrazionalità della radice di due (utile per riproporre in un contesto nuovo l'aritmetica dei numeri interi) e l'altra, probabilmente risalente alla scuola pitagorica, che si basa sulla geometria della sezione aurea.

Diamo ora la prima dimostrazione. Supponiamo per assurdo che esistano due numeri interi n ed m *senza fattori comuni* tali che

$$\varphi = \frac{x}{u} = \frac{\sqrt{5}-1}{2} = \frac{n}{m} \ .$$

Con semplici calcoli troviamo

$$m\sqrt{5} - m = 2n \ , \quad m\sqrt{5} = m + 2n \ , \quad 5m^2 = m^2 + 4mn + 4n^2 \ , \quad m^2 = n(m+n) \ .$$

Possiamo ora ragionare basandoci sulle proprietà di divisibilità dei numeri interi: se p è un fattore primo di m, p divide m^2 e quindi deve dividere n(n+m), ma p non divide n perchè abbiamo supposto la frazione ridotta ai minimi termini; p deve dunque dividere n+m, ma questo è assurdo perchè se p divide m e n+m deve dividere anche n, mentre avevamo supposto m ed n privi di fattori comuni. La seconda dimostrazione sarà data alla fine della sezione "Il rettangolo aureo".

Daremo più avanti anche un algoritmo per calcolare alcune cifre dello sviluppo decimale di φ. Se ci fermiamo alle sole prime 24 cifre troviamo i valori

$$\varphi = 0{,}618033988749894848204586\ldots$$

3. Il rettangolo aureo

Si tratta di un rettangolo i cui lati stanno nel rapporto aureo. Questi rettangoli sono caratterizzati da una sorprendente proprietà che Pacioli chiama il *quarto ineffabile effetto*:

Teorema

Se a un rettangolo aureo aggiungiamo un quadrato sul lato maggiore (o lo togliamo dal lato minore) troviamo un nuovo rettangolo aureo. E viceversa, un rettangolo che sia simile a quello che si ottiene aggiungendo (o levando) un quadrato, è il rettangolo aureo.

Infatti, consideriamo un rettangolo di lati a , b (a>b) (rettangolo bruno) e aggiungiamo sul lato maggiore a un quadrato, otteniamo in questo modo un nuovo rettangolo di lati a+b e a. Questi due rettangoli sono simili se e solo se

$$\frac{a+b}{a}=\frac{a}{b} \quad \Leftrightarrow \quad 1+\frac{b}{a}=\frac{a}{b} \quad \Leftrightarrow \quad \frac{b}{a}=\varphi \quad e \quad \frac{a}{b}=\phi \, .$$

Possiamo ovviamente iterare il procedimento e aggiungere via via nuovi quadrati sul lato maggiore.

Nella figura siamo partiti dal rettangolo di lati a e b (a>b) e abbiamo via via aggiunto un quadrato sul lato maggiore. La tabella riporta le lunghezze dei due lati dei vari rettangoli

	lato maggiore	lato minore
I rettangolo	a	b
II rettangolo	a+b	a
III rettangolo	2a+b	a+b
IV rettangolo	3a+2b	2a+b
V rettangolo	5a+3b	3a+2b

Non è difficile capire come continua la successione: indicando con $L_1, L_2, L_3, L_4, L_5, ...$ il lato maggiore e $l_1, l_2, l_3, l_4, l_5, ...$ il lato minore dei rettangoli che via via si costruiscono, abbiamo

$$L_1=a \, , \quad l_1=b$$

$$l_n = L_{n-1} \, , \quad l_{n+1}= l_{n-1}+ l_n \quad \text{per ogni } n >1.$$

Tutti questi infiniti rettangoli, stante il teorema che abbiamo dimostrato, sono simili tra loro: sono tutti aurei. In formule

$$\phi = \frac{a}{b} = \frac{b}{a+b} = \frac{a+b}{a} = \frac{2a+b}{a+b} = \frac{3a+2b}{2a+b} = \frac{5a+3b}{3a+2b} = \dots = \frac{L_n}{l_n} = \frac{l_{n+1}}{l_n} = \dots$$

Un'ulteriore conseguenza di questo teorema è il fatto che, costruendo con l'aggiunta di due quadrati, tre rettangoli aurei, i punti A, B, C risultano allineati

dato che i rapporti a:b e (a+b):a sono uguali.

Ciò significa che, iterando il processo e costruendo i rettangoli R_1, R_2, R_3 ecc., togliendo ogni volta un quadrato sul lato più corto, abbiamo una successione di rettangoli aurei che diventano via via più piccoli

$$R_1 \supset R_2 \supset R_3 \supset \dots$$

ma che contengono tutti il punto O che si ottiene intersecando la diagonale di R_1 con quella di R_2.

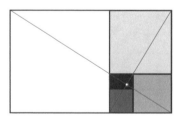

Questo punto O, che viene anche detto l'occhio di Dio, appartiene a tutti gli infiniti rettangoli, e anzi

$$\bigcap_i R_i = \{O\}.$$

Costruendo in ogni quadrato un quarto di circonferenza troviamo una sorta di spirale che approssima, come vedremo, *la spirale logaritmica aurea*. L'occhio di Dio è il punto intorno al quale la spirale si avvolge infinitamente.

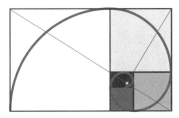

L'esistenza di questa spirale che si avvicina sempre più all'occhio di Dio senza mai raggiungerlo si lega strettamente alla incommensurabilità di un segmento con la sua sezione aurea.

L'argomento che segue potrebbe rappresentare una prima semplice dimostrazione di incommensurabilità. È un argomento di carattere geometrico e non usa proprietà aritmetiche dei numeri interi.

Se a e b (a>b) sono i lati di un rettangolo aureo, supponiamo per assurdo che questi segmenti possano essere misurati entrambi con una certa unità di misura u, eventualmente piccolissima, piccola come una *monade*, supponiamo cioè che esistano due numeri naturali n e m (n>m) tali che a=nu , b=mu . Togliamo ora al rettangolo aureo di lati a e b il quadrato di lato b: otteniamo un altro rettangolo aureo di lati a'= b e b'=a-b. Osserviamo che i lati del nuovo rettangolo *aureo* sono ancora misurati esattamente dal segmento u dato che a'=b=mu, b'=a-b=(n-m)u. Procedendo *in discesa* troviamo rettangoli aurei sempre più piccoli ognuno dei quali, come il precedente, ha i lati che possono misurati esattamente con la monade u. In questo modo possiamo arrivare a dei rettangoli aurei con i lati piccoli quanto vogliamo e quindi più piccoli anche della monade u, cosa assurda dato che il segmento u misura ogni lato di ogni rettangolo aureo che via via andiamo costruendo.

Crediamo che questa dimostrazione di incommensurabilità sia più semplice e probabilmente precedente a quella che troviamo in Aristotele[2], e poi in Euclide e poi sui nostri libri di testo, relativa alla diagonale di un quadrato. La sua semplicità deriva dal fatto che essa si riferisce direttamente alla definizione naturale di commensurabilità e il ragionamento proposto (che prefigura in una situazione semplice il metodo della discesa di Fermat) aiuta a capire meglio il delicato concetto di commensurabilità e incommensurabilità. Ancora una volta sembra confermarsi l'idea che la storia offra suggestioni interessanti per la didattica.

[2] Si veda Heath [3], pp. 22-23.

4. Il triangolo aureo

Un triangolo è detto *aureo* se è isoscele e se gli angoli alla base sono il doppio dell'angolo al vertice.

In questo caso $5\alpha = \pi$ e dunque, se il lato obliquo viene pensato come raggio di una circonferenza, il triangolo aureo è uno spicchio di un decagono regolare e due triangoli aurei consecutivi, composti come indicato in figura, danno uno spicchio di un pentagono regolare.

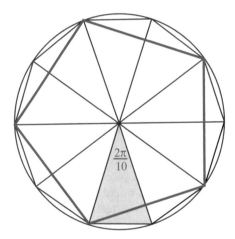

Il triangolo aureo ha una proprietà importante che lo lega alla sezione aurea e che Pacioli ha chiamato il *settimo inextimabile effecto*.

Teorema
Un triangolo isoscele ABC è un triangolo aureo se e solo se la proporzione tra la base AB e il lato obliquo AC è la divina proporzione.

Dato il triangolo isoscele ABC (AC=BC) con gli angoli α e β come nella figura seguente ($2\beta+\alpha=\pi$) costruiamo sul lato BC un punto D tale che AD=AB tracciando la circonferenza di centro A e raggio AB.
 Nasce un nuovo triangolo isoscele ABD che ha lo stesso angolo alla base di ABC.
 Calcolando gli angoli di questi triangoli come mostrato nella figura, dato che $2\beta+\alpha=\pi$, $\alpha = \pi/5$ se e solo se $\beta=2\alpha$ e questo avviene se e solo se il trian-

golo ADC è isoscele (AD=DC); ma essendo ACB simile a DAB, ciò avviene se e solo se AC:AB=DA:DB ovvero CB:CD=CD:DB, e in definitiva se e solo se CD *è la sezione aurea di* BC.

Per costruire un triangolo aureo a partire dal segmento BC, basta costruire la sua sezione aurea individuando il punto D, e poi facilmente col compasso si costruiscono i due triangoli isosceli.

Il punto A si trova intersecando la circonferenza di centro D e raggio DC con quella di centro B e raggio DC.

La possibilità di costruire, a partire da un dato segmento, il triangolo aureo che ha questo segmento come lato obliquo permette di costruire con riga e compasso sia il dodecaedro sia il pentagono. Nel CD allegato al libro *Capitolo II/Triangolo aureo.ggb*, si trova questa costruzione realizzata col software di geometria dinamica, open source, Geogebra.

La geometria del pentagono presenta molte interessanti proprietà di regolarità e simmetria che probabilmente hanno decretato il successo di questa figura come rappresentazione simbolica, a partire dalla scuola pitagorica, di sette politico-religiose.

I numeri in rosso indicano l'ampiezza dei relativi angoli espressi in multipli di
π/5. Dalla figura si vede quanti triangoli aurei e quante divine proporzioni
sono presenti in un pentagono. In particolare il lato di un pentagono regolare
è la sezione aurea della sua diagonale. Osserviamo per esempio che se aggiun-
giamo a un triangolo aureo di angoli 1, 2, 2 un triangolo isoscele di angoli 3, 1,
1 in modo che l'angolo 2 sia adiacente all'angolo 3 (che insieme fanno un
angolo piatto) otteniamo un triangolo di angoli 2, 1+1, 1 cioè un altro trian-
golo aureo più grande del precedente. Il triangolo che aggiungiamo viene chia-
mato lo *gnomone* del triangolo aureo. In generale, lo gnomone di una figura F,
oggetto fondamentale nella ricerca matematica pitagorica, è una figura F' tale
che F + F' (o F - F') è simile a F.

Nel caso del rettangolo aureo, come abbiamo visto, lo gnomone è un quadrato
mentre nel caso del triangolo aureo lo gnomone è un triangolo isoscele il cui
angolo al vertice è tre volte l'angolo alla base.

In generale, data una figura e il suo gnomone, si viene a creare un proces-
so di sviluppo che si accresce su se stesso, sulla base di un unico principio
(l'aggiunta dello gnomone), producendo delle forme sempre più grandi (o più
piccole) simili alla forma iniziale. Sul libro di Thompson D'Arcy *Crescita e
forma* ([4], cap. 6) questo processo è ben illustrato in relazione allo sviluppo di
un essere vivente. Nei due esempi che abbiamo considerato, la nuova forma
prodotta con l'aggiunta dello gnomone è ruotata, rispetto alla precedente, di
π/2 nel caso del rettangolo e di 3π/5 nel caso del triangolo, questo è il motivo
per cui iterando il processo si ha una dilatazione e una rotazione che produce
come risultato una forma a spirale.

L'ubiquità della sezione aurea nella filosofia rinascimentale risiedeva anche
nel fatto che la costruzione del dodecaedro, il poliedro con 12 facce pentago-
nali, si fonda ripetutamente sulla sezione aurea. La costruzione di questo

oggetto che si trova nell'ultimo libro degli *Elementi* di Euclide ([2], Libro XIII, Proposizione 17), e che rappresenta l'apoteosi di tutta la geometria classica, rischia di sparire completamente dalla nostra cultura sostituito da banali concretizzazioni. Euclide *dimostra* che esiste un corpo formato da 12 facce pentagonali regolari, uguali tra loro con tutti gli angoli diedri uguali tra loro. Nel CD allegato al libro *Capitolo II/Dodecaedro.mov,* si trova un'animazione (Ghione [5]) che illustra la costruzione euclidea del dodecaedro a partire dalla sfera nella quale è inscritto. L'idea è molto bella: si parte da un cubo e su ognuna delle sei facce si costruisce un "tetto". Questi 6 tetti passando da una faccia a quella vicina si combinano tra loro formando 12 pentagoni regolari.

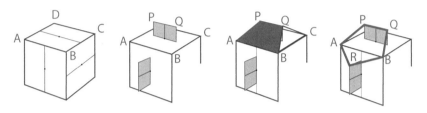

Più precisamente si trova il centro di ogni faccia e si traccia una linea, parallela al lato del cubo e passante per il centro, alternando le direzioni come nella prima figura. Su ognuna di queste linee si alza un "sostegno" centrale di forma rettangolare con la base PQ doppia dell'altezza, in modo che PQ sia la sezione aurea del lato AB del cubo. Si costruisce il tetto congiungendo A e D con P e B e C con Q. Si fa questo su ogni faccia e si dimostra che:

- il triangolo ABR e il trapezio APQB si trovano su uno stesso piano;
- il pentagono che si forma ha tutti i lati e gli angoli uguali;
- gli angoli diedri sono uguali (vista la simmetria della costruzione, basta farlo per due soli angoli).

Nella simbologia platonica e poi neo-platonica ancora viva ai tempi di Keplero, i primi 4 poliedri regolari rappresentano i quattro costituenti fondamentali: fuoco, terra, aria, acqua.

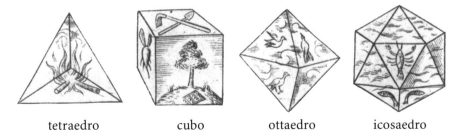

tetraedro cubo ottaedro icosaedro

Il dodecaedro rappresenta invece una quinta essenza, che nella tradizione cristiana diventa la virtù divina, che infonde l'intero creato.

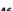

dodecaedro

Questa metafora tra i poliedri e la natura terrena ed extraterrena trova conferma in un bel teorema non evidente, la cui origine non è chiara: il teorema afferma che il dodecaedro è il solo poliedro regolare nel quale si possano inscrivere tutti gli altri 4 poliedri regolari. Qua si intende che due poliedri sono inscrivibili uno nell'altro se tutti i vertici dell'uno appartengono alle facce dell'altro.

Nel CD allegato al libro *Capitolo II/Polyhedra/index.htm,* si trova un'animazione interattiva (da [5], autore Gianmarco Todesco), che permette di inscrivere, quando possibile, un qualunque poliedro in un altro.

5. I numeri di Fibonacci

I numeri di Fibonacci sono intimamente legati alla sezione aurea e tramite loro è possibile trovare un algoritmo molto veloce per calcolare il valore di Φ con un'approssimazione arbitraria. Questi numeri formano una successione infinita di numeri interi

$$\{ f_1, f_2, f_3, f_4, ..., f_n, ...\}$$

i cui elementi sono definiti da una legge ricorsiva a partire dai primi due:

$$f_1 = 1, f_2 = 1,$$

$$f_{n+2} = f_{n+1} + f_n \text{ per ogni n} \geq 1.$$

La formula ricorsiva che esprime il termine generico della successione in funzione dei due termini precedenti si chiama anche *equazione alle differenze.*

Cominciamo intanto col calcolare alcuni termini della successione (in rosso abbiamo segnato il quinto, il decimo, il quindicesimo, il ventesimo termine):

$\{1, 1, 2, 3, 5, 8, 13, 21, 34, 55, 89, 144, 233, 377, 610, 987, 1597, 2584, 4181, 6765, 10946, ...\}.$

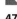
Questi numeri diventano sempre più grandi, ma se facciamo i rapporti di due numeri successivi della successione troviamo una nuova successione di grande interesse:

$$\left\{1, 2, \frac{3}{2}, \frac{5}{3}, \frac{8}{5}, \frac{13}{8}, \frac{21}{13}, \, ... \, , \frac{f_{n+1}}{f_n}, \, ... \right\}.$$

Questa nuova successione ha una proprietà molto importante: fissato un numero ε piccolo quanto si vuole, per esempio 10^{-5}, da un certo n in poi la differenza tra due termini consecutivi della successione è più piccola di ε. Ciò significa che se facciamo calcolare queste frazioni da una calcolatrice tascabile (che per esempio lavora con 5 cifre decimali) da un certo punto in poi la calcolatrice scriverà sempre la stesso risultato proprio perché i termini successivi della successione differiscono per meno di 10^{-5} e quindi hanno le stesse prime 5 cifre decimali. Le successioni che hanno questa proprietà si chiamano *successioni di Cauchy* e definiscono, al limite, un numero reale che tramite la successione (o una calcolatrice tascabile) può essere approssimato arbitrariamente. È didatticamente utile e molto facile verificare quanto detto con una calcolatrice tascabile dato che possiamo facilmente produrre i numeri che formano la successione di Fibonacci, tuttavia pensiamo sia utile dare una dimostrazione rigorosa che per altro non è particolarmente difficile.

Cominciamo col dimostrare che la nostra successione di quozienti è una successione di Cauchy, cioè che la differenza tra due termini successivi man mano che n cresce tende a zero:

$$\left| \frac{f_{n+2}}{f_{n+1}} - \frac{f_{n+1}}{f_n} \right| = \left| \frac{f_{n+2}f_n - f_{n+1}f_{n+1}}{f_{n+1}f_n} \right|.$$

Usando la proprietà ricorsiva si può vedere, andando a ritroso, che il numero a numeratore, a ogni discesa, cambia solo il segno, cioè

$$f_{n+2}f_n - f_{n+1}\,f_{n+1} = -[f_{n+1}f_{n-1} - f_n\,f_n].$$

Scendendo fino a n=2 abbiamo $f_4 f_2 - f_3\,f_3 = 3\text{-}4 = -1$, e per n=1 $f_3 f_1 - f_2\,f_2 = 2\text{-}1 = 1$. In ogni caso

$$\left| \frac{f_{n+2}}{f_{n+1}} - \frac{f_{n+1}}{f_n} \right| = \left| \frac{f_{n+2}f_n - f_{n+1}f_{n+1}}{f_{n+1}f_n} \right| = \left| \frac{1}{f_{n+1}f_n} \right| < \left(\frac{1}{f_n} \right)^2.$$

Ora, dato che f_n cresce infinitamente, per quanto sia piccolo il numero ε esiste un n per il quale $(1/f_n)^2 < \varepsilon$. Da quel punto in poi la differenza tra due termini della successione sarà minore di ε.

Possiamo ora usare la nostra calcolatrice per concretizzare quanto dimostrato. Per esempio, dato che l'undicesimo numero di Fibonacci $f_{11} = 89$, e dato che $89^{-2} < 0,000127...$, già a partire dal tredicesimo termine della successione, $233/144=1,618055...$ abbiamo un'approssimazione del limite con tre cifre decimali stabili. Dopo 21 termini, dato che $f_{19} = 4181$ e $4181^{-2} < 0,000000056...$, abbiamo 7 cifre decimali stabili, dunque il limite della successione si approssima con $f_{21} / f_{20} =10946/6765=1,6180338134...$ a meno di 10^{-7}. Come si vede la convergenza è molto rapida e anche con la nostra calcolatrice tascabile si possono trovare facilmente ottime approssimazioni del limite.

Ma come fare a calcolare questo limite?

Ancora la relazione ricorsiva ci dà un metodo per farlo molto generale e applicabile a tutte le situazioni simili a questa:

$$\frac{f_{n+2}}{f_{n+1}} = \frac{f_{n+1} + f_n}{f_{n+1}} = \frac{\dfrac{f_{n+1}}{f_n} + 1}{\dfrac{f_{n+1}}{f_n}} .$$

Poiché

$$\lim_{n \to \infty} \frac{f_{n+2}}{f_{n+1}} = \lim_{n \to \infty} \frac{f_{n+1}}{f_n} ,$$

passando al limite nell'espressione precedente e indicando tale limite con ρ abbiamo

$$\rho = \frac{\rho + 1}{\rho}$$

da cui ricaviamo che il limite della successione verifica l'equazione $\rho^2 = \rho+1$, detta *equazione caratteristica* dell'equazione alle differenze $f_{n+2} = f_{n+1} + f_n$. Essendo positivo il limite che cerchiamo, si ha $\rho > 0$ e dunque

$$\rho = \frac{\sqrt{5} + 1}{2} = \phi .$$

Abbiamo così dimostrato che il limite della nostra successione è proprio il rapporto aureo ϕ: in definitiva, a partire dai numeri di Fibonacci e dalla loro definizione ricorsiva, possiamo calcolare la sezione aurea. Questo si sarebbe potuto dimostrare anche senza far entrare in gioco le successioni di Cauchy (si veda per esempio Pagani-Salsa, [6], Vol. 1, cap. 4). Nel CD allegato al libro *Capitolo II/Sezione Aurea.ppt, Punto di vista matematico*, si trova il calcolo del numero usando il suo sviluppo in frazione continua, che con un altro algoritmo genera la stessa successione. Pensiamo che sia didatticamente utile cominciare a parlare di queste successioni fin dagli anni della scuola superiore dal momento che, disponendo oggi di calcolatrici tascabili, è molto facile iterare un processo e verificare che, da un certo punto in poi, il risultato che si stam-

pa sul display non cambia, cosa che corrisponde bene all'idea intuitiva di successione di Cauchy.

Vediamo ora come, viceversa, le proprietà della sezione aurea ci permettono di ritrovare i numeri di Fibonacci o, come si può anche dire, di *risolvere l'equazione alle differenze* trovando il termine n-esimo f_n in funzione di n.

Per fare questo torniamo ai rettangoli aurei e alla costruzione dei loro lati che abbiamo messo in successione. Osservando la tabella che abbiamo scritto e la legge ricorsiva, ci rendiamo conto che il processo di costruzione di rettangoli aurei sempre più grandi produce via via tutti i numeri di Fibonacci. Ciò deriva dalla natura delle potenze di ϕ. Abbiamo infatti

$$\phi^2 = 1+\phi \ , \ \ \phi^3 = \phi + \phi^2 = 1+2\phi \ , \ \ \phi^4 = \phi + 2\phi^2 = 2+3\phi \ , \ \ \phi^5 = 3+5\phi \ , \ \ \phi^6 = 5+8\phi$$

e, in generale, è facile vedere che la legge ricorsiva con la quale si trovano le potenze di ϕ è quella di Fibonacci. Precisamente

$$\phi^n = f_{n-1} + f_n\,\phi.$$

Possiamo fare la stessa cosa anche con le potenze di Φ il che corrisponde geometricamente a costruire rettangoli aurei via via più piccoli. In questo caso il calcolo richiede una buona destrezza con l'uso dei segni e degli indici e per questo è un ottimo esercizio:

$$\varphi^2 = 1-\varphi, \ \varphi^3 = \varphi - \varphi^2 = -1+2\varphi, \ \varphi^4 = -\varphi + 2\varphi^2 = 2-3\varphi \ , \ \varphi^5 = -3+5\varphi, \ \varphi^6 = 5-8\varphi\ldots$$

In generale

$$(-1)^n \, \varphi^n = f_{n-1} - f_n\,\varphi.$$

Sottraendo questa relazione alla precedente abbiamo

$$\phi^n - (-1)^n \, \varphi^n = f_n\,\phi + f_n\,\varphi$$

e quindi la notevolissima formula che esprime il termine n-esimo della successione di Fibonacci in funzione di n:

$$f_n = \frac{\phi^n - (-\varphi)^n}{\phi + \varphi} = \frac{\left(\dfrac{1+\sqrt{5}}{2}\right)^n - \left(\dfrac{1-\sqrt{5}}{2}\right)^n}{\sqrt{5}}\ .$$

È interessante notare che la formula precedente fornisce per ogni valore di n un numero intero positivo: per n=1 viene 1, per n=2 viene 1, …, per n=20 viene 6765, e così via.

⚪ Ma chi era Fibonacci? Come e perché è arrivato a considerare la sua successione? Nel CD allegato al libro *Capitolo II/ Fibonacci.ppt* si può trovare una rassegna storica sulla figura e le opere del matematico pisano e sul suo contributo allo sviluppo della scienza. Restando però alla successione che porta il suo nome, sappiamo che la sua origine risale a un torneo tra matematici e abachisti che si tenne a Pisa nel lontano 1223. L'imperatore Federico II di Svevia propose il seguente quesito:

Quante coppie di conigli si ottengono in un anno, salvo i casi di morte, supponendo che ogni coppia dia alla luce un'altra coppia ogni mese e che le coppie più giovani siano in grado di riprodursi già al secondo mese di vita?

Fibonacci partecipò al torneo con lo scopo di dimostrare che l'uso dei numeri arabi, da lui introdotti in Europa nel 1202 col suo *Liber abbaci*, permetteva di calcolare più velocemente!

Supponiamo che nel mese n vi siano a_n coppie con un mese di età e b_n coppie con almeno due mesi di età: il mese successivo avremo b_n coppie con un mese di vita nate dalle b_n coppie con almeno due mesi e $a_n + b_n$ coppie con almeno due mesi di vita (quelle a_n che sono cresciute di un mese e quelle b_n che c'erano già e che si suppone non siano morte). Risulta dunque

$$a_{n+1} = b_n \quad e \quad b_{n+1} = a_n + b_n.$$

Le coppie complessive di conigli $f_n = a_n + b_n$ dopo due mesi saranno

$$f_{n+2} = a_{n+2} + b_{n+2} = b_{n+1} + (a_{n+1} + b_{n+1}) = (a_n + b_n) + (a_{n+1} + b_{n+1}) = f_n + f_{n+1}.$$

Se il primo mese abbiamo una sola coppia giovane, il secondo mese abbiamo quella coppia che è cresciuta ma non ha generato nulla, dunque la condizione iniziale è

$$f_1 = 1 \quad e \quad f_2 = 1,$$

e dopo 12 mesi il numero di conigli è $f_{12} = 144$.

La soluzione al problema dei conigli ideata da Fibonacci è un primo significativo esempio di modellizzazione di una data dinamica di crescita. Oggi esistono modelli molto più sofisticati e realistici che tengono conto delle percentuali di natalità e di morte nelle varie fasce di età di una data popolazione di esseri viventi. Questi modelli permettono di simulare l'andamento della popolazione dopo un tempo molto lungo e prevedere se, all'infinito, il destino di quella specie è l'estinzione, la stabilità o la sovrappopolazione. Un modello ancora più semplice di quello di Fibonacci è il modello di Malthus: si ipotizza che la popolazione, in un dato lasso di tempo, cresca proporzionalmente al numero di individui che vi sono: se al tempo n vi sono x_n individui, nel tempo n+1 vi siano $k\, x_n$ individui, essendo k una costante positiva che misura, mediamente, il rapporto tra le nascite e le morti nel lasso di tempo considerato. k>1 significa che, mediamente, le nascite prevalgono

sulle morti, k<1 invece significa che sono le morti a prevalere. Se supponiamo che questo rapporto non cambi, ma sia una caratteristica della popolazione otteniamo la semplice equazione alle differenze che descrive questo modello

$$x_{n+1} = k \, x_n$$

con la condizione iniziale

$$x_1 = a.$$

Non è difficile in questo caso trovare il termine n-esimo della successione, dato che per iterazione

$$x_2 = kx_1 = ka \quad , \quad x_3 = kx_2 = k^2 a \quad , \quad x_4 = kx_3 = k^3 a$$

e in generale

$$x_n = k^{n-1} \, a.$$

Se la costante $k > 1$, x_n tende all'infinito, da cui la preoccupazione di sovraffollamento del pianeta da parte di Malthus. Sono stati utilmente proposti numerosi altri modelli di crescita che, come è facile immaginare, trovano numerose applicazioni, in economia, in informatica oltre che in ecologia, in medicina e in fisica. La genesi di tutto questo si trova nel problema dei conigli! La stessa successione di Fibonacci trova varie applicazioni, per esempio alla *fillotassi* (il termine viene dal greco *phyllon* = foglia e *taxis* = ordine, e significa disposizione delle foglie sul fusto della pianta), alla formazione dei semi di girasole e ad altre questioni che si possono vedere nel CD allegato al libro *Capitolo II/Sezione Aurea.ppt, La spirale in natura* e *Capitolo II/Fibonacci.ppt.*

È interessante osservare anche come questa successione e i suoi legami con la divina proporzione abbiano affascinato scrittori e musicisti. Vari esperimenti hanno dimostrato che la percezione umana mostra una naturale preferenza per le proporzioni in accordo con la sezione aurea. I musicisti, quindi, tenderebbero, a volte inconsciamente, a disporre gli elementi di una composizione in base a tali rapporti.

Un esempio significativo è quello del compositore francese Claude Debussy (1862 – 1918). Egli era certamente a conoscenza degli studi di scienziati e psicologi sul rapporto aureo condotti alla fine dell'800. Recenti studi hanno evidenziato che la struttura proporzionale di molta della sua musica è basata su tale rapporto (si veda Howat [7]) e in alcuni casi vi è testimonianza del fatto che Debussy scelse consciamente tale costruzione. Un esempio è la composizione per pianoforte *La Cathédrale Engloutie,* tratta dal primo libro dei *Préludes.* Il pezzo, che si compone di 89 battute, può essere paragonato a un segmento diviso in due parti, di lunghezza a e b, con a+b=89. Debussy esegui-

va la prima parte, (a), di 68 battute, a velocità doppia rispetto alla seconda, (b), di 21. In questo modo la sezione (a) viene percepita dall'ascoltatore come fosse di 34 battute, perché eseguita a velocità doppia. Così il brano sembra formato da 55 battute, anziché da 89. E 55,0051... è proprio la sezione aurea di 89. Nel CD allegato al libro *Capitolo II/ TrabuccoDebussy.aif*, il preludio è eseguito al pianoforte da Luca Trabucco, nella versione di Debussy. La registrazione è stata effettuata grazie alla collaborazione della Scuola di Musica e Nuove Tecnologie del Conservatorio Tartini di Trieste.

La successione di Fibonacci, oltre a legarsi strettamente alla sezione aurea, ha varie strane proprietà aritmetiche molte delle quali scoperte di recente e, come pensano alcuni, altre non ancora scoperte, tanto che esiste una rivista trimestrale *The Fibonacci Quarterly* che raccoglie numerosi appassionati di questa materia. Nel CD allegato al libro *Capitolo II/Fibonacci.ppt, Particolarità*, si trovano alcune di queste divertenti proprietà. Questi piccoli teoremi di natura aritmetica, sorprendenti nei loro enunciati, possono essere utili per creare delle sfide matematiche tra gli studenti del laboratorio. Nel CD abbiamo comunque inserito le dimostrazioni nella scheda *Capitolo II/Particolarità.pdf*.

6. La spirale logaritmica

La geometria classica ha studiato a partire dalla scuola pitagorica dei modelli di crescita caratterizzati dalla proprietà che l'azione che determina lo sviluppo produce una nuova figura simile alla figura di partenza. La figura che si aggiunge, come abbiamo detto, si chiama gnomone e la forma che si ottiene iterando il processo, se la crescita si accompagna a una rotazione, è una spirale.

Gli esempi di questo tipo che abbiamo considerato sono relativi al rettangolo e al triangolo aureo.

Nel caso del rettangolo, i vari passi della costruzione prevedono una dilatazione attraverso l'aggiunta di un quadrato, i cui lati crescono ricorsivamente come i numeri di Fibonacci, e una rotazione di 90 gradi.

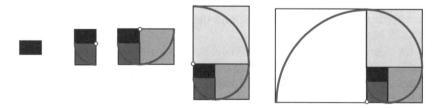

Se a e b (a>b) sono le misure dei lati del rettangolo iniziale bruno, i lati dei vari quadrati che si aggiungono sono rispettivamente: a, a+b, 2a+b, 3a+ 2b ecc. I rettangoli che si creano sono sempre più grandi, tutti simili ma ogni volta ruotati di 90 gradi.

Il caso del triangolo è molto simile

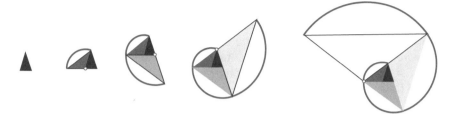

Se a e b (a>b) sono le misure dei lati iniziali del triangolo iniziale bruno, i vari triangoli che si aggiungono hanno i lati uguali rispettivamente ad: a, a+b, 2a+b, 3a+2b ecc.

La *spirale logaritmica*, o *equiangolare*, si ottiene a partire da un triangolo infinitesimo al quale si aggiunge via via un nuovo triangolo a esso simile.

Anche in questo caso abbiamo un processo ricorsivo attraverso il quale possiamo costruire, a partire da un punto iniziale, una successione di punti che descrivono una forma poligonale a spirale.

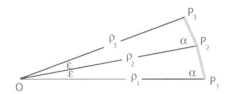

Fissiamo un punto O, un angolo α e un punto iniziale P_1. Prendiamo un angolo ε molto piccolo che ci serve a discretizzare la rotazione, a dividere cioè la costruzione in un numero finito di passi. Il punto P_2 si trova costruendo sul segmento dato OP_1 il triangolo OP_1P_2 definito univocamente dagli angoli α ed ε. Abbiamo così costruito il segmento P_1P_2 che forma un angolo α col raggio OP_1.

Applichiamo ora la stessa costruzione al segmento OP_2: troveremo un nuovo triangolo OP_2P_3 simile al precedente con il lato P_2P_3 che forma un angolo α col raggio OP_2. Iterando il processo troviamo un poligono i cui lati P_nP_{n+1} formano un angolo fisso α col raggio OP_n. Nella figura seguente abbiamo iterato il processo 26 volte.

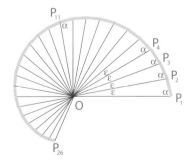

Questo poligono approssima la spirale logaritmica nello stesso modo che un poligono regolare approssima la circonferenza.

Un punto P della spirale è individuato dal raggio OP che indichiamo con ρ e dall'angolo che questo raggio forma con la retta OP_1(coordinate polari). Nel caso dei punti ρ_n che abbiamo costruito nel modo detto contano solo i raggi ρ_n, dato che l'angolo è $(n-1)\varepsilon$. La formula ricorsiva con cui si calcolano questi raggi si può trovare applicando il teorema dei seni. Osservando i triangoli simili OP_1P_2 e OP_2P_3 abbiamo

$$\frac{\rho_1}{\sin(\pi - \varepsilon - \alpha)} = \frac{\rho_2}{\sin(\alpha)}$$

e quindi

$$\rho_2 = \frac{\sin(\alpha)}{\sin(\alpha + \varepsilon)}\rho_1 = k\rho_1 \ .$$

In generale essendo i triangoli tutti simili abbiamo la formula ricorsiva

$$\rho_{n+1} = k^n\rho_1 \qquad \text{dove} \qquad k = \frac{\sin(\alpha)}{\sin(\alpha)\cos(\varepsilon) + \cos(\alpha)\sin(\varepsilon)}$$

è una costante. Essendo ε un angolo molto piccolo, risulta $k < 1$ se α è un angolo acuto, e $k > 1$ se α è un angolo ottuso.

Vediamo ora come nel continuo possiamo trovare l'equazione della spirale. Cominciamo col definire questa curva.

Definizione
Un punto P, di coordinate (ρ,θ) in un sistema di coordinate polari avente origine O, descrive una curva detta *spirale logaritmica* (o *equiangolare*) se la retta tangente alla curva in P forma un angolo costante α con il raggio OP.

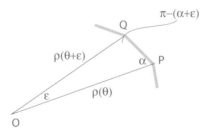

Sia $\rho(\theta)$ la funzione che associa a ogni angolo α (misurato in radianti) la lunghezza del raggio corrispondente quando P descrive la curva. Vogliamo ricavare l'espressione analitica di questa funzione, e a tale scopo facciamo uso del

calcolo sublime di Leibnitz brevemente trattato nel Capitolo 1 di questo libro (si veda anche Giusti [8]). Calcoliamo la variazione del raggio ρ in corrispondenza a una variazione infinitesima ε di θ. Chiamiamo Q il punto della curva corrispondente all'angolo θ+ε.

Applicando ancora il teorema dei seni al triangolo OPQ (il tratto PQ considerato rettilineo è preso sulla tangente alla curva in P) abbiamo:

$$\frac{\rho(\theta+\varepsilon)}{\sin(\alpha)} = \frac{\rho(\theta)}{\sin(\alpha+\varepsilon)} \quad , \quad \rho(\theta+\varepsilon) = \frac{\sin(\alpha)}{\sin(\alpha+\varepsilon)}\rho(\theta) \quad , \quad \rho(\theta+\varepsilon)-\rho(\theta) = \left(\frac{\sin(\alpha)}{\sin(\alpha+\varepsilon)} - 1\right)\rho(\theta)$$

$$\frac{\rho(\theta+\varepsilon)-\rho(\theta)}{\varepsilon} = \frac{1}{\sin(\alpha+\varepsilon)}\left(\frac{\sin(\alpha)-\sin(\alpha)\cos(\varepsilon)-\sin(\varepsilon)\cos(\alpha)}{\varepsilon}\right)\rho(\theta) =$$

$$= \frac{1}{\sin(\alpha+\varepsilon)}\left[\sin(\alpha)\frac{1-\cos(\varepsilon)}{\varepsilon} - \cos(\alpha)\frac{\sin(\varepsilon)}{\varepsilon}\right]\rho(\theta).$$

Passando al limite per ε che tende a zero troviamo,

$$\frac{d\rho}{d\theta} = -\frac{\cos(\alpha)}{\sin(\alpha)}\rho \quad , \quad \frac{d\rho}{\rho} = -c\,d\theta \quad ,$$

dove

$$c = \frac{\cos(\alpha)}{\sin(\alpha)} = \cot an(\alpha).$$

Supponendo che il punto iniziale P_0 abbia coordinate polari $(0,\rho_0)$, integrando abbiamo

$$\int_{\rho_0}^{\rho}\frac{d\rho}{\rho} = -c\int_0^{\theta} d\theta \quad , \quad \log(\rho)-\log(\rho_0) = -c\theta \quad , \quad \log\left(\frac{\rho}{\rho_0}\right) = -c\theta \quad ,$$

da cui il nome di spirale logaritmica (introdotto per la prima volta dal matematico francese Pierre Varignon). Invertendo il logaritmo abbiamo l'equazione che cercavamo

$$\rho(\theta) = \rho_0 e^{-c\theta}$$

con c = cotan(α). Dunque c è positivo se α è acuto, e in questo caso la spirale si avvolge intorno a O avvicinandosi infinitamente a quel punto senza mai toccarlo, mentre c è negativo se l'angolo α è ottuso e in questo caso la spirale gira intorno a O allargandosi.

Un'interessante proprietà della spirale logaritmica è che, se si considera una qualunque semiretta di origine O, i punti che questa sega sulla curva hanno raggi vettori che stanno fra loro in rapporto costante. Possiamo fare facilmente il calcolo:

$$\frac{\rho(\theta+2\pi)}{\rho(\theta)} = \frac{\rho_0 e^{-c(\theta+2\pi)}}{\rho_0 e^{-c\theta}} = e^{-2c\pi} \quad , \quad \frac{\rho(\theta+4\pi)}{\rho(\theta+2\pi)} = \frac{\rho_0 e^{-c(\theta+4\pi)}}{\rho_0 e^{-c(\theta+2\pi)}} = e^{-2c\pi} \quad , \; ...$$

Il rapporto costante trovato si chiama fattore di accrescimento (o di rimpicciolimento) della curva. Si chiama *spirale aurea* la spirale logaritmica con fattore di accrescimento pari a φ^4. In altre parole, se si prendono due raggi vettori che differiscono di un angolo retto, il loro rapporto è aureo. Quindi si ha $e^{-2\pi c} = \varphi^4$, e, ricavando c, l'equazione della spirale aurea è

$$\rho(\theta) = \rho_0 e^{\frac{2\log(\varphi)}{\pi}\theta} = \rho_0 \varphi^{\frac{2\theta}{\pi}} .$$

È proprio questa la spirale che passa per i vertici dei rettangoli aurei che abbiamo considerato nella sezione "Il rettangolo aureo", ed è approssimata dalla figura costituita da archi di circonferenza che lì avevamo costruito.

7. Punto di vista meccanico

Dal punto di vista meccanico, la spirale logaritmica si presta a essere interpretata in due modi diversi come traiettoria percorsa da un punto P in movimento.

Il moto del punto P può esser descritto da due funzioni del tempo t: $\rho(t)$ e $\theta(t)$ in coordinate polari, oppure x(t) e y(t) in coordinate cartesiane. In ogni caso rimane determinato il vettore velocità funzione del tempo $\overline{v(t)}$, che ha in ogni punto direzione tangente alla traiettoria. Le sue proiezioni sulla direzione del raggio vettore e sulla direzione a esso ortogonale si chiamano velocità radiale e velocità trasversale. Per la definizione di spirale logaritmica, la retta tangente forma un angolo costante α con il raggio vettore OP, quindi per essa la velocità radiale e trasversale sono rispettivamente $v(t)\cos\alpha$ e $v(t)\sin\alpha$. La prima interpretazione segue dalla semplice osservazione che la definizione data nel paragrafo precedente può essere tradotta così: il rapporto fra la velocità radiale e la velocità trasversale di P è costante, essendo dato dalla tangente dell'angolo α costante per ipotesi.

La seconda interpretazione si ha quando si interpreta il moto di P come la composizione di due movimenti: P si muove su di una semiretta r di origine O, che contemporaneamente ruota intorno a O. Se P si muove su r con velocità proporzionale alla sua distanza da O e se la velocità angolare di r è costante, allora la traiettoria descritta da P è proprio una spirale logaritmica. Infatti il moto di P su r è descritto da $\rho'(t)=a\rho(t)$ mentre quello di r da $\theta'(t)=b$ dove a e b sono opportune costanti.

Scrivendo

$$\rho'(t) = \frac{d\rho}{dt} \quad e \quad \theta'(t) = \frac{d\theta}{dt}$$

e manipolando le due equazioni, si ottiene che

$$\frac{d\rho}{d\theta}$$

è proporzionale a ρ, come nell'equazione trovata nel paragrafo 2.6 per la spirale logaritmica.

Se i moti di P su r e di r intorno ad O seguono altre leggi, le traiettorie descritte da P sono ancora delle spirali, ma di altro tipo. Per esempio, se la velocità di P su r e la velocità angolare sono entrambe costanti si ottiene la spirale detta *di Archimede*, descritta da un'equazione polare del tipo ρ = a+bθ. Altre spirali sono la spirale iperbolica, la spirale di Fermat, la clotoide (per saperne di più, si veda Cresci [9] e [10]).

Il primo matematico a studiare la spirale logaritmica di Archimede fu Cartesio, ma colui che più si appassionò ad essa fu Jacob Bernoulli, che la chiamò *spira mirabilis*, ossia *spirale meravigliosa* o *ammirevole*. Se ne appassionò a tal punto, da chiedere che, dopo la sua morte, sulla sua tomba venisse scolpita una spirale logaritmica con la scritta *Eadem mutata resurgo* ossia "Sebbene trasformata, rinasco identica a me stessa" (Figura 4). Purtroppo l'ignorante scalpellino non conosceva la matematica, o non era capace di scolpire una spirale logaritmica, perciò oggi sulla tomba di Bernoulli si ammira una spirale ... di Archimede!

◂ **Figura 4** Spirale di Archimede incisa sulla tomba di Jacob Bernoulli

Gli studenti partecipanti ai laboratori, nel vedere la foto della tomba di Bernoulli, sono rimasti molto colpiti e hanno apprezzato meglio la differenza fra le due spirali.

8. L'accrescimento del girasole

La spirale logaritmica e i numeri di Fibonacci si incontrano spesso in natura. Un esempio è la conchiglia del Nautilus, la cui sezione ha proprio la forma di una spirale logaritmica.

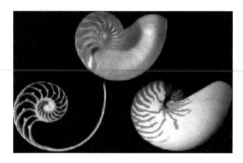

◀ **Figura 5** Conchiglia Nautilus

Al centro del grande fiore del girasole, i fiorellini che poi si trasformano in semi si dispongono secondo due serie di spirali logaritmiche, una in verso antiorario e l'altra in verso orario. Una situazione analoga si incontra nelle pigne, nell'ananas e in molte altre piante. Un semplice modello matematico che spiega perché compaiono queste forme in natura si trova in Michael Naylor [11] (disponibile anche sul sito web dell'autore: www.ac.wwu.edu/~mnaylor). Nel CD allegato al libro *Capitolo II/Girasoleqbasic.rtf*, è riportato un programma in Q-basic che riproduce questa situazione.

L'idea è che i semi si formano via via nel centro del girasole e spingono verso l'esterno i semi precedenti. Ogni seme si colloca in una determinata posizione, il cui raggio vettore forma un certo angolo costante con quello del seme precedente: ciò produce lo schema a spirale che osserviamo nel fiore.

Per simulare questo schema a spirale, Naylor suppone di avere una configurazione con k semi: l'ultimo seme è denotato con il numero 1, il precedente col 2, e così via, il seme più lontano dal centro è il numero k. Se supponiamo che la superficie di ogni seme abbia area pari a 1, allora con buona approssimazione la superficie complessiva è un cerchio di area k e raggio

$$\frac{\sqrt{k}}{\pi},$$

quindi la distanza di ogni seme dal centro del fiore è proporzionale al quadrato del suo numero. Se chiamiamo α l'angolo costante, possiamo scegliere un asse x in modo che l'angolo fra tale asse e la retta congiungente il centro con il seme k sia $k\alpha$. Usando coordinate polari (ρ,θ), la posizione del seme k è data perciò da

$$\rho=\sqrt{k} \text{ e } \theta=k\alpha.$$

Ora, se α è una frazione razionale di un angolo giro, da un certo punto in poi i semi si disporranno lungo raggi distinti, e la distribuzione dei semi sarà molto poco omogenea nel cerchio. Per avere semi distribuiti uniformemente bisogna dunque che α sia una frazione irrazionale di 360°. Che cosa accade se l'angolo è ϕ =1,618 giri, cioè circa 222,5°? I semi si distribuiscono come in Figura 6, non si ammassano in zone particolari e non ci sono spazi sprecati.

◀ **Figura 6** La distribuzione dei semi di girasole simulata al calcolatore

Ma come entrano in gioco i numeri di Fibonacci? Leggete l'articolo di Naylor. Inoltre le proprietà del numero aureo garantiscono che la distribuzione dei semi così ottenuta è la più compatta possibile, anche paragonata a quelle ottenute con altri angoli irrazionali (e questo è legato a un altro argomento, le frazioni continue, vedi per esempio Marco Abate [12]).

Bibliografia

[1] Mezzetti, E. (2009) *Con le mani e con la mente*, EUT Trieste.

[2] Euclide (1956) *The thirteen books of Euclid's elements*, Dover, New York.

[3] Heath, T. (1949) *Mathematics in Aristotle*, Oxford University Press, Oxford.

[4] D'Arcy Thompson, W. (1992) *Crescita e forma*, Bollati Boringhieri, Torino.

[5] Ghione, F. (1999) *Divina proporzione, il trattato di Luca Pacioli con i disegni di Leonardo da Vinci e il libello di Piero della Francesca*, Edizioni Hochfeiler, Roma.

[6] Pagani, C.D., Salsa, S. (1994) *Analisi Matematica*, Zanichelli, Bologna.

[7] Howat, R. (1983) *Debussy in proportion: A musical analysis*, Cambridge University Press, Cambridge.

[8] Giusti, E. (2007) *Piccola storia del calcolo infinitesimale dall'antichità al Novecento*, Istituti editoriali e poligrafici internazionali, Pisa-Roma.

▶ [9] Cresci, L. (1998) *Le curve celebri, invito alla storia della matematica attraverso le curve piane più affascinanti*, Muzzio, Padova.

[10] Cresci, L. (2005) *Le curve matematiche tra curiosità e divertimento*, Hoepli, Milano.

[11] Naylor, M. (2002) Golden, $\sqrt{2}$, and π flowers: a spiral story, *Mathematics Magazine* 75, 163-172.

[12] Abate, M. (2007) Il girasole di Fibonacci, in Emmer, M. (a cura di) *Matematica e Cultura 2007*, Springer, Milano, pp. 227-240.

Si segnala inoltre:

Livio, M. (2003) *La sezione aurea. Storia di un numero e di un mistero che dura da duemila anni*, Rizzoli, Milano.

Huntley, H.E. (1970) *The divine proportion*, Dover, New York.

Courant, R., Robbins, H. (2000) *Che cos'è la matematica?*, Bollati Boringhieri, Torino.

Loria, G. (1930) *Curve piane speciali, algebriche e trascendenti*, II, Hoepli, Milano.

Siti web

http://www.geogebra.org/
http://turnbull.mcs.st-and.ac.uk/history/Curves/Curves.html
http://www.imss.fi.it/index.html
http://xahlee.org/SpecialPlaneCurves_dir/specialPlaneCurves.html
http://virtualmathmuseum.org/

Capitolo 3
Esempi d'impiego della tassellazione del piano nelle arti figurative

di *Michele Cascino*

In primo luogo il mio lavoro è strettamente connesso alla divisione regolare del piano. Tutte le immagini degli ultimi anni derivano da questo, dal principio delle figure congruenti che, senza lasciare nessuno "spazio aperto", riempiono il piano all'infinito o in modo illimitato. Una volta tuo padre lo ha espresso perfettamente: per me si tratta sempre di porre dei limiti al piano illimitato, di "metterci una fine", farne una "composizione". Devo combattere, per così dire, con due distinte difficoltà che insieme rendono il tutto così affascinante per me: primo, "trovare" o incastrare o mettere insieme le figure congruenti che mi servono; secondo, comporre un piano chiuso con misure specifiche nel quale queste figure, che portano in sé infinito e sconfinatezza, per così dire, giacciano incatenate o imprigionate.
Questo doppio livello dei miei quadri è quindi astratto. La motivazione dei miei tentativi non ha nulla a che fare con l'effettiva realtà.[1]

1. Introduzione e contesto didattico

Questo capitolo illustra i presupposti teorici di alcune tra le attività proposte, nell'ambito del Progetto Lauree Scientifiche, agli alunni delle classi terminali (4°-5° anno) dei Licei statali palermitani Regina Margherita e Umberto I e dell'Istituto paritario Don Bosco.

L'impiego dei contenuti matematici come strumento per la comprensione e l'analisi critica dell'opera d'arte, la natura interdisciplinare dell'argomento trattato e l'impiego in laboratorio del software di geometria dinamica hanno destato negli allievi notevoli livelli d'interesse e coinvolgimento anche per i contenuti matematici più astratti o di natura puramente teorica.

Lo studio dell'opera d'arte, concretizzatosi "in toto" con la realizzazione di copie "geometricamente coerenti", ha consentito agli allievi di acquisire la facoltà di coglierne una nuova – e più profonda – bellezza, celata sotto quella puramente esteriore.

Tale risultato, ovviamente, è stato conseguito con gradualità.

La sequenza dei contenuti e delle attività proposte agli studenti, che qui di seguito si riassume, rispecchia, con una certa fedeltà, la struttura successiva di questo capitolo.

[1] M.C. Escher, *Lettera al nipote Rudolf Escher*, 17 gennaio 1944.

I prerequisiti indispensabili per affrontare l'argomento sono quelli elementari di geometria piana, già acquisiti dagli alunni nel biennio della scuola secondaria.

Gli allievi, inizialmente, hanno acquisito familiarità con il software di geometria dinamica (GeoGebra) e, nel contempo, grazie proprio allo strumento informatico, hanno rivisto le isometrie nel piano. A tal fine, sono state predisposte – a cura del docente – alcune semplici animazioni utili per riprendere questi contenuti, essenziali per la comprensione di argomenti che sarebbero stati trattati nel seguito (i files relativi si trovano nella cartella *Capitolo III/Animazioni /Isometrie* del CD allegato al libro).

Successivamente gli studenti, seguiti dall'insegnante, hanno costruito alcune semplici tassellazioni del piano, "montando" in GeoGebra un certo numero di tasselli poligonali.

A partire dalle semplici definizioni di *disegno minimo* e di *parallelogramma di base*, sono stati poi presentati i diciassette gruppi cristallografici: ognuno di essi è stato analizzato in dettaglio, riconoscendo il disegno minimo e individuando le isometrie con le quali ricavare, a partire da quello, il parallelogramma di base (la cartella *Capitolo III/I 17 gruppi* del CD riassume le caratteristiche peculiari dei vari gruppi di simmetria e può risultare utile agli allievi per riconoscere la struttura matematica di una tassellazione assegnata).

A questo punto, è stato proposto lo "studio matematico" delle tassellazioni d'arte. L'attenzione è stata focalizzata su alcuni decori dell'Alhambra e su alcune tassellazioni "zoomorfe" di M.C. Escher: compito dell'insegnante è stato quello di realizzare in ambiente GeoGebra, ispirandosi agli originali, le copie "di lavoro" delle varie tassellazioni. Inoltre, per illustrare in maniera più coinvolgente le varie tassellazioni, sono state prodotte alcune animazioni. Queste possono essere utili per presentare l'argomento anche a un pubblico vasto e introdurre la teoria dei gruppi cristallografici. Agendo sui *cursori*, si mostra come il disegno si genera e si sviluppa. (Si vedano le cartelle del CD: *Capitolo III/Animazioni/Escher* e *Capitolo III/Animazioni/Alhambra*).

Gli studenti del laboratorio hanno quindi avuto il compito di creare le tassellazioni partendo dagli elementi minimi e indispensabili alla loro realizzazione. La figura, prima, e la tassellazione, poi, sono state completate attraverso l'applicazione delle necessarie isometrie del piano. Quest'attività "creativa" ha suscitato in loro un entusiasmo crescente e accentuatosi via via per la consapevolezza che i decori, anche quelli in apparenza molto complicati, potevano essere facilmente riprodotti in maniera perfetta, con l'uso del computer, alla luce della loro struttura matematica.

Infine si è incrementato il livello di difficoltà del lavoro: è stata concessa la possibilità di visionare soltanto l'animazione ed è stato richiesto agli studenti di riconoscere le trasformazioni utilizzate e di impiegarle in maniera consapevole nella realizzazione del "loro" disegno.

Gli alunni più brillanti, alla fine del corso, sono stati in grado di riconoscere le simmetrie del decoro dall'esame di una sua riproduzione fotografica e di utilizzarle creativamente al computer.

2. La tassellazione periodica del piano

Osservando una comune pavimentazione, è possibile notare come la sua superficie sia spesso interamente ricoperta da piastrelle identiche di forma: queste sono disposte in maniera ordinata sul piano in modo tale da ricoprirne l'intera superficie senza sovrapporsi.

Nelle figure sottostanti, sono riportati esempi particolari di pavimentazioni ottenute per mezzo di poligoni regolari che, a due a due, hanno in comune un lato.

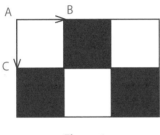

▲ Figura 1

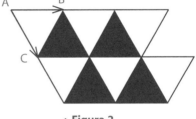

▲ Figura 2

Idealmente, tali pavimentazioni possono estendersi all'infinito, coprendo interamente il piano euclideo: una pavimentazione illimitata costituisce una *tassellazione* del piano.

Approfondimento

Non è difficile dimostrare che gli unici **poligoni regolari** in grado di tassellare il piano sono i quadrati, i triangoli equilateri e gli esagoni regolari.

▲ Figura 3

Esaminando la figura seguente vediamo che l'angolo giro di vertice A è interamente "ricoperto" dagli angoli interni (di vertice A) dei tre esagoni in bruno, beige, bianco. Gli angoli interni di un esagono regolare (n=6 lati), hanno un'ampiezza di 120°, per cui sono necessari k=3 esagoni per ricoprire l'intero angolo giro.

Possiamo riproporre questo ragionamento in generale. Gli angoli interni di un poligono regolare di n lati hanno un'ampiezza $\alpha°$ pari a:

$$\alpha° = 180° \, (n-2)/n \, .$$

Volendo ricoprire l'intero angolo giro, occorrono k (numero intero!) poligoni con un vertice in comune, in modo che sia:

▶

$$k\alpha° = 360°$$

cioè

$$k\,180°\,(n-2)/n = 360°.$$

Risolvendo rispetto a k, otteniamo:

$$k = 2n/(n-2).$$

Se n=3 (triangolo equilatero) allora k=6 (6x60° = 360°);
se n=4 (quadrato) si ha k=4 (4x90° = 360°);
se n=5 (pentagono regolare) si ha k = 10/3
 (k non è un numero intero);

se n=6 (esagono regolare) allora k = 3 (3x120°=360°);
se n>6 impossibile poiché 2<k<3
 (k non è un numero intero).

Nelle figure sopra, inoltre, sono evidenziati due vettori indipendenti (cioè non paralleli) *vett*(AB) e *vett*(AC)[2]. Immaginiamo che tali vettori individuino i *passi* che è possibile fare muovendosi sulle pavimentazioni.

Partendo da un qualunque punto P di una piastrella, supponiamo di fare *m* passi in direzione AB e *n* passi in direzione AC (con *m* e *n*, ovviamente, interi): evidentemente, il punto P', di arrivo, sarà "omologo" al punto P di partenza; se, cioè, P fosse il baricentro della piastrella di partenza, P' sarebbe il baricentro di quella di arrivo.

Potremmo anche pensare di impiegare i due vettori per far scorrere la tassellazione (illimitata), traslando i suoi vertici secondo il vettore

$$vett(\text{PP}') = m\ vett(\text{AB}) + n\ vett(\text{AC}):$$

in tal caso, dopo lo scorrimento, essa assumerà una configurazione finale identica a quella iniziale. Diremo allora che, dopo lo scorrimento, la tassellazione si sovrappone su se stessa.

Quando è possibile individuare una coppia di vettori indipendenti che, attraverso una traslazione, sovrappongono una data tassellazione su se stessa, diremo che la tassellazione stessa è *periodica*.

La tassellazione in Figura 3, per esempio, ha questa caratteristica: scelti comunque due esagoni della tassellazione, è possibile sovrapporli l'uno sull'altro, combinando opportunamente due traslazioni lungo le direttrici AE e AC.

[2] Dati due punti A e B del piano, indichiamo con *vett*(AB) il vettore definito dal segmento orientato AB.

Osserviamo ancora le Figure 1 e 2.

Nel caso 1 è possibile generare l'intera tassellazione, traslando il quadrato di lato AB secondo i vettori prima citati.

Nel caso 2 la traslazione del triangolo ABC genera solo i triangoli bianchi. Se volessimo generare l'intera tassellazione, con le traslazioni citate, bisognerebbe far scorrere un intero "modulo" costituito da due triangoli confinanti (ossia il parallelogramma bianco e bruno).

Prescindendo dal colore, il triangolo bruno può pensarsi ottenuto per simmetria assiale del bianco e costituisce quindi l'elemento minimo col quale, ricorrendo anche alle altre isometrie (oltre la semplice traslazione), potrebbe generarsi l'intera tassellazione.

Le seguenti definizioni sono molto importanti nello studio delle tassellazioni periodiche:

Definizione 1
*Chiamiamo **parallelogramma di base** il parallelogramma in grado di generare, **per sola traslazione**, l'intera tassellazione. I lati di questo parallelogramma sono individuati dai due vettori di modulo minimo con questa proprietà.*

Definizione 2
*Chiamiamo **disegno minimo** la figura in grado di ricoprire interamente il parallelogramma di base, servendosi di altre isometrie[3].*

Approfondimento

Nella figura a fianco, è evidenziato (in beige) il parallelogramma di base per la tassellazione del piano con esagoni regolari.

Due esagoni confinanti della tassellazione si sovrappongono traslando opportunamente uno di essi lungo un lato del parallelogramma di base.

[3] Un caso più semplice di tassellazione si ottiene quando il gruppo delle traslazioni è generato da un solo vettore. In questo caso, viene tassellata una striscia infinita (cioè una porzione di piano compresa tra due rette parallele al vettore). Gli ornamenti che si ottengono, molto usati nella storia dell'arte per realizzare ogni tipo di cornice, si chiamano *fregi*. Anche in questo caso, è possibile definire un segmento di base (della striscia) la cui lunghezza è data dal modulo del vettore che genera il gruppo delle traslazioni. Il segmento di base può essere diviso in parti ricostruibili, a partire da un disegno minimo, agendo su questo con le isometrie (simmetrie assiali e centrali, glissosimmetrie). I diversi casi di fregi realizzabili sono solo 7.

> La tassellazione per esagoni è diversa dalla corrispondente tassellazione ottenuta con suoi parallelogrammi di base: ovviamente i lati degli esagoni e i lati dei parallelogrammi generano divisioni del piano completamente differenti.
>
> Questo, però, è vero se ci riferiamo **soltanto** ai lati dei poligoni:
>
> considerando, infatti, anche il disegno interno al parallelogramma di base (figura a fianco), si nota che le due tassellazioni (figura in basso) sono in grado di "generare" lo stesso motivo "a nido d'ape".
>
> Le due figure, quindi, tassellano il piano disegnando su di esso lo stesso motivo; quella fatta con il parallelogramma di base consente di evidenziare immediatamente la coppia di vettori di modulo minimo che generano la tassellazione periodica.

3. Tassellazioni e isometrie

Supponiamo di avere una piastrella quadrata con la quale "disegnare" una pavimentazione.

Applicando alcune delle possibili isometrie[4] (traslazioni, rotazioni, simmetrie assiali e centrali, glissosimmetrie), è possibile ricoprire il piano in diverse maniere. In figura, sono riportati alcuni esempi nei quali il disegno minimo è sempre lo stesso (una piastrella quadrata con un triangolo scuro); il parallelogramma base, però, cambia ed è ottenuto trasformando il disegno minimo con le diverse isometrie. Il tipo di tassellazione che si ottiene volta per volta, cambia radicalmente aspetto.

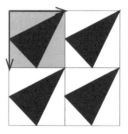

In questo caso il parallelogramma di base coincide col disegno minimo.

[4] Per le isometrie, si veda per esempio Dedò [1].

In questo caso il parallelogramma di base è dato da due mattonelle ed è ottenuto applicando alla prima mattonella una glissosimmetria verticale: si trasla verso il basso e si riflette rispetto alla verticale.

In questo caso il parallelogramma di base è dato da 4 mattonelle ed è ottenuto con 4 rotazioni successive di 90° della piastrella intorno ad un suo vertice.

In questo caso il parallelogramma di base è dato da 4 mattonelle ed è ottenuto applicando al disegno minimo una riflessione orizzontale e una verticale.

Si deduce che esistono "diverse" maniere di disporre le piastrelle di una pavimentazione in modo da ottenere decori differenti.

Nella cartella *Capitolo III/Animazioni/Isometrie* del CD allegato, si possono trovare, per ogni isometria, i files realizzati in ambiente GeoGebra che potranno essere utili agli insegnanti per mostrare, con un'animazione, l'effetto di una data isometria e richiamare brevemente la teoria generale.

4. I 17 gruppi cristallografici

L'interesse per la classificazione delle tassellazioni è nato in cristallografia. Nel 1891 E. S. Fedorov, cristallografo russo, elaborò per primo una classificazione, resa poi nota nel 1924 dal matematico G. Polya.

Fedorov dimostrò che esistono solo 17 tipi di tassellazioni del piano, ciascuno corrispondente a uno dei 17 gruppi cristallografici.

Si riporta di seguito lo schema della notazione cristallografica, con la quale s'identificano i 17 gruppi di simmetria. La notazione è di tipo alfanumerica e riporta:

* una "p" o una "c" ("c" per i casi in cui si vuole evidenziare la presenza di un asse o di un centro di simmetria);
* una cifra che, se presente, indica la più piccola rotazione in grado di sovrapporre due disegni minimi:
 * 1 – la rotazione minima è pari all'intero angolo giro (coincidente, in definitiva, con la rotazione nulla; non esistono rotazioni significative in grado di sovrapporre due tasselli)
 * 2,3,4,6 – l'angolo minimo con cui è possibile sovrapporre, per rotazione intorno a un centro, due tasselli è pari rispettivamente a 1/2 ; 1/3 ; 1/4 ; 1/6 di angolo giro;
* una (o due) "m" (mirror): nel caso in cui vi siano riflessioni (simmetrie assiali);
* una (o due) "g" (glide): nel caso in cui si possano individuare glissosimmetrie.

Consideriamo inizialmente i gruppi di simmetria che non ammettono rotazioni: essi sono identificati dalle notazioni cristallografiche p1, pm, cm.

Simmetria *p1*

Tassellazione per traslazione semplice: il parallelogramma di base coincide col disegno minimo e ricopre il piano per traslazione lungo due direzioni non-parallele (coincidenti con i lati del parallelogramma).

Non esistono riflessioni né rotazioni (se non quella di 360° – da cui il nome "p1" – che sovrappone ogni piastrella su se stessa).

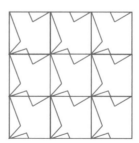

La figura precedente mostra un esempio di tassellazione del piano con una forma poligonale chiusa: il disegno minimo/parallelogramma di base è evidenziato dal rettangolo azzurro. Nel comporre la tassellazione, i punti della figura che "insistono" sul lato AB si sovrappongono "direttamente" ai punti del lato CD (A su C, B su D)[5]; analogamente quelli del lato AC vanno a coincidere con quelli del lato BD (la sovrapposizione è ancora "diretta": A su B e C su D). Nell'esempio, i tasselli sono poligoni concavi chiusi, tra loro congruenti.

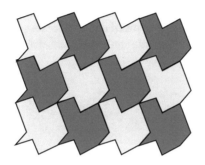

Simmetria *pg*

Il disegno minimo è un rettangolo (disegnato in azzurro).

Il parallelogramma di base si ottiene per simmetria di scorrimento (g) del rettangolo minimo rispetto a un asse verticale. Il parallelogramma di base, nella figura a sinistra, è costituito da due rettangoli adiacenti (lo indichiamo con la notazione "2x1": due righe, una colonna).

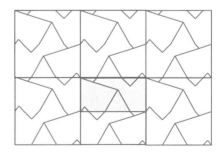

[5] La sovrapposizione si definisce "diretta" se un lato si sovrappone sull'altro, senza subire riflessioni lungo l'asse di scorrimento.

La figura precedente mostra un esempio di tassellazione del piano di tipo "pg".

È evidenziato (in azzurro) il rettangolo minimo: questo s'individua immediatamente, partendo dalla tassellazione completa, notando che esso ammette per asse di simmetria verticale l'asse della glissosimmetria e ha altezza pari alla metà dell'altezza del parallelogramma di base.

Quest'ultimo, poi, è facilmente individuabile, ricordando che i suoi lati sono i vettori di modulo minimo che sovrappongono la tassellazione su se stessa.

Volendo ottenere un tassello di forma chiusa, bisognerà realizzare il disegno minimo facendo in modo che i punti della figura che insistono sul lato AB si sovrappongano inversamente ai punti del lato CD (A su D, B su C); quelli sul lato AC dovranno sovrapporsi "direttamente" a quelli del lato BD (A su B e C su D).

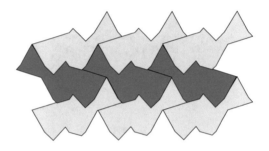

Simmetria *pm*

Il disegno minimo è un rettangolo.

Il parallelogramma di base si ottiene per simmetria assiale (m) fatta rispetto a un lato del rettangolo minimo.

Il gruppo genera anche glissosimmetrie, i cui assi coincidono con gli assi di simmetria (si noti infatti la trasformazione che lega i rettangoli più piccoli situati lungo le diagonali).

Si riporta un esempio di tassellazione di tipo "pm" (a due motivi).

Il disegno minimo è facilmente individuabile partendo dalla tassellazione completa, determinando, per esempio, gli assi di simmetria della tassellazione.

Simmetria *cm*

Il parallelogramma di base si ottiene per simmetria (m) fatta rispetto a un lato (verticale, in figura) del rettangolo minimo in azzurro e per successiva glissosimmetria lungo un asse parallelo (distinto dal primo), passante per il centro (c) del rettangolo.

Non vi sono rotazioni.

Come prima, il rettangolo minimo (evidenziato in rosso nella figura a pagina seguente) s'individua immediatamente dopo aver determinato gli assi di simmetria della figura. La sua altezza coincide col modulo del vettore di traslazione associato alla glissosimmetria.

Evidenziato, il parallelogramma di base.

Passiamo ora a elencare i gruppi di simmetria che ammettono solo rotazioni di 180°, cioè simmetrie rispetto a un punto.

Simmetria *p2*

Il disegno minimo, nella figura, è il parallelogramma più piccolo; il parallelogramma di base si ottiene per simmetria centrale (o tramite una rotazione di 180°, da cui il nome "p2") fatta rispetto al punto medio del lato orizzontale del parallelogramma minimo.

Non vi sono riflessioni.

L'esempio evidenzia in rosso il parallelogramma (rettangolo) minimo; più scuro, quello di base. Si notino le simmetrie delle singole tessere: le porzioni di silhouette che insistono sui lati orizzontali del rettangolo ammettono centri di simmetria allineati lungo un asse verticale (parallelo all'asse della traslazione dei parallelogrammi di base).

La porzione destra di silhouette si può ottenere pensando di traslare orizzontalmente la corrispondente parte sinistra.

Simmetria *cmm*

Il gruppo di simmetria presenta simmetrie centrali e due simmetrie assiali (m-m) fatte rispetto a una coppia di assi ortogonali.

Gli assi di riflessione s'intersecano in un centro simmetria.

Esistono centri di simmetria (punti medi delle diagonali rettangoli più piccoli) per i quali non passano assi di simmetria.

In figura, da sinistra, il disegno minimo, il parallelogramma di base e l'avvio di una tassellazione "cmm" che, sotto, è stata colorata in modo da "celarne" la struttura geometrica.

Simmetria *pmm*

Il rettangolo più piccolo (disegno minimo) subisce due riflessioni (m-m) fatte rispetto a una coppia di assi ortogonali che s'intersecano in un centro di simmetria. Sopra il parallelogramma di base ("2x2"). Sotto una tassellazione "pmm" a due motivi (in rosso il disegno minimo, più scuro il parallelogramma di base).

Simmetria *pmg*

Il rettangolo più piccolo (disegno minimo) subisce una rotazione di 180° (simmetria centrale) rispetto al punto medio di un suo lato orizzontale e, quindi, una riflessione (m) rispetto al lato verticale.

Il lato orizzontale è asse di una glissosimmetria (tra i tasselli disposti lungo le diagonali).

La figura predecente riporta un esempio di tassellazione con simmetria "pmg".

La tassellazione è generata a partire dal quadrato rosso che ne costituisce il disegno minimo.

Più scuro il parallelogramma di base.

Simmetria *pgg*

Il disegno minimo è il rettangolo azzurro.

Il parallelogramma di base ("2x2") si ottiene, partendo dal disegno minimo, attraverso:
- una glissosimmetria in direzione orizzontale (g);
- una glissosimmetria in direzione verticale (g).

Gli assi delle glissosimmetrie passano per il centro del rettangolo minimo e sono tra loro ortogonali. La tassellazione, inoltre, ammette centri di simmetria esterni agli assi delle glissosimmetrie (in figura: il centro del rettangolo, "2x2", di base). Non esistono riflessioni.

Esempio di tassellazione "pgg":

I vertici del quadrato in rosso sono centri di simmetria per gli elementi disposti lungo le sue diagonali.

Passiamo ora all'analisi dei gruppi che ammettono rotazioni minime di 120°.

Simmetria *p3*

Il gruppo ammette rotazioni minime di 120° ("p3") e non presenta assi di riflessione. Il disegno minimo è dato dal parallelogramma azzurro. Questo parallelogramma è ruotato tre volte.

Il parallelogramma di base è invece il parallelogramma rosso.

Un esempio di tassellazione di tipo p3 con un solo tipo di tassello, generata a partire dal parallelogramma azzurro (disegno minimo). Il parallelogramma di base è quello più grande.

Simmetria *p31m*

Il parallelogramma di base è generato, partendo dal disegno minimo (triangolo isoscele con angolo al vertice di 120°), attraverso tre rotazioni e una simmetria assiale. Il gruppo di simmetria ammette centri di rotazione di 120°. Ci sono inoltre tre fasci di assi di riflessione paralleli inclinati, tra loro, di 120° che **non passano** per i centri di rotazione.

Esempio di tassellazione "p31m". In evidenza il disegno minimo (triangolo rosso) e il parallelogramma di base (grigio).

Simmetria *p3m1*

Il disegno minimo è un triangolo equilatero ruotato sei volte di 60°. Il parallelogramma di base è ottenuto come in figura. Il gruppo di simmetria ammette centri di rotazione di 120° ma non di 60°.

Esistono inoltre tre fasci di assi di riflessione paralleli, inclinati reciprocamente di 120°, più scuri nel disegno, che **passano** per i centri di rotazione. Il parallelogramma di base è in rosso.

In figura, un esempio di tassellazione di tipo "p3m1" a due motivi. Il disegno minimo è colorato in rosso, il parallelogramma di base è più scuro.

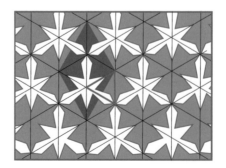

Passiamo ora all'analisi dei gruppi che ammettono rotazioni minime di 90°.

Simmetria *p4*

 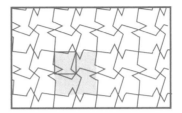

Il disegno minimo è un quadrato. Le uniche trasformazioni presenti nel gruppo di simmetria sono le rotazioni (minima di 90°).

Non vi sono riflessioni.

Sotto un esempio di tassellazione con simmetria "p4".

Simmetria *p4m*

Il gruppo di simmetria ammette 4 (schiere di) assi di simmetria, più scuri nella figura, a due a due ortogonali, che s'intersecano in un centro di rotazione (minima) di 90°. Esistono direzioni di riflessione a 45° tra loro.

Nella figura sopra un esempio di tassellazione costruita a partire dal modulo triangolare evidenziato in rosso.

Simmetria *p4g*

Il gruppo ammette centri di rotazione di 90° e schiere di assi di riflessione ortogonali che **non** li contengono.

Il disegno minimo è "contenuto" in un triangolo rettangolo-isoscele.

Considerando una coppia di quadrati "1x1" confinanti (aventi per lato l'ipotenusa del triangolo minimo), s'individua una glissosimmetria avente, per asse, l'asse del lato comune.

Di seguito, un esempio. Il disegno minimo e il parallelogramma di base sono evidenziati nel modo consueto.

Passiamo ora all'analisi dei gruppi che ammettono rotazioni minime di 60°.

Simmetria *p6*

Il gruppo ammette centri di rotazione (minima) di 60°. Non presenta assi di riflessione.

Nella figura qui sotto, un esempio di tassellazione "p6".

Simmetria *p6m*

Il gruppo ammette centri di rotazione minima di 60° coincidenti con i vertici del parallelogramma di base e presenta simmetrie di riflessione lungo le rette scure. Le "G" più chiare al centro evidenziano la rotazione di 60°.

Di seguito, il parallelogramma di base che viene mostrato, mentre compone la tassellazione di tipo "p6", costruita a partire dal disegno minimo triangolare evidenziato in rosso (il disegno minimo, evidentemente, è un triangolo rettangolo con un angolo acuto di 60°).

Il parallelogramma di base è colorato in grigio.

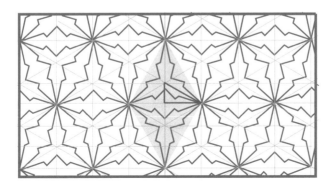

Tavola riassuntiva
I 17 Gruppi cristallografici

A	B	C	D	E
p1	360°	NO		NO
pg	360°	NO		SI
pm	360°	SI: lungo una schiera di assi paralleli		NO
cm	360°	SI: lungo una schiera di assi paralleli		SI
p2	180°	NO		NO
cmm	180°	SI: due schiere di assi ortogonali	NO	NO
pmm	180°	SI: due schiere di assi ortogonali	SI	NO
pmg	180°	SI: una schiera di assi paralleli	NO	SI
pgg	180°	NO		SI: due schiere di rette ortogonali
p3	120°	NO		NO
p31m	120°	SI	NO	NO
p3m1	120°	SI	SI	NO
p4	90°	NO		NO
p4m	90°	SI: 4 schiere di assi a 45°	SI	NO
p4g	90°	SI: due schiere di assi ortogonali	NO	SI
p6	60°	NO		NO
p6m	60°	SI	SI	NO

A Gruppo

B Angolo minimo di rotazione che sovrappone la tassellazione su se stessa

C Il gruppo ammette assi di simmetria (riflessioni?)

D Gli assi di simmetria passano per i centri di rotazione minima?

E Esistono glissosimmetrie?

5. I decori dell'Alhambra

Le tassellazioni generate dall'applicazione dei 17 gruppi di simmetria precedentemente illustrati sono notevoli non solo per le peculiari proprietà geometriche che esse presentano, ma anche per le loro caratteristiche puramente estetiche.

Per questo motivo si ritrovano – con finalità puramente decorative – come rivestimento di pareti e pavimenti di edifici: gli esempi forse più eclatanti dell'uso ornamentale delle tassellazioni si possono ammirare nella fortezza dell'Alhambra a Granada (Spagna), le cui sale sono variamente adornate da tassellazioni riconducibili a tutti i gruppi di simmetria.

Nel seguito, verranno analizzati soltanto otto di questi decori: per identificare i rispettivi gruppi di simmetria, si farà riferimento soltanto alla struttura geometrica dell'opera, trascurando, quindi, le eventuali differenze nella colorazione dei suoi tasselli.

Inoltre (per agevolare il lavoro dello studente in laboratorio d'informatica) saranno descritte le fasi per riprodurre i disegni al calcolatore, con GeoGebra e con Cabri.

I colleghi che lo riterranno opportuno, potranno far precedere le esercitazioni di laboratorio dalla visione delle relative animazioni che mostrano le differenti costruzioni in tutto il loro sviluppo (le animazioni si trovano nella cartella *Capitolo III/Animazioni/Alhambra* del CD allegato).

Esempio 1: tassellazione "p6"

La figura seguente mostra una tassellazione dell'Alhambra.

La tassellazione è appartenente al gruppo di simmetria "p6": ciò si desume, servendosi della tabella riassuntiva, osservando che la rotazione minima in grado di sovrapporre due tasselli è pari a 60° e che non esistono assi di simmetria.

◄ **Figura 4** Particolare di mosaico dell'Alhambra (Granada), riconducibile a un gruppo di simmetria "p6"

 Matematica e Arte

84

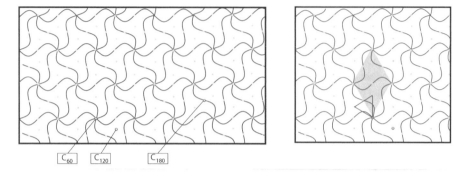

La figura a sinistra riproduce la tassellazione. Sono evidenziati tutti i centri di rotazione propri del gruppo di simmetria: esistono centri di rotazione di 60, 120 e 180° (indicati con C_{60}, C_{120} e C_{180}).

Nella figura a destra, si evidenzia il disegno minimo (triangolo blu) e il parallelogramma (grigio) di base.

Dopo aver individuato la struttura della tassellazione, è possibile riprodurla al computer. Si potrebbero adottare due metodi differenti:

1. Ricostruire il parallelogramma di base a partire dal disegno minimo e, quindi, traslarlo parallelamente ai suoi lati.
2. Riprodurre il tassello triangolare curvo e, successivamente, comporre il decoro ruotando e traslando questa forma.

Di seguito verrà descritto il secondo metodo di costruzione che, per la particolare configurazione della tassellazione in esame, si rivela come quello più semplice.

La forma dei singoli tasselli può essere ottenuta (figura in basso) partendo da una tassellazione poligonale costituita da triangoli equilateri (aventi i vertici sui centri di rotazione C_{60}) i cui lati vengono sostituiti da tratti di linea curva (per esempio da archi di circonferenza).

La silhouette deve ovviamente rispettare le condizioni imposte dal gruppo di simmetria di appartenenza della tassellazione: partendo dalla configurazione riportata a sinistra, è immediato verificare che le trasformazioni che consentono di completare il tassello sono proprio le rotazioni caratteristiche del gruppo "p6", prima individuate.

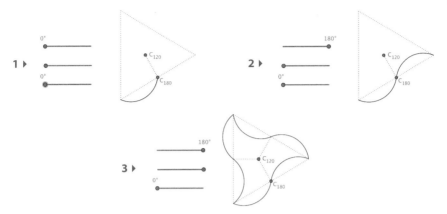

1. Configurazione iniziale.
2. La linea curva ruota di 180° intorno al centro C_{180}.
3. La porzione di silhouette ruota di 60° intorno ai vertici del triangolo (C_{60}) oppure di 120° intorno al suo baricentro.

LABORATORIO: Utilizzando GeoGebra, riprodurre la tassellazione.

Nel file del CD allegato *Capitolo III/Esercitazioni/Alhambra/x_Alhambra1.ggb* è già disegnata la sagoma iniziale. Servendosi del comando "rotazione", completare la sagoma. Applicando soltanto il comando "rotazione" sui singoli archi, disegnare la figura seguente e, quindi, espandere la tassellazione usando il comando "traslazione".

Esempio 2: tassellazione "p3".

Il decoro appena illustrato, con lievi modifiche (l'aggiunta degli esagoni bianchi e delle stelle a sei punte inscritti nella silhouette curvilinea studiata prima), assume la configurazione riportata nella figura seguente.

Tenendo conto che, adesso, la rotazione minima che sovrappone due motivi ha ampiezza di 120° si deduce che – a seguito delle modifiche apportate – la nuova tassellazione è appartenente al gruppo "p3".

◀ **Figura 5** A sinistra: decoro dell'Alhambra appartenente al gruppo simmetria "p3". A destra: la sua analisi geometrica

La Figura 5 di destra, raffigura in bianco e grigio lo stesso decoro[6] e mostra, in colore, il disegno minimo (rombo verde) e il parallelogramma di base (rombo rosso) della tassellazione.

Esempio 3: tassellazione "p4g".

La tassellazione qui sotto fa parte del gruppo di simmetria "p4g".

◀ **Figura 6** Decoro dell'Alhambra riconducibile al gruppo di simmetria "p4g"

La figura seguente evidenzia i centri di rotazione quaternari (C_{90}) e le due schiere ortogonali di assi di simmetria che generano una nuova tassellazione poligonale a base quadrata.

C_{90}

La tassellazione originaria si può riprodurre facilmente, riconoscendo che la porzione di decoro contenuta in un quadrato ammette un centro di rotazione C_{90} coincidente col centro geometrico del quadrato stesso.

Di seguito, le fasi di costruzione del parallelogramma di base a partire dal disegno minimo.

[6] Si è stabilito di individuare i gruppi di simmetria prescindendo dalla colorazione dei decori. Ciò significa che due figure uguali di forma, ma differenti per colore, sono considerate sovrapponibili.

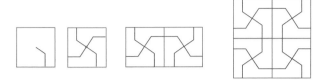

La prima figura a sinistra rappresenta il disegno minimo, la seconda è ottenuta dalla precedente con quattro rotazioni di 90°, la terza con una riflessione verticale, l'ultima con una riflessione orizzontale. Il risultato è il parallelogramma base.

LABORATORIO: Utilizzando GeoGebra, riprodurre la tassellazione.

Nel CD allegato al libro *Capitolo III/Esercitazioni/Alhambra/x_Alhambra2.ggb* viene fornito il disegno minimo in formato figura-GeoGebra: completare la sagoma, utilizzando i comandi "rotazione" e "simmetria assiale" di GeoGebra. Dopo aver ricostruito la seconda figura (sopra), è conveniente utilizzare il comando "poligono" per evidenziare i quattro poligoni concavi che compongono il quadrato. In questo modo, operando sugli oggetti poligonali, risulta agevole colorare il motivo e trasformarlo (per sole simmetrie assiali o, eventualmente, anche per traslazione) in modo da completare il parallelogramma di base e avviare la tassellazione.

Utilizzando lo stesso schema, è possibile riprodurre nuove tassellazioni del piano con simmetria "p4g". Qui sotto, per esempio, si riproduce un altro decoro dell'Alhambra.

Esempio 4: una nuova tassellazione "p4g".

La fotografia riprodotta nella pagina seguente mostra un decoro appartenente ancora al gruppo di simmetria "p4g".

Sotto, sono riportati i passi necessari per costruire il parallelogramma base a partire dal disegno minimo.

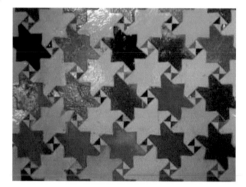

◀ **Figura 7** Un secondo esempio
di decorazione appartenente al gruppo
"p4g"

Il disegno minimo viene ruotato di 90° quattro volte attorno al punto nero evidenziato. Successivamente, per ottenere il parallelogramma di base, si eseguono due riflessioni lungo assi ortogonali che non passano per i centri di rotazione minima.

LABORATORIO: Utilizzando GeoGebra, riprodurre la tassellazione.

Nel file *Capitolo III/Esercitazioni/Alhambra/x_Alhambra4.ggb* del CD allegato al libro, è già fornito il disegno minimo. Completare il parallelogramma di base, usando i comandi "rotazione" e "simmetria assiale" e, quindi, espandere la tassellazione, impiegando le trasformazioni opportune.

Esempio 5: tassellazione "p6m".

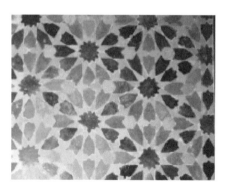

▲ **Figura 8** A sinistra: un decoro dell'Alhambra con simmetria "p6m".
A destra: il suo schema geometrico

La fotografia mostra un decoro, con simmetria "p6m": a destra la sua riproduzione grafica in cui si evidenzia, in grigio, il parallelogramma base.

Qui sopra si evidenziano i passi successivi che consentono di ottenere la tassellazione:

1. Disegno minimo (triangolo rettangolo con un angolo acuto di 60°).
2. Simmetria assiale fatta rispetto a un cateto (in figura, la simmetria è fatta rispetto al cateto maggiore).
3. Sei rotazioni di 60° del triangolo equilatero ottenuto generano un modulo esagonale col quale è semplice tassellare il piano.

LABORATORIO: Utilizzando GeoGebra si riproduce la tassellazione.

Nel file GeoGebra *Capitolo III/Esercitazioni/Alhambra/x_Alhambra3.ggb* del CD, viene fornito, un po' semplificato, il disegno minimo. Occorre completare la sagoma usando i comandi "rotazione" e "simmetria assiale". È lasciato come esercizio la riproduzione del disegno minimo con tutte le decorazioni e i colori della figura precedente.

Esempio 6: tassellazione "pmm".

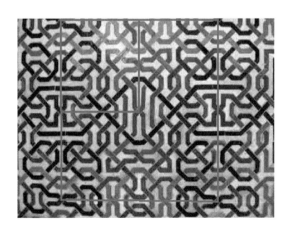

◀ **Figura 9** Fotografia di un decoro dell'Alhambra con simmetria "pmm"

Nella figura, sono evidenziati in rosso il disegno minimo (rettangolo piccolo) e il parallelogramma di base.

Si riportano di seguito le fasi di costruzione del parallelogramma di base:

1. Disegno minimo.
2. Simmetria assiale con asse verticale.
3. Un'ulteriore simmetria assiale con asse orizzontale genera il parallelogramma di base

 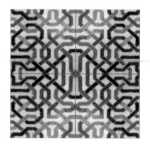

Esempio 7: tassellazione "p4"

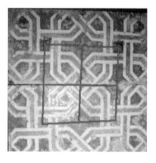

◄ **Figura 10** Tassellazione dell'Alhambra appartenente al gruppo "p4". Disegno minimo e parallelogramma di base sono evidenziati

La Figura 10 mostra, con una lieve distorsione prospettica, un esempio di tassellazione "p4" dell'Alhambra[7] ed evidenzia il parallelogramma di base (quadrato grande) e i quattro disegni minimi che lo compongono, per rotazioni successive di 90°.

LABORATORIO: Utilizzando GeoGebra riprodurre la tassellazione.

Il disegno minimo è già fornito col file GeoGebra *CapitoloIII/Esercitazioni/ Alhambra/x_Alhambra5.ggb*.
Si tratta di completare il parallelogramma di base, come nei casi precedenti.
Il risultato da ottenere è riportato nella figura seguente: a sinistra il disegno minimo a destra il parallelogramma di base. Espandere la tassellazione:

[7] Si osservi che, trascurando l'effetto di "sovrapposizione" dei nastri, il disegno minimo ammette un asse di simmetria coincidente con una delle diagonali del quadrato minimo. Con questa "semplificazione", la tassellazione apparterebbe al gruppo "p4m" e ammetterebbe, come disegno minimo, uno dei due triangoli rettangoli-isosceli individuati dalla diagonale prima citata.

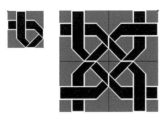

Esempio 8: tassellazione "p4m".

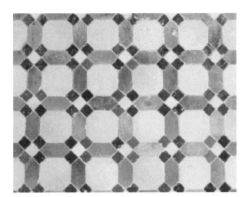

◄ **Figura 11** Decoro dell'Alhambra con simmetria "p4m"

Nella foto, una tassellazione dell'Alhambra con simmetria "p4m".

Nella figura in basso, l'immagine è riprodotta al computer. Si evidenziano (in grigio) gli assi di simmetria che rivelano il disegno minimo (triangolo rettangolo-isoscele); a partire da esso è semplice generare la tassellazione ove si osservi che il parallelogramma minimo è uno qualsiasi dei quadrati costituiti da otto triangoli minimi.

LABORATORIO: Utilizzando GeoGebra riprodurre la tassellazione.

La realizzazione del disegno minimo si lascia come esercizio.

6. Tassellazioni "alla Escher" con GeoGebra

L'artista olandese Maurits Cornelis Escher, proprio dopo aver visitato la for-
tezza dell'Alhambra, si chiese se fosse possibile rivestire il piano ricoprendolo,
piuttosto che con figure geometriche astratte, con forme più familiari come
pesci, uccelli, insetti, cavalli, ecc.

Affermava, in occasione di una conferenza sulla *regolare suddivisione dei
piani*:

> È comprensibile che queste forme, ritmicamente ripetute, possano, volendo,
> essere rese più complesse, fino a evocare qualcosa di riconoscibile, per esem-
> pio la silhouette di un animale.
> Questa ricerca di nuove possibilità, questa scoperta di nuove tessere di un puzz-
> le, che in primo luogo sorprende e stupisce il disegnatore stesso, è un gioco che
> nel corso degli anni non ha mai smesso di affascinarmi e incantarmi.[8]

La risposta alla domanda iniziale si ritrova nella sua opera.

Nelle pagine seguenti vengono descritte le proprietà geometriche delle
silhouettes concepite dall'artista. Le opere originali collegate sono visiona-
bili, per esempio, visitando il sito ufficiale della Fondazione Escher all'indi-
rizzo *www.mcescher.com*.

Con l'impiego del software di geometria dinamica, abbiamo realizzato
alcune tassellazioni, imitando i disegni di Escher.

Le caratteristiche del programma ci hanno consentito di realizzare ogni
tipo di tassellazione a partire dal disegno minimo e, forse grazie alla fantasia
e al genio di Escher, di produrre cose belle e intelligenti nello stesso tempo.

[8] M.C. Escher, *Stedelijk Museum*, 15 Febbraio 1956.

Esempio 1: Pegaso.

La silhouette di "Pegaso" è basata su una tassellazione regolare a base quadrata" con simmetria "p1".

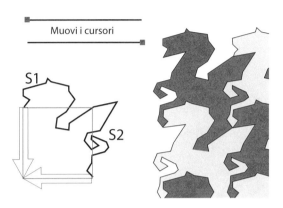

In figura, è mostrata la silhouette incompleta che "insiste" su due lati consecutivi del quadrato di base. Una porzione di silhouette, <S1> (testa), insiste sul lato orizzontale del quadrato. La parte residua, <S2> (coda), sul lato verticale. Le figure giallo/rosse combaciano in modo tale che la testa si incastri col ventre e la coda con le zampe anteriori. Per garantire l'incastro, quindi, Escher completa la sagoma traslando <S1> sul lato inferiore del quadrato e <S2> sul suo lato sinistro.

LABORATORIO: Utilizzando GeoGebra, riprodurre la tassellazione.

Nel file *Capitolo III/Esercitazioni/Escher/x_pegaso.ggb* del CD allegato al libro, è assegnata parzialmente la silhouette di Pegaso: completarla e avviare la tassellazione.

Procedura:

1. Tracciare <*vett*(CA)> e <*vett*(AB)>.
2. Traslare ogni segmento della spezzata <A...C> secondo il <*vett*(AB)>.
3. Idem: spezzata <C...D> secondo <*vett*(CA)>.
4. Costruire il poligono chiuso <A...B...D...C...A> (che richiama la forma di "Pegaso" e che, per comodità, è già costruito in: *Capitolo III/Esercitazioni/Escher/x_pegaso1.ggb*).

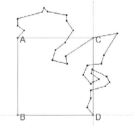

5. Traslare il poligono secondo i due vettori assegnati fino a ricoprire una certa porzione del piano di lavoro.
6. Verificare il corretto incastro testa/ventre e coda/zampa.
7. Colorare le sagome usando il numero minimo di colori necessari a far sì che due sagome confinanti siano sempre di colore diverso (colorare a "scacchiera").

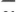
Esempio 2: Cavalieri.

La tassellazione dei "Cavalieri" appartiene al gruppo "pg".

<Cavaliere2>

La struttura è basata su un quadrilatero <BHCK> simmetrico rispetto a un asse orizzontale <BC> e appartiene al gruppo "pg".

Fissiamo l'attenzione sul cavaliere bianco a sinistra.

È assegnata la parte superiore della sua sagoma <S1>, <S4>.

Dobbiamo determinarne, tramite le isometrie note, la parte inferiore <S3>, <S6>.

1. Otteniamo prima <S2> per simmetria di <S1> rispetto a un asse verticale arbitrario.
2. <S3> è ottenuta per traslazione di <S2> secondo il *vett*(H'B)[9].
3. Analogamente: <S4> si ribalta in <S5> che trasla in <S6> secondo il *vett*(H'C) (anche la trasformazione composta <S4>/<S6>, con le avvertenze della nota 9, è riconducibile a una glissosimmetria).

Dopo aver costruito il cavaliere "tratteggiato" (a destra), la tassellazione si avvia, traslandolo secondo il *vett*(H'C), e si completa, traslando i due cavalieri diretti a destra (bianchi) e a sinistra (colorati), orizzontalmente secondo ±*vett*(CB) e verticalmente secondo ±*vett*(HK).

[9] La trasformazione che lega <S1> con <S3> diviene una "simmetria di scorrimento" nel caso in cui l'asse di simmetria (scelto prima arbitrariamente) passi per il punto medio del segmento <BH>: in tal caso, infatti, il *vett*(H'B) ha direzione parallela all'asse.

LABORATORIO: Utilizzando GeoGebra si riproduce la tassellazione.

Nel CD allegato al libro, nel file *Capitolo III/Esercitazioni/Escher/ x_cavalieri.ggb*, è assegnata parzialmente la silhouette di un "Cavaliere": completarne la sagoma. Avviare quindi la tassellazione: si consiglia di usare il file *Capitolo III/Esercitazioni/Escher/x_cavalieri1.ggb*, che fornisce la silhouette completa di un cavaliere come un unico oggetto poligonale.

Di seguito, in maniera dettagliata, si indica la procedura per completare il lavoro.

1. Completamento della silhouette:
 - simmetrico del triangolo <BHC> rispetto alla retta <BC>;
 - noto <K>, tracciare quadrilatero <BHCK>;
 - disegna una retta verticale arbitraria <r> (perpendicolare a <BC>);
 - simmetria assiale rispetto a <r> della porzione di silhouette <B...H...C> e del quadrilatero <BHCK>. **Risultato**: Poligono <B'...H'...C'> e quadrilatero <B'H'C'K'>;
 - traccia: <*vett*(H'B)>,<*vett*(H'C)>;
 - trasla i Poligoni <B'...H'...C'> due volte secondo i vettori costruiti precedentemente;
 - disegnare il Cavaliere1 come poligono (per comodità, la sagoma è pronta nel file *Capitolo III/Esercitazioni/Escher/x_cavalieri1.ggb*).
2. Disegna Cavaliere2:
 - simmetria assiale del <Cavaliere1> rispetto a <r>;
3. Incastra <cavaliere2>:
 - trasla <cavaliere2> secondo *vett*(H'C).
4. Tassella il piano:
 - crea il *vett*(CB);
 - crea *vett*(HK);
 - trasla l'ultimo cavaliere creato, verticalmente secondo *vett*(HK) e orizzontalmente secondo il *vett*(BC). e ripeti un numero arbitrario di volte.
5. Colora le sagome usando il numero minimo di colori necessari a far sì che due sagome confinanti siano sempre di colore diverso (colorare con la stessa tinta i cavalieri rivolti nella stessa direzione).

Esempio 3: Rettili.

La tassellazione "Rettili" di Escher si basa su una tassellazione a esagoni regolari e appartiene al gruppo "p3".

Il rettile bianco centrale <R1> insiste sull'esagono <ABCDEF>.

Guardiamo i rettili colorati che hanno in comune con <R1> il punto <A>: quello giallo è generato da una rotazione di <R1>: +120°

(antioraria), centro in <A>; analogamente quello verde: –120° (oraria), centro in <A>.

Discorso analogo può ripetersi per le due coppie di rettili che hanno in comune con <R1> i vertici <C> e <E>[10].

La tassellazione, avviata dal nucleo centrale colorato, figura in alto, si completa traslando le sagome dei rettili secondo i vettori: ±*vett*(AA'), ±*vett*(AA"), ±*vett*(A'A"), dove <A"> e <A'> sono ottenuti per rotazione di <A>: ±120° , centro <C>.

LABORATORIO: Utilizzando GeoGebra si riproduce la tassellazione.

Nel CD allegato al libro *Capitolo III/Esercitazioni/Escher/x_rettili.ggb*, è assegnata parzialmente la silhouette di "Rettili". Completare la sagoma e avviare la tassellazione del piano.
Diamo di seguito nei dettagli la procedura che abbiamo usato.
1. Completamento della silhouette:
 • Completamento porzione AB:
 • ruota i singoli segmenti della porzione <AF> di +120° (rotazione antioraria), centro <A>;
 • Completamento porzione <CD>:
 • ruota i singoli segmenti della porzione <BC> di +120°, centro <C>;
 • Completamento porzione <ED>:
 • ruota i singoli segmenti della porzione <EF> di –120° (rotazione oraria), centro <E>;
 • Crea poligono <R1> passante per tutti i punti della spezzata chiusa appena generata.
2. Avvio della tassellazione:
 • ruota poligono <R1>: centro <A>, +120°;
 • come sopra: –120°;
 • come ai precedenti punti 2.1 e 2.2, centro <C>;
 • come sopra centro <E>.
3. Creazione di un secondo "livello" di rettili:
 • individua i punti <A"> e <A'> (ruota <A>, ±120°, centro <C>);
 • crea *vett*(AA'), *vett*(A'A), *vett*(AA"), *vett*(A"A), *vett*(A'A"), *vett*(A"A');
 • trasla <R1>, per sei volte, utilizzando tutti i vettori appena definiti.
4. Colora le sagome usando il numero minimo di colori necessari a far sì che due sagome confinanti siano sempre di colore diverso (colorare con la stessa tinta i rettili rivolti nella stessa direzione): 3 colori necessari.

[10] Per garantire l'incastro, Escher definisce "arbitrariamente"solo le porzioni di sagoma che insistono sui lati: <AB>,<CD>,<EF>. L'arbitrarietà è limitata soltanto dalla necessità di ottenere una figura riconoscibile, una volta completata la sagoma. Le porzioni residue, che insistono sui lati <AF>,<CB>,<ED>, sono ottenute ordinatamente dalle prime per rotazione di –120° intorno ai vertici <A>,<C>,<E>.

Esempio 4: Farfalle.

La tassellazione "Farfalle" di Escher è strutturata sulla base di una tassellazione regolare per triangoli equilateri e ha simmetria "p6".

Nella figura è evidenziato un "modulo triangolare" <ABC>.

Ogni modulo è costituito da tre farfalle indicate, nel disegno, con <1>,<2>,<3>.

La sagoma di una farfalla è individuata sulla base:
1. della porzione di silhouette che insiste sul lato <AC>: spezzata <S1>, rossa in figura;
2. di una linea "arbitraria" che unisce <C1>, baricentro di <ABC>, con un punto "arbitrario" (v. nota 8) di <S1>: spezzata <S2>, rossa in figura.

Proprietà di <S1>: la linea <S1> definisce parte del contorno delle farfalle 1-1' e 3-3'. Tali coppie, evidentemente, sono legate da una simmetria centrale di centro <K> (con <K> = punto medio del lato <AC> del triangolo). <S1> pertanto non può essere una linea arbitraria ma, per garantire la tassellazione, deve risultare simmetrica rispetto al punto <K>.

La sagoma di una farfalla (anzi di un intero modulo) si completa ruotando il sistema di linee <<S1>,<S2>> di ±120° con centro <C1>.

Completata la costruzione di un modulo, si prosegue la tassellazione per rotazioni successive di <1>,<2>,<3> di 60°, con centro <C>.

LABORATORIO: Utilizzando GeoGebra si riproduce la tassellazione.

Nel CD allegato al libro *Capitolo III/Esercitazioni/Escher/x_farfalle.ggb*, è assegnato il triangolo <ABC> e il sistema di spezzate <<S1>,<S2>>. Tassellare il piano.
Diamo di seguito, nei dettagli, la procedura che abbiamo usato per completare il disegno:

1. Costruzione di una sagoma:
 * ruotare ciascun segmento che costituisce il sistema di spezzate <<S1><S2>> di –120° , centro <C1>;
 * poligono sui vertici della farfalla <3> ormai completa.
2. Costruzione del modulo <1>,<2>,<3>
 * farfalla <1>: Ruotare farfalla <3>: +120° , centro <C1>;
 * farfalla <2>: Ruotare farfalla <3>: –120° , centro <C1>.
3. Costruzione del modulo <1'>,<2'>,<3'>
 * ruotare <1>,<2>,<3>: +60°, centro <C> oppure simmetria centrale di <1>,<2>,<3> con centro <K>. (<K> punto medio di <AC>);
 * ripetere l'operazione precedente, operando sull'ultimo "modulo" costruito (fino a completare l'angolo giro di vertice <C>).
4. Colora le farfalle usando il numero minimo di colori necessari a far sì che due sagome confinanti siano sempre di colore diverso.

7. Ulteriori proposte di lavoro

Concludiamo questo capitolo suggerendo alcune ulteriori proposte di lavoro che possono essere sviluppate con gli allievi, in laboratorio d'informatica, a partire da alcuni files GeoGebra che contengono gli elementi iniziali per costruire la tassellazione assegnata.

I fogli GeoGebra consentono di svolgere con facilità le esercitazioni proposte e si trovano nel CD allegato al libro *Capitolo III/ Esercitazioni/Escher/*.

Le tassellazioni proposte possono essere ricostruite subito in laboratorio a partire dal disegno minimo (che è dato), ma i colleghi, se lo ritengono opportuno, possono far precedere questo lavoro dalla visione delle animazioni della cartella *Capitolo III/Animazioni/Escher/*: tali animazioni non sono altro che files GeoGebra movimentabili con i "cursori" e mostrano la costruzione in tutte le sue fasi di sviluppo: dal disegno minimo al disegno finale.

Tassellazione di tipo *p4*
Nel CD *Capitolo III/Esercitazioni/Escher/x_rettiles.ggb*.

Tassellazione di tipo *pg*
Nel CD *Capitolo III/Esercitazioni/Escher/x_cigni.ggb*.

Tassellazione di tipo *pm*
Nel CD *Capitolo III/Esercitazioni/Escher/x_scarabei.ggb*.

Tassellazione di tipo *p4g*
Nel CD *Capitolo III/Esercitazioni/Escher/x_angeli e demoni.ggb*.

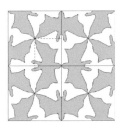

Tassellazione di tipo *p1*
Nel CD *Capitolo III/Esercitazioni/Escher/x_pesci e colombe.ggb*.

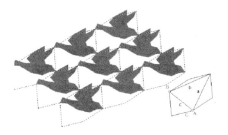

Tassellazione di tipo _p4_
Nel CD _Capitolo III/Esercitazioni/Escher/x_pesci4.ggb._

Tassellazione di tipo _p31m_
Nel CD _Capitolo III/Esercitazioni/Escher/x_pesci2.ggb._

Bibliografia

Weyl, H. (1962) _La simmetria_, Feltrinelli Milano.
Dedò, M. (2000) _Forme simmetria topologia_, Zanichelli, Bologna.
Schattschneider, D. (1992) _Visioni della simmetria – I disegni periodici di M.C. Escher_, Zanichelli, Bologna. Testo utile per uno studio non specialistico dei gruppi di simmetria e per l'esame dell'opera matematica di Escher.
Tedeschini Lalli, L. (2009) _Trasformazioni, simmetrie e tassellazioni del piano_: disponibile su
http://www.mat.uniroma3.it/users/magrone/didattica/architettura/magistrale/simmetrie-e-tass.pdf
Akleman, E., Chen, J., Meric, B. (2000) _Intuitive and Effective Design of Periodic Symmetric Tiles_, ACM Multimedia: disponibile su
http://www.viz.tamu.edu/faculty/ergun/research/architecture/papers/acadia00.pdf

▶

Grünbaum, B. (2006) What Symmetry Groups Are Present in the Alhambra?, *Notices of the AMS* 53, n. 6: disponibile su *http://www.math.boun.edu.tr/instructors/ozturk/eskiders/bahar08m1 62/comm-grunbaum.pdf*

AA.VV. (1948) *Le Magiche visioni di M.C. Escher*, Taschen, Köln (splendido libro d'arte ricco di citazioni e riproduzioni dell'opera di Escher, ma privo di ogni riferimento matematico).

Per "giocare" con i 17 gruppi di simmetria (e anche con i fregi), si consiglia il piccolo programma freeware "Kali", scaricabile gratuitamente da: *http://www.geometrygames.org/Kali/*

Il software freeware GeoGebra è reperibile: *www.geogebra.org*

Capitolo 4
Dalla geometria della visione alla trasformazione prospettica

di *Laura Catastini*

1. Introduzione e contesto didattico

Il metodo assiomatico deduttivo, che è alla base del metodo d'indagine scientifica moderno, trae la sua origine e la sua più chiara esemplificazione nella matematica ellenistica, da Euclide ad Archimede. L'educazione al metodo dimostrativo e a una logica rigorosa si può proporre in modo appassionante anche attraverso la lettura e lo studio di opere che nel corso dei secoli hanno affrontato temi legati alla prospettiva, in particolare l'*Ottica* di Euclide (III secolo a.C.), il *De Pictura* di Leon Battista Alberti (inizio Quattrocento), il *De Prospectiva Pingendi* di Piero della Francesca (fine Quattrocento). Il confronto tra metodo scientifico e creazione artistica si pone infatti in modo naturale nel campo delle arti visive, allargando la valenza del pensiero matematico.

La geometria della visione diretta, quale per esempio si trova trattata nell'*Ottica* di Euclide, permette di matematizzare un aspetto importante della realtà offrendo spunti di vario genere per una didattica nuova a vari livelli: dai licei artistici e classici alle accademie e alle università. In questi ultimi anni abbiamo effettuato varie sperimentazioni in cui la storia dell'arte, soprattutto della pittura rinascimentale, si lega intrinsecamente alla geometria e alla filosofia. In questo lavoro l'essere di un oggetto e il suo apparire in rapporto alla posizione dell'osservatore si pongono in termini rigorosamente geometrici, e con pochissimi prerequisiti di geometria euclidea è possibile sviluppare teoremi di grande interesse per le loro applicazioni al disegno prospettico. Anche dal punto di vista cognitivo l'argomento presenta particolare interesse poiché vi si realizza un fecondo rapporto tra astratto e concreto[1], tra pensiero analitico-verbale e pensiero sintetico-immaginativo, rapporto di fondamentale importanza per la formazione di un pensiero scientifico produttivo. In particolare permette di rendere intuitivi e quasi "necessari" i passaggi fondamentali dalla geometria euclidea a quella proiettiva.

"L'entendement s'y perd" diceva giustamente Desargues [2] nel *Brouillon* introducendo i suoi assiomi proiettivi e postulando che ogni fascio di rette avesse un *but* comune, intendendo con esso un destino comune che oggi chiamiamo punto d'intersezione, al finito o all'infinito. Il suo termine *but* rendeva conto di un elemento estraneo agli enti euclidei[2], che non era astra-

[1] Si veda Catastini [1].
[2] Vedi Catastini [3].

zione di un oggetto concreto ma di un'astrazione anch'essa, la direzione, ed è stato successivamente sostituito dai matematici, nel caso di rette parallele, con il termine "punto all'infinito", contribuendo a rendere tutta la questione ancor più difficile e anti-intuitiva per menti che si stanno formando alla matematica. "Rette parallele hanno un punto comune, all'infinito" così recitano gli studenti, rinunciando a capire il mistero e tenendo alla fine per sé la sensazione di arbitrarietà della questione. Buon avviamento all'educazione formale, certo, ma, come scriveva De Finetti:

> A differenza di quella che è forse l'opinione più comune, l'astrazione (almeno in campi come quello matematico) non significa distacco dai problemi concreti e dagli scopi pratici, ma è proprio il mezzo necessario per trattare i problemi concreti nel modo più pratico, che consiste nel depurarli dagli accessori che turbano la visuale e nel riconoscere l'identità logica di problemi apparentemente diversi per appartenere magari a campi disparati. Anziché significare distacco dal concreto e ridursi a vana costruzione nel vuoto, l'astrazione costituisce pertanto l'essenza del concreto e lo strumento pratico più appropriato per dominarlo. [4]

Recentemente una serie di risultati convergenti in psicologia e neurobiologia hanno indicato un ruolo importante delle rappresentazioni percettivo-motorie, in particolare di quelle anticipatorie, in molte funzioni cognitive, riconoscendo alla mente l'uso di rappresentazioni interne. Sulle rappresentazioni anticipatorie, cioè sulla capacità del sistema percettivo-motorio di anticipare le conseguenze sensoriali delle proprie azioni, si fondano capacità cognitive più complesse, come per esempio quella di immaginare ciò che non è mai stato esperito (e in alcuni casi non può esserlo), pur restando ancorata (*grounded*) alla realtà concreta. In questo senso negli ultimi anni sono stati presentati, in accordo con studi sperimentali quali quelli dei "neuroni specchio" [5], modelli teorici di rappresentazioni interne come "simulazioni" [6] o "emulazioni" [7] o saggi sul senso del movimento [8]. Il pensiero rappresentativo così generato è capace di concepire in modo endogeno ciò che non è immediatamente percepibile, o ancora di ricostruire ambienti percettivi memorizzati, come nel caso della *visual imagery* [9].

In questo senso è molto utile, nell'insegnamento dell'*Ottica* di Euclide, uno strumento, il *prospettimetro*, da noi ideato e sperimentato, che permette la riproduzione di configurazioni geometriche legate alla visione diretta e ai "raggi visivi", altrimenti impossibili da osservare concretamente.

In questo breve lavoro illustreremo l'uso della teoria euclidea e di questo strumento in vista della costruzione intuitiva del "piano proiettivo reale" con i suoi punti all'infinito, dando particolare rilievo agli aspetti cognitivi coinvolti e alle considerazioni didattiche e metodologiche. Questa proposta è stata positivamente sperimentata con studenti della penultima e ultima classe di liceo classico, con modalità laboratoriale, nell'ambito del Progetto Nazionale Lauree Scientifiche 2005/06 e 2006/07.

Ecco di seguito una breve sintesi degli obiettivi, delle strategie didattiche proposte e degli strumenti utilizzati.

Obiettivi disciplinari e formativi

In generale, lo scopo del laboratorio è quello di costruire, insieme agli studenti, una teoria assiomatico-deduttiva che possa descrivere la visione degli oggetti spaziali e la loro rappresentazione su un supporto materiale: parete, computer, quadro, scenografia ecc. Il modello dovrà render conto in particolare di come la visione modifichi la geometria degli oggetti osservati chiarendo in modo preciso il rapporto tra l'*essere* di un oggetto geometrico e il suo *apparire* in funzione del dato punto di vista.

In particolare, si vuole:

· Rendere chiaro, nella storia del pensiero umano, lo stretto rapporto della matematica con le altre forme di cultura, inserendo le teorie matematiche in un contesto storico ed evidenziando le loro interazioni con altre discipline (filologia classica, filosofia, storia dell'arte).
· Illustrare in profondità il metodo assiomatico-deduttivo alla base del pensiero scientifico costruendo, in condivisione con gli studenti, un modello geometrico della visione.
· Applicare conoscenze matematiche di base (geometria elementare, algebra letterale, geometria analitica) in contesti concreti e inusuali per abituare alla flessibilità nell'uso di tali strumenti.
· Sviluppare l'intuizione spaziale e i primi elementi di geometria dello spazio.
· Approfondire i legami tra la pittura e la geometria da un punto di vista storico-culturale e da un punto di vista matematico.
· Portare a una comprensione concreta ma non ambigua del concetto di trasformazione geometrica e in particolare della corrispondenza puntuale definita da tali trasformazioni che, tra l'altro, motivi concettualmente e renda spontanea la necessità non banale di estendere il piano euclideo aggiungendovi i punti all'infinito.
· Collegare i primi concetti di geometria proiettiva (punti all'infinito e rette all'infinito) alla rappresentazione prospettica euclidea e rinascimentale.
· Compiere l'analisi geometrica di alcuni quadri del XIV e XV secolo e del loro impianto prospettico.

Strategie didattiche per gli obiettivi disciplinari e formativi

Le varie simulazioni delle situazioni matematiche effettuate con l'uso di software di geometria dinamica o di strumenti reali che permettono di "girare intorno" agli oggetti geometrici e di manipolarli nei loro movimenti nello spazio, l'abbondanza e la varietà di stimoli al pensiero percettivomotorio che accompagna l'attività, il tipo di esercizi proposti e i frequenti

momenti di descrizione verbale di situazioni spaziali, permette la formazione di modelli visivi rigorosi e complessi, isomorfi alla complessità e al rigore della teoria formale che devono affiancare e per questo capaci di creare un'utile sinergia tra i processi di pensiero sintetico-immaginativi e quelli analitico-verbali.

Queste attività sono continuamente proposte in ogni lezione e mirano alla costruzione, nel pensiero dello studente, di uno stile cognitivo "integrato", stile che senza un addestramento adeguato non è affatto facile da instaurare nelle attività di tipo formale quali quelle matematiche. Gli strumenti utilizzati sono quindi parte importante e irrinunciabile della strategia didattica e sono usati attivamente dagli studenti per fare congetture, per visualizzare le ipotesi e la tesi dei teoremi, per costruire definizioni e per risolvere problemi.

Il lavoro sperimentale viene fatto collettivamente e le osservazioni o le proposte individuali vengono commentate, discusse e, nel caso, messe in pratica per esplorare la loro validità.

La consapevolezza della dimensione storica del pensiero matematico si ricerca attraverso la collaborazione degli insegnanti di filosofia, di lingue classiche e di storia dell'arte. In particolare sono stati effettuati interventi sulla scienza ellenistica e sulle teorie della visione da Empedocle a Euclide, la lettura di alcuni passi del testo greco dell'*Ottica* e la comparazione dei termini usati con altri testi classici quali i testi omerici o testi più tardi, la lettura di parti del *De Pictura* di Alberti riguardanti la composizione nel dipingere, la rappresentazione dei movimenti dell'anima e del corpo, i movimenti delle cose non animate. Gli esercizi sono svolti in modo formativo, non sempre la risoluzione è chiusa. A volte la discussione si ferma su considerazioni intuitive, senza formalizzarle o senza avere esplorato tutte le possibilità. Questo succede in modo dichiarato.

Strumenti utilizzati

- *Animazioni*: animazioni con Cabri II Plus.
- *Tavole*: fogli (formato A4, A3 o da disegno) che contengono degli esercizi grafici da risolvere durante la lezione intervenendo sulla figura riportata sulla tavola.
- *Tavola delle tangenti*: è una tavola cartacea dove è riportata la tangente di un angolo espresso in gradi e primi da 0° 0' a 89° 80' ogni 20 primi.
- *Prospettimetro*: è uno strumento concepito appositamente per il laboratorio, in legno e plexiglas smontabile che contiene tre piani ortogonali tra loro (il piano di terra, il piano dell'orizzonte e il piano di profondità), l'occhio dove sono legati dei fili che simulano i raggi visivi e un regolo angolare in plexiglas che permette di fare proiezioni ortogonali e alzate.
- *Strumenti classici da disegno*: riga, squadra, compasso.
- *Computer collegato con un proiettore*

- *CD allegato al Manuale:* Catastini L., Ghione F., (2004) *Le geometrie della visione*, Springer, Milano.

Nel CD allegato al libro sono disponibili i testi di tutte le lezioni svolte (*Capitolo IV/LEZIONE*), le tavole di lavoro (*Capitolo IV/LEZIONE/TA-VOLE*) e le animazioni (*Capitolo IV/LEZIONE/ANIMAZIONI*) da presentare agli studenti. Ciascuna lezione contiene specifici obiettivi disciplinari e formativi.

2. L'*Ottica* di Euclide: angoli e raggi visivi

La nozione chiave su cui poggia il modello geometrico dell'opera di Euclide è quella di angolo visivo[3], l'angolo formato dai due raggi visivi passanti per gli estremi del segmento considerato. L'opera è trattata quasi esclusivamente sulla base di questa nozione, che la caratterizza fortemente come geometria della "visione diretta". L'angolo visivo permette apprezzamenti qualitativi sull'apparire delle grandezze in funzione della posizione dell'occhio,
 Tra le premesse iniziali dell'*Ottica* di Euclide, troviamo:

Premessa 4
Le cose viste sotto angoli più grandi appaiono più grandi, quelle viste sotto angoli più piccoli più piccole, uguali quelle viste sotto angoli uguali.

La geometrizzazione dell'atto visivo, cioè, porta a definire la dimensione apparente di un oggetto come funzione dell'angolo visivo che lo sottende. La determinazione della sua posizione apparente utilizza invece la nozione di raggio visivo, secondo le successive premesse.

Premesse 5-6
Le cose viste sotto raggi più alti appaiono più in alto, quelle viste sotto raggi più bassi più in basso, più a destra quelle viste con raggi più a destra, più a sinistra quelle viste sotto raggi più a sinistra.

Queste premesse sono fondamentali per la concezione dell'aspetto prospettico di una scena e usate nella dimostrazione dei teoremi prospettici dell'*Ottica*, il teorema 6 e quelli dal 10 al 14. La *Stanza della maschere*, scoperta al Palatino a Roma nel 1961 e datata intorno al 50 a.C., presenta un unico punto di fuga centrale al quale convergono più di 200 linee, oltre a una perfetta degradazione delle tre colonnine del teatro[4].

[3] Uno studio approfondito su questo tema si trova in Catastini, Ghione [10].
[4] Si veda Carlevaris [11].

◀ **Figura 1** Affresco nella *Stanza delle maschere* al Palatino a Roma (50 a.C. ca)

3. Segmenti paralleli e difficoltà cognitive

Una delle regole base della prospettiva è che segmenti paralleli (due o più segmenti) vengono visti convergere verso uno stesso punto infinitamente lontano, il quale però, sul quadro, dove la profondità è schiacciata nelle due dimensioni, si rappresenta con un punto "al finito". Questa proprietà della geometria della visione darà origine, nel modello matematico formale, ai punti all'infinito, nei quali s'incontrano le rette tra loro parallele. Nel caso particolare in cui le linee parallele siano ortogonali al quadro (linee dette anche "di profondità") esse si vedono convergere verso un punto che sul quadro è rappresentato dalla proiezione ortogonale dell'occhio - punto noto col nome di "punto di fuga principale" - chiamato punto "centrico" da Alberti. Nell'*Ottica* di Euclide la visione di segmenti o rette parallele viene affrontata nel seguente teorema:

Teorema 6
Segmenti paralleli visti da lontano appaiono non paralleli.

La dimostrazione dell'apparente convergenza di segmenti paralleli presente nel teorema 6 è molto importante perché il procedimento seguito permette di ritrovare le prime tracce di quello che poi sarà chiamato punto di fuga. Qui l'i-

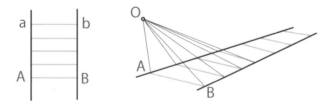

▲ **Figura 2** La misura degli angoli visivi che sottendono i segmenti di distanza, da un certo punto in poi tende a zero

dea di parallelismo è legata, come nell'intuizione e come nel Rinascimento, all'idea di equidistanza: una retta parallela a una retta *r* è descritta da un punto P che si muove mantenendosi equidistante da *r*. Euclide dimostra che due rette parallele si vedono convergere perché l'angolo visivo che sottende un generico segmento di distanza[5] AB, da un certo punto in poi, con l'allontanarsi all'infinito del segmento, tende a zero (Fig. 2).

Questo contesto in qualche modo rafforza il concetto intuitivo di limite, indispensabile per il proseguimento della trattazione, ma contemporaneamente crea una forte rappresentazione spaziale che contrasta il formarsi di una giusta immaginazione della distribuzione dei raggi visivi, distribuzione che è alla base della proiezione prospettica. L'apparente convergenza delle rette parallele che deriva dal diminuire della grandezza apparente dei segmenti di distanza è abbastanza facile da concepire, ma proprio la focalizzazione del pensiero su tali segmenti rende difficile immaginare il reale movimento compiuto dai raggi visivi che corrono sulle rette stesse.

◀ **Figura 3** Miniatura di un'edizione manoscritta dell'*Ottica* di Euclide (1458) dove si vedono i lati della strada convergere e salire verso l'alto

La difficoltà consiste nel fatto che i raggi visivi che partono dall'occhio corrono effettivamente lungo i segmenti paralleli, sul piano di terra, e colgono gli estremi dei segmenti di distanza, di lunghezza costante nella realtà. L'essere fissati a punti del piano di terra separati da una lunghezza fissa non si concilia, nell'immaginazione, con il loro effettivo tendere a un unico raggio visivo, parallelo alle rette, che si trova sopra di esse (Fig. 4 a pagina seguente).

Separati inesorabilmente, per quanto lontano si vada, come possono tali raggi sovrapporsi, se pur al limite, a un raggio comune che non coglie nessun punto del piano di terra? I segmenti di distanza costituiscono così un grave ostacolo epistemologico.

[5] Chiamiamo così un segmento perpendicolare alle rette, con gli estremi su di esse.

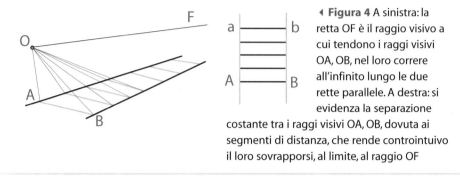

◀ **Figura 4** A sinistra: la retta OF è il raggio visivo a cui tendono i raggi visivi OA, OB, nel loro correre all'infinito lungo le due rette parallele. A destra: si evidenzia la separazione costante tra i raggi visivi OA, OB, dovuta ai segmenti di distanza, che rende controintuitivo il loro sovrapporsi, al limite, al raggio OF

In questo caso la simulazione della situazione effettuata mediante il prospettimetro, strumento studiato appositamente, ha raggiunto lo scopo di offrire agli studenti percezioni concrete della situazione con le quali costruire immagini dinamicamente produttive e capaci di guidare il pensiero nella formulazione di risposte riguardanti il comportamento dei raggi visivi all'infinito e della loro corrispondenza con i punti delle rette.

4. Il prospettimetro

Il prospettimetro è uno strumento di legno e plexiglas, formato da tre piani: uno fisso in legno (piano di terra su cui possono essere disposti dei fogli per scrittura) e due in plexiglas rimovibili: il piano dell'orizzonte parallelo al piano di terra e il piano di profondità a essi perpendicolare. Un chiodo al quale sono fissati dei fili colorati simula il punto di vista e i fili i raggi visivi.

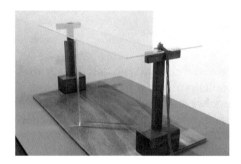

◀ **Figura 5** Prospettimetro e supporto verticale

Lo strumento è corredato da un supporto verticale in plexiglas formato da due rettangoli alti e stretti uniti lungo il lato maggiore a formare un angolo retto, in modo da fornire un appoggio cui, all'occorrenza, fissare i fili che colgono punti dello spazio che non stanno sul piano di terra o sul piano dell'orizzonte. Il supporto verticale è rimovibile e posizionabile a piacere.

Una scheda tecnica di questo strumento si trova nel CD allegato al libro: *Capitolo IV/Prospettimetro.pdf*.

Il nome "prospettimetro" deriva dalla possibilità di effettuare misurazioni nell'ambito della *perspectiva naturalis*, come veniva chiamata la visione diretta fino al Quattrocento, epoca nella quale viene messa a punto la *perspectiva lineare*, tecnica di rappresentazione pittorica il cui strumento principe sarà il prospettografo.

Il piano di profondità, in questo primo prototipo, si ferma sotto il piano dell'orizzonte per semplificare la costruzione dello strumento, ma non impedisce un'agevole attività di laboratorio per simulare anche la visione di punti che si trovano più in alto dell'occhio.

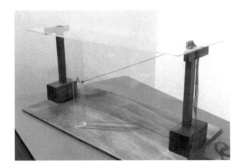

◄ **Figura 6** Prospettimetro e supporto verticale al quale è stato fissato un filo che coglie il punto A e che simula il raggio visivo uscente dall'occhio posto nella posizione del chiodo, al quale è legato il capo fisso del filo

L'uso del prospettimetro permette una simulazione dinamica nello spazio che "educa" e potenzia scientificamente il pensiero immaginativo nel senso che fornisce ricche descrizioni multisensoriali di oggetti matematici e delle tante relazioni concrete tra essi. L'educazione scientifica del pensiero immaginativo consiste nella continua verifica della corrispondenza rigorosa tra modelli e configurazioni che si costruiscono con il pensiero e le relazioni formali della teoria matematica all'interno della quale si svolge il lavoro. Spesso negli studenti la modellizzazione, che avviene in modo spontaneo e di norma non seguita dall'insegnante, si ferma a uno stadio iniziale perché contiene errori che la rendono presto inutilizzabile[6]. Si perde così un importante strumento di pensiero, prezioso perché instaura flessibilità ideativa, creatività scientifica e un'intensa partecipazione emotiva che motiva positivamente al lavoro.

5. Il prospettimetro nella simulazione dei raggi visivi

Il passaggio cognitivo-geometrico dalla visione diretta alla prospettiva si snoda dunque nel passaggio concettuale dall'angolo ai raggi visivi. Ancora nel teorema 6 dell'*Ottica* la dimostrazione si fonda sulla misura dell'angolo che sottende i segmenti di distanza tra rette parallele. Nel passaggio alla geometria

[6] Si veda Catastini [12].

proiettiva, è necessario spostare l'attenzione al raggio visivo, che diventerà il nuovo focus cognitivo. Per permettere la concreta visualizzazione e misurazione della distribuzione dei raggi viene usato il prospettimetro, sia nella costruzione di definizioni rigorose delle varie posizioni menzionate solo qualitativamente nelle premesse 5 e 6, "essere più alto, più basso, più a destra, più a sinistra", sia nella figurazione successiva dei teoremi prospettici.

Per quanto riguarda le definizioni, s'individuano nel cono visivo piani e assi di riferimento "naturali" legati all'osservatore.

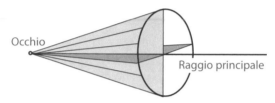

▲ **Figura 7** Cono visivo, asse del cono, coppia di piani perpendicolari contenenti il vertice e l'asse

Nello spazio vengono individuati:

- il *raggio principale*: asse del cono visivo;
- il *piano di terra*: piano orizzontale perpendicolare nel piede all'asse occhio-piede dell'osservatore;
- il *piano dell'orizzonte*: piano contenente l'occhio parallelo al piano di terra;
- il *piano di profondità*: piano contenente l'asse occhio-piede e il raggio principale, perpendicolare al piano di terra e al piano dell'orizzonte.

Definiamo rispetto al piano di profondità un verso "a destra" e di conseguenza anche un verso "a sinistra". Concordiamo di usare il verso naturale. Il piano di profondità determina quindi due semispazi, uno destro e uno sinistro. Analogamente il piano dell'orizzonte determina due semispazi uno alto e uno basso.

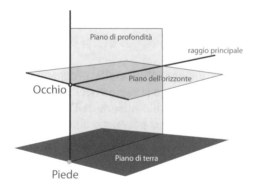

◀ **Figura 8** Piani individuati nello spazio tra cui scegliere i possibili piani di riferimento

La scelta e la messa a punto delle definizioni vengono fatte usando il prospettimetro, mediante il quale è possibile simulare la posizione dei punti nello spazio, l'incidenza dei raggi visivi sui punti osservati e la misurazione di segmenti o degli angoli che un raggio visivo, o una sua proiezione particolare, forma con altri elementi dello strumento, come per esempio il raggio principale. Si costruiscono in maniera condivisa con gli studenti le seguenti definizioni:

Definizione
"Essere più a destra o più a sinistra" di raggi visivi nello spazio (rispetto al piano di profondità): dati i raggi visivi OA e OB a destra del piano di profondità, considerate le loro proiezioni OA' e OB' sul piano dell'orizzonte, e gli angoli O'OA' e O'OB' che esse formano con il raggio principale, diremo che è più a destra il raggio visivo che forma con il raggio principale l'angolo più grande. Analogamente se i raggi si trovano a sinistra del piano di profondità.

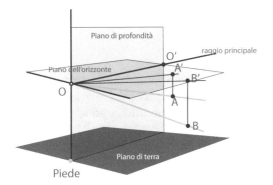

◄ **Figura 9** Come misurare l'essere più a destra o più a sinistra dei raggi visivi che colgono punti dati

Per la premessa 6 dell'*Ottica*, dati due punti A e B nel semispazio destro, colti dai raggi visivi OA e OB, si *vede* più a destra il punto il cui raggio visivo corrispondente *è* più a destra. Viceversa se i punti si trovano nel semispazio sinistro.

Nel caso dell'uso reale del prospettimetro che permette di fare le misure necessarie, proietteremo, se più comodo, sul piano di terra invece che sul piano dell'orizzonte (figura a pagina seguente) data l'uguaglianza degli angoli garantita dal parallelismo tra i due piani.

Usando solo riga graduata e squadra e volendo conoscere la misura degli angoli in questione si possono misurare i cateti degli angoli retti che si formano, costruire i rapporti giusti per determinare le tangenti degli angoli interessati e finalmente, usando una tavola delle tangenti, determinare la misura dell'angolo.

Questo procedimento certamente più complicato dell'uso di un semplice goniometro permette anche di giustificare la trigonometria come quel procedimento che fa passare dalla misura di lunghezze di segmenti a quella di angoli e viceversa.

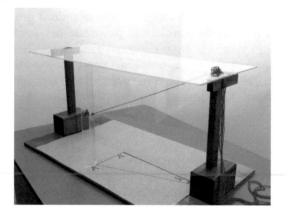

◄ **Figura 10** Procedura pratica di misura di quanti gradi si vede a sinistra il punto A

Analogamente si procede per definire cosa vuol dire "essere più in alto o più in basso" dei raggi visivi e il conseguente "apparire più in alto o più in basso" di un punto rispetto al piano dell'orizzonte. L'esperienza fatta in precedenza porta velocemente alle definizioni.

Definizione

"Essere più in alto o più in basso" di raggi visivi nello spazio (rispetto al piano dell'orizzonte): dati i raggi visivi OA e OB sopra il piano dell'orizzonte, considerate le loro proiezioni OA' e OB' sul piano di profondità, e gli angoli O'OA' e O'OB' che esse formano con il raggio principale, diremo che è più in alto il raggio la cui proiezione forma con il raggio principale l'angolo più grande. Analogamente se i raggi si trovano sotto il piano dell'orizzonte.

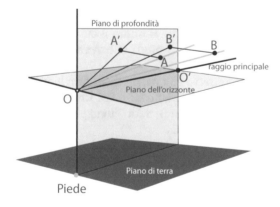

◄ **Figura 11** Come misurare l'essere più in alto o più in basso dei raggi visivi che colgono punti dati

Per la premessa 5 dell'*Ottica*, dati due punti A e B sopra il piano dell'orizzonte, colti dai raggi visivi OA e OB, si vede più in alto il punto il cui raggio visivo corrispondente è più in alto. Viceversa se i punti si trovano sotto il piano dell'orizzonte.

Osserviamo infine che è possibile definire questi angoli solo per i raggi visivi (appartenenti cioè a un cono visivo) ma non per quei raggi che si trovano sul piano passante per l'occhio perpendicolare al raggio principale che darebbero un'apertura del cono di 180°: per le rette di quel piano infatti il punto O' s'identifica con O.

L'attività prosegue con le misurazioni e le conclusioni in casi concreti presentati sul prospettimetro.

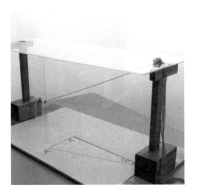 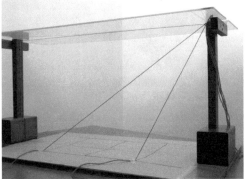

▲ **Figure 12 e 13** A sinistra: il momento iniziale del processo di misurazione di quanti gradi si vede a sinistra e in alto un punto A. A destra: il punto e il raggio sono stati rimossi per evidenziare le proiezioni ultimate, sui piani di profondità e dell'orizzonte dei raggi visivi e del punto e le misurazioni necessarie a determinare la tangente degli angoli richiesti

Tra i casi trattati si segnala che *un segmento verticale non sembra deviare né a destra né a sinistra*, infatti i suoi punti si proiettano sul piano dell'orizzonte in uno stesso punto. Lo stesso accade per un segmento orizzontale: *esso sarà visto come un segmento orizzontale senza alcuna deviazione né verso l'alto né verso il basso.*

In più, dato un singolo raggio visivo, *tutti i punti colti nello spazio dal raggio si vedono ugualmente rispetto all'alto, basso, destra o sinistra*, dato che la proiezione del raggio visivo è la medesima per ogni punto. Ciò porta all'equivalenza visiva tra i punti che appartengono a un singolo raggio visivo. Da un punto di vista geometrico, senza indizi psicologici di distanza, tutti questi punti appaiono il medesimo e non si distinguono l'uno dall'altro rispetto alla loro posizione per esempio in profondità, dando la stessa impressione visiva. Non apparendo il "più avanti" e il "più indietro", la visione geometrica diretta si può senz'altro definire una visione "piatta" dello spazio.

Quest'ultima osservazione è molto importante nel passaggio dalla visione diretta alla rappresentazione prospettica (e alla geometria proiettiva).

La posizione di un punto A nello spazio, il suo "essere", è determinata da una terna ordinata di numeri reali, le coordinate cartesiane.

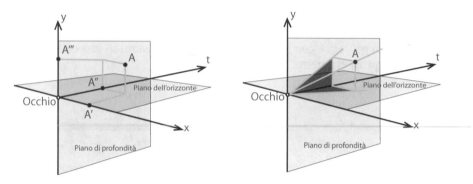

▲ **Figura 14** Coordinate cartesiane e angoli direttori

La x definisce l'essere più o meno a destra, la *y* l'essere più o meno in alto e la t l'essere più o meno in profondità. L'"apparire" di un punto A, invece, non distinguendo rispetto alla profondità, è determinato da due soli angoli che lo definiscono più o meno alto o più o meno a destra. Questa differenza si traduce analiticamente nel passaggio dalle coordinate cartesiane alle coordinate omogenee, passaggio generalmente affrontato, nei nostri corsi universitari, solo in modo formale senza alcuna giustificazione euristica o storica.

6. Le coordinate omogenee

Ora tutti i punti del raggio OP sono visti da O ugualmente e sono nella stessa misura a destra o in alto dato che si proiettano sulle medesime rette OA e OB. Non è difficile vedere come cambiano le coordinate di un punto P quando P varia sullo stesso raggio visivo. Se P' è un altro punto sullo stesso raggio visivo abbiamo

$$OP' : OP = \lambda = OA' : OA = OB' : OB = OT' : OT$$

▸ **Figura 15**

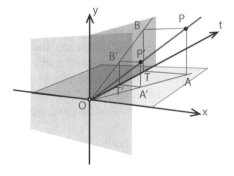

dato che i triangoli che intervengono nelle proiezioni ortogonali sono simili tra loro. In termini di coordinate abbiamo

$$x' = \lambda x \, , \, y' = \lambda y \, , \, t' = \lambda t.$$

Punti dello stesso raggio visivo hanno le coordinate proporzionali e viceversa. Le coordinate dei punti di un raggio visivo sono dunque gli elementi della classe [x,y,t], la classe cioè di tutte le terne multiple, secondo un numero λ non nullo, di x,y,t. Queste terne, che sono definite a meno di un fattore di proporzionalità, si chiamano *coordinate omogenee* del raggio che contiene (x,y,t) . Per esempio i punti dello spazio di coordinate (0,1,1) o (0,2,2) o (0,a,a) stanno tutti sul piano di profondità a diverse distanze dall'occhio, ma tutti sullo stesso raggio: quello del piano di profondità che forma un angolo di 45° con la retta t. Tale raggio ha come coordinate omogenee

$$[0,1,1] = [0,2,2] = [0,a,a].$$

7. Punti all'infinito

La considerazione dei raggi di fuga, dei punti di fuga e dei corrispondenti punti all'infinito nasce quando si cerca di far corrispondere ai raggi visivi i punti di un piano. Un piano, che non contenga l'occhio, interseca in generale un raggio visivo in un punto e in questo modo possiamo proiettare sul piano i punti che vediamo al di là, senza modificare la loro apparenza: muoviamo, per così dire, il punto P che stiamo guardando, sul suo raggio visivo OP fino a portarlo in un punto P' del piano.

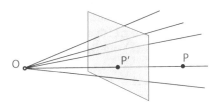

In questo modo P e P', essendo sullo stesso raggio visivo, vengono visti da O nello stesso modo. Facendo questo per ogni punto di una data figura che si estenda in profondità al di là del piano, riusciamo a schiacciare la figura sul piano in modo che sia vista da O esattamente come è vista la figura di partenza. Su questa semplice idea si basa la prospettiva greca e quella rinascimentale. Il piano sul quale avviene la rappresentazione pittorica verrà chiamato da Piero della Francesca "il termine che è intra l'ochio e la cosa veduta dove se intende ponere le cose".

La cosa interessante da capire è come si rappresenta sul quadro un punto P che si allontani dall'occhio, per esempio, lungo una retta *r*.

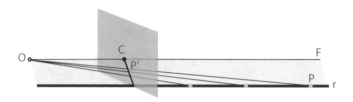

Ciò che accade è che i raggi visivi OP, man mano che P si allontana, si avvicinano sempre più al raggio OF. La retta OF è l'unica retta (per il V postulato di Euclide) che passa per O, parallela alla retta *r*. Le immagini sul piano del quadro dei punti P di *r* sono punti allineati P' che si avvicinano sempre più al punto C, il punto nel quale il raggio OF incontra il quadro. Al raggio OF, a cui tendono i raggi visivi che percorrono la retta *r*, abbiamo dato il nome di *raggio di fuga* della retta *r*, mentre il punto C a cui tendono i punti P' corrispondenti dei punti P di *r*, si chiama *punto di fuga* della retta *r*. La corrispondenza tra i punti della retta *r* e le loro immagini sul piano del quadro diventa biunivoca se aggiungiamo alla retta *r* un nuovo "punto" che pensiamo infinitamente lontano che sia il corrispondente di C. Tale punto si chiama il *punto all'infinito* della retta *r*. Ogni retta ha dunque il suo punto all'infinito. Ma la cosa molto interessante è che due rette parallele *r* e *r'* hanno lo stesso punto all'infinito dato che hanno lo stesso raggio di fuga e quindi, sul quadro, lo stesso punto di fuga cui deve corrispondere un unico punto all'infinito. Questo fatto si vede formalmente senza fatica ricorrendo alla transitività della relazione di parallelismo. Se infatti OF è il raggio di fuga di *r*, OF è la sola retta per O parallela a *r*, ma *r* è parallela a *r'* e quindi OF è anche parallela a *r'*, poiché questa parallela è unica, essa è il raggio di fuga anche di *r'*. Tutto questo, che riesce facile da capire dal punto di vista formale, è il punto concettuale più importante che lega il passaggio dalla geometria della visione alla prospettiva. Si tratta di idee molto profonde e tutt'altro che banali sostanzialmente già implicite nella trattazione euclidea, ma mal comprese fino alla rivoluzione desarguesiana.

La considerazione del punto di fuga, anche se non formalizzata, è molto antica. Scrive Lucrezio (I sec. a.C.) nel *De rerum natura*:

Un portico benché abbia profilo costante,
e appoggi completamente su uguali colonne,
se si vede da una parte finale in tutta la sua lunghezza,
poco a poco si stringe nella punta di un cono sottile
congiungendo tetto e suolo, tutto ciò che sta a destra e a sinistra,
fino a terminare nella punta oscura di un cono. [13]

In questi versi si ritrovano i teoremi 10,11,12 dell'*Ottica* di Euclide che riassunti in un solo enunciato dicono:

Teorema 10-11-12
Tra i piani che giacciono sotto l'occhio quelli più lontani appaiono più in alto, tra i piani che stanno sopra l'occhio i più lontani appaiono più in basso, tra i

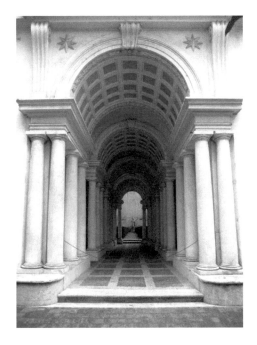

◀ **Figura 16** Portico Borromini,
Palazzo Spada, Roma.
Il portico, posto nel cortile
del Palazzo, esalta la natura illusoria
della prospettiva, creata
dal Borromini attraverso artifizi
geometrici

segmenti che si estendono longitudinalmente, quelli a destra sembrano deviare verso sinistra, quelli a sinistra verso destra.

Questi enunciati, la cui comprensione profonda è essenziale per i nostri scopi, vengono indagati col prospettimetro nel caso particolare di due segmenti sul piano di terra, paralleli al piano di profondità, che si estendono longitudinalmente all'infinito. Inizialmente vengono montati i raggi visivi su due segmenti paralleli, come nella figura seguente in modo da poter effettuare le proiezioni sui piani di terra e di profondità per misurare il loro effettivo alzarsi e deviare a destra o a sinistra con l'allontanarsi in distanza dei punti.

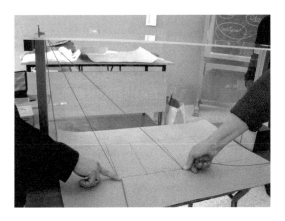

◀ **Figura 17** Momenti di
simulazione sul prospettimetro
dell'andamento di raggi visivi
che colgono rette parallele
di profondità

Terminata questa fase, si tolgono i piani in plexiglas e viene aggiunta una cornice vuota, virtuale piano di proiezione prospettica, attraverso la quale passano i raggi visivi sui quali si segnano i "punti di intersezione" col piano del quadro, ricordando l'equivalenza visiva tra tutti i punti colti da un singolo raggio. Da essa deriva che per l'impressione visiva è equivalente vedere i punti appartenenti ai segmenti paralleli o vedere i punti intersezione col piano virtuale.

In particolare si evidenzia come "punto di fuga principale" l'intersezione del raggio principale con il piano del quadro

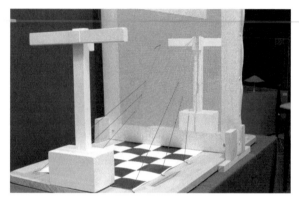

▲ **Figure 18 e 19** A sinistra la cornice che individua un virtuale piano del quadro, a destra l'individuazione delle intersezioni dei raggi visivi con il piano virtuale

Queste considerazioni, oltre che a preparare alla resa prospettica, sono opportune per avvicinare concettualmente gli studenti al tendere di una successione di elementi a un altro, concetto dinamico che è del tutto estraneo alla loro preparazione scolastica ma centrale nell'affrontare l'analisi matematica e lo studio dei punti all'infinito.

▲ **Figure 20 e 21** Le studentesse, discutendo tra loro, figurano con le mani, a sinistra, l'andamento parallelo dei segmenti, a destra, la distribuzione dei raggi visivi che li colgono, e verificano le loro verbalizzazioni con quanto vedono sul prospettimetro.

La pratica diretta porta un'illuminante consapevolezza negli studenti, che discutono tra loro, a parole ma anche a gesti, la scoperta dell'effettivo distribuirsi dei raggi visivi

Questa esperienza percettivo-motoria favorisce la produzione di dinamiche rappresentazioni mentali che supporteranno con un modello ben formato intuizioni e ragionamenti successivi. Il tendere dei raggi visivi al raggio principale e il corrispondente tendere al punto di fuga principale dei punti proiettati sul piano del quadro, rende infatti plausibile la domanda: cosa corrisponde al punto di fuga principale?

Gli studenti che hanno studiato la situazione sul prospettimetro hanno prodotto, guidati, le seguenti osservazioni: più il punto che percorre una retta sotto l'orizzonte si allontana dall'occhio più il relativo raggio visivo si alza e si stringe, tendendo a sovrapporsi al raggio principale, qualunque sia la retta del fascio. Inoltre il raggio visivo è tanto più alto quanto più il punto cui si applica è lontano. Il raggio principale è il più alto di tutti quindi il punto cui si applica dovrebbe essere il più lontano di tutti. Tale raggio quindi, vista la corrispondenza uno a uno tra raggi visivi e punti da essi colti in un piano, dovrebbe cogliere un elemento infinitamente lontano comune a ogni retta del fascio, se esistesse, ma le rette euclidee sono infinite solo potenzialmente: dato un punto lontano a piacere posso trovarne uno ancora più lontano, e proprio questa proprietà impedisce di determinare in esse il punto più lontano di tutti. Le rette parallele hanno tuttavia qualcosa che comunque le accomuna: la medesima direzione.

Proponiamo allora di associare al raggio principale la direzione del fascio di rette considerate, aggiungendo questo astratto elemento al piano euclideo. È opportuno a questo punto un breve inquadramento storico che tratti della figura di Desargues e del suo termine *but*[7]. Possiamo facilmente generalizzare la costruzione aggiungendo un *but* per ogni direzione del piano, creando in tal modo un nuovo oggetto matematico, il piano proiettivo, diverso da quello euclideo, che porta interessanti e feconde informazioni sulla trasformazione visiva, diretta e inversa. Solo dopo un adeguato numero di esercizi sull'argomento il termine desarguesiano sarà abbandonato, spiegando come questo astratto elemento comune ha preso poi il nome di *punto all'infinito* per adeguarsi al linguaggio della trasformazione puntuale.

In questo nuovo mondo matematico, il piano proiettivo, le rette diventano "attualmente"[8] infinite, abbandonando definitivamente lo stato potenziale di segmento prolungabile a piacere cui erano costrette dalla trattazione euclidea.

Ogni fascio di rette parallele, avendo una propria direzione, ha quindi un proprio punto all'infinito, che viene colto dal raggio visivo avente la stessa direzione. Si può allora pensare al piano proiettivo come contenente anche una retta all'infinito, insieme di tutte le direzioni.

[7] Vedere Catastini [3] e Catastini, Ghione, [14]
[8] È interessante e formativo affrontare, nell'ambito delle lezioni di filosofia, la lettura di passi classici riguardanti il problema, confrontando per esempio le posizioni di Aristotele con quelle di Giordano Bruno sull'infinito attuale.

Riassumendo la situazione, si arriva alla costruzione, condivisa con gli studenti, delle seguenti definizioni:

- *Punto all'infinito* di un fascio di rette parallele: elemento comune a tutte le rette del fascio, corrispondente alla loro direzione.
- *Raggio di fuga* di un fascio di rette parallele: è il raggio visivo avente la stessa direzione del fascio, cui convergono i raggi che colgono i punti delle rette, nel loro tendere all'infinito.
- *Punto di fuga* di un fascio di rette parallele: punto di intersezione col piano del quadro del raggio di fuga del fascio, che coglie il loro punto all'infinito.
- *Punto di fuga principale*: punto di intersezione del raggio principale col piano del quadro.

Si individuano poi con facilità la *linea dell'orizzonte* costituita da tutti i punti di fuga delle rette parallele al piano di terra, e i *punti di distanza* (punti sulla linea dell'orizzonte corrispondenti ai punti all'infinito del fascio di rette con direzione a 45° o 135° rispetto alla linea di terra).

8. Il piano proiettivo reale P^2

Riassumendo quanto detto passiamo ora a ricordare anche formalmente i fondamenti della geometria proiettiva. Come abbiamo visto la geometria della visione fissa innanzitutto un punto dello spazio, che chiamiamo "occhio" e che indichiamo con O, dal quale parte una stella di raggi visivi cioè delle rette che passano per O. L'ipotesi fondamentale è che punti sullo stesso raggio visivo sono equivalenti nel senso che sono visti da O nel medesimo luogo. La visione quindi elimina una dimensione che è la lontananza dall'occhio e il risultato di questo appiattimento è il piano proiettivo. Il piano proiettivo viene dunque pensato come l'insieme delle rette uscenti da un punto O (chiameremo tali rette "raggi", un termine ottocentesco molto appropriato in questo contesto). Il simbolo con cui si indica questa stella di raggi è P^2 e si pensa un raggio come un singolo "punto" del piano proiettivo. C'è evidentemente una difficoltà linguistica e concettuale: col termine punto indichiamo il normale punto dello spazio euclideo ma anche un raggio visivo che ci si chiede di pensare come un "punto" dello spazio proiettivo, "punto" formato, esso stesso, da punti. Per sciogliere questa difficoltà, i punti del piano proiettivo, cioè i raggi che escono da O, saranno indicati in corsivo e in corsivo saranno indicati anche gli altri oggetti propri del piano proiettivo: il *punto A* è dunque un raggio visivo. Possiamo ora vedere alcune proprietà del piano proiettivo introducendo il concetto di *allineamento* e di *retta*.

Definizioni base

Dati tre *punti A,B,C* diciamo che questi tre *punti* si vedono *allineati* se i tre raggi visivi stanno su uno stesso piano.

La *retta* del piano proiettivo che congiunge i *punti A* e *B* è l'insieme dei *punti C* che si vedono *allineati* con A e B.

Queste definizioni sono alla base della geometria della visione e lì trovano una loro profonda motivazione. Possiamo ora dimostrare facilmente i due principi della geometria piana proiettiva:

Teorema 1
Dati due punti A e B, esiste una e una sola retta del piano proiettivo che contiene A e B.
Basta infatti osservare che i due raggi *A* e *B* passano per O e dunque esiste un unico piano, nello spazio euclideo che li contiene. I raggi contenuti in questo piano danno luogo a una *retta* del piano proiettivo che contiene *A* e *B*.

Teorema 1*
Date due rette a e b del piano proiettivo esiste un unico punto P contenuto in a e b.
Le due *rette* danno luogo nello spazio euclideo a due piani che passano per O i quali avendo in comune un punto hanno in comune una retta la quale, passando per O, è un raggio visivo cioè un *punto P* in comune ad *a* e *b*.

I problemi che ora si pongono sono essenzialmente due. Il primo è quello di sviluppare delle tecniche di calcolo che permettano di trattare le questioni coi metodi della geometria analitica e il secondo consiste nel farsi un'immagine intuitiva di questo piano che tenga conto delle continuità. Lo strumento analitico iniziale sono naturalmente le coordinate omogenee che abbiamo già introdotto e con le quali, una volta fissato il riferimento visivo, possiamo stabilire una corrispondenza biunivoca tra i raggi uscenti da O e le classi [x,y,t] di terne di numeri reali definite a meno di un comune fattore di proporzionalità non nullo.

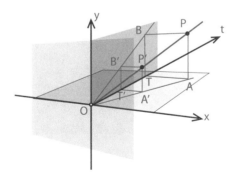

Queste coordinate ci permettono di caratterizzare con equazioni i raggi visivi (cioè i *punti* del piano proiettivo) che hanno determinate proprietà. Per esempio i raggi che si trovano sul piano di profondità (che non sono né a destra né a sinistra) hanno tutti la prima coordinata x uguale a zero, dunque

$$x=0$$

è l'equazione di una *retta* del piano proiettivo: i *punti* che appartengono a quella retta sono quelli che hanno la prima coordinata omogenea nulla. Questa *retta* è la retta verticale che vedo di fronte al mio occhio. Per esempio il *punto* [0,a,b] corrisponde al raggio visivo del piano di profondità che forma un angolo α con l'asse t la cui tangente è a/b.

$$\tan(\alpha) = a/b$$

Ovviamente un altro rappresentante della classe [0,a,b] per esempio [0,2a,2b] dà luogo allo stesso raggio dato che il rapporto 2a/2b = a/b. Nel linguaggio della geometria della visione, questo raggio è 0 gradi a destra e α gradi in alto.

Lo stesso si può fare per i raggi che si trovano sul piano orizzontale: essi sono caratterizzati dall'equazione

$$y = 0$$

e corrispondono ai punti che hanno la seconda coordinata omogenea nulla. Per esempio il *punto* [1,0,-1] corrisponde al raggio visivo che è 0 gradi alto e 45° a sinistra

In questo modo vediamo che i raggi che sono posizionati α gradi a destra e β gradi in alto hanno coordinate omogenee [a,b,c] dove

$$\tan(\alpha) = a/c \, , \tan(\beta) = b/c \, .$$

Ci si potrebbe chiedere se con questi due angoli si riesce a descrivere tutti i punti del piano proiettivo: la risposta è no. I raggi che si trovano sul piano verticale passante per O sfuggono a questa descrizione.

Riguardo al secondo problema, cioè quello di crearsi un'immagine intuitiva del piano proiettivo, possiamo cercare di rappresentare biunivocamente e con continuità i raggi visivi con i punti di un piano euclideo.

Consideriamo a tal scopo il piano t=1.

Ogni raggio visivo [x,y,t] per il quale t ¹ 0 si può rappresentare sul piano t=1 dato che, non essendo parallelo a quel piano, lo incontra in un punto le cui coordinate sono (x/t,y/t,1).

In questo modo abbiamo una corrispondenza biunivoca tra i *punti* del piano proiettivo che non stanno sulla *retta* t=0 e i punti del piano (euclideo) t=1.

Cosa succede se il raggio visivo si avvicina con continuità a un raggio del piano verticale? Possiamo vedere bene la situazione sul piano di profondità y,t.

Man mano che il raggio visivo *A* tende all'asse delle y il punto P di intersezione si allontana verso l'alto o verso il basso. Ma quando il raggio è parallelo alla retta t=1 manca il punto di intersezione nel piano euclideo. Per questo si aggiunge un punto che si immagina infinitamente lontano che corrisponde alla direzione dell'asse y e che è lo stesso sia che sia infinitamente lontano verso l'alto che verso il basso. Dal punto di vista delle coordinate la cosa è molto chiara: il raggio *A* ha le coordinate omogenee [0,y,1], quando y tende all'infinito *A*, nel piano proiettivo, ha un limite ben determinato, infatti A= [0,y,1] = [0,1,1/y] e, quando y tende a + o -, troviamo come limite il punto [0,1,0].

In questo modo possiamo, in generale, stabilire un isomorfismo tra il piano proiettivo pensato come insieme di raggi uscenti da un punto O e il piano euclideo purché si aggiungano a questo tutti i punti all'infinito.

Un altro modo di rappresentare i punti del piano proiettivo mantenendo la bicontinuità consiste nel proiettare i raggi su una semisfera di centro O.

Possiamo pensare a una cupola che abbia al suo centro l'occhio O, come la volta celeste, e identificare un raggio visivo *A* con il punto della cupola nel quale quel raggio la incontra, esattamente come si fa per rappresentare gli astri del cielo. In questo modo abbiamo una corrispondenza biunivoca e bicontinua tra i raggi non orizzontali e i punti della cupola. La difficoltà consiste nel fatto che i raggi orizzontali incontrano la cupola in due punti (Nord-Sud, Est-Ovest ecc) invece che in uno, venendo così meno la biunivocità della corrispondenza. In definitiva tutti i *punti* del piano proiettivo si rappresentano con un unico punto della cupola tranne quelli di una *retta* (l'orizzonte), che fanno eccezione dato che ognuno di loro si rappresenta sulla cupola con due punti diametralmente opposti. Per semplificare il problema possiamo schiacciare la cupola in un disco (cosa che non altera la bicontinuità della rappresentazione) e cercare di identificare, cioè di incollare tra loro, i punti antipodali. Anche da questo tipo di problema nasce una nuova branca della matematica moderna di grande importanza: la topologia.

9. Conclusioni

Il tendere al proprio raggio di fuga dei raggi visivi che percorrono un fascio di rette parallele su un piano (dominio), si concretizza nel tendere dei punti proiettati sul piano del quadro (codominio) a un determinato punto di fuga, che appare al finito. La ricerca nel dominio dell'elemento corrispondente a questo punto di fuga porterà a un modello mentale dinamico che supporterà adeguatamente la definizione di punto all'infinito e quella conseguente di retta all'infinito. L'uso del prospettimetro e di una cornice vuota che simula virtualmente il piano del quadro, lasciando però passare i "fili" visivi, aiuta la formazione di questi modelli mentali mediante il concreto operare dello studente, permettendo un gioco immaginativo geometricamente corretto – anche se ovviamente non esaustivo riguardo al problema – e assolutamente propedeutico e coerente con il successivo sviluppo della teoria in ambito universitario.

Le varie simulazioni delle situazioni matematiche effettuate con l'uso di software di geometria dinamica o di strumenti reali che permettono di "girare intorno" agli oggetti geometrici e di manipolarli nei loro movimenti nello spazio, l'abbondanza e la varietà di stimoli al pensiero percettivo-motorio che accompagna l'attività, il tipo di esercizi proposti e i frequenti momenti di descrizione verbale di situazioni spaziali, permette la formazione di modelli visivi rigorosi e complessi, isomorfi alla complessità e al rigore della teoria formale che devono affiancare e per questo capaci di creare un'utile sinergia tra i processi di pensiero sintetico-intuitivi e quelli analitico-verbali.

Queste attività sono continuamente proposte in ogni lezione e mirano alla costruzione, nel pensiero dello studente, di uno stile cognitivo "integrato"[9], stile che senza un addestramento adeguato non è affatto facile da instaurare nelle attività di tipo formale quali quelle matematiche. Gli strumenti utilizzati sono quindi parte importante e irrinunciabile della strategia didattica e sono usati attivamente dagli studenti per fare congetture, per visualizzare le ipotesi e la tesi dei teoremi, per costruire definizioni e per risolvere problemi.

Il lavoro sperimentale viene eseguito collettivamente e le osservazioni o le proposte individuali vengono commentate, discusse e, nel caso, messe in pratica per esplorare la loro validità.

La dimensione storica del pensiero matematico, che crea un utile contesto[10] che dà senso allo svolgersi delle costruzioni intellettuali nel tempo, viene rafforzata dalla collaborazione con gli insegnanti di filosofia, di lingue classiche e di storia dell'arte. In particolare in questa sperimentazione sono stati effettuati interventi sulla scienza ellenistica e sulle teorie della visione da Empedocle a Euclide, la lettura di alcuni passi del testo greco dell'*Ottica* e la comparazione dei termini usati con altri testi classici quali i testi omerici, la lettura di parti del *De Pictura* di Alberti e del *De Prospectiva Pingendi* di Piero della Francesca.

Bibliografia

[1] Catastini, L. (2009) Concretamente astratto, anzi... simulabile, *La Matematica nella Società e nella Cultura, Rivista dell'Unione Matematica Italiana*, serie I, vol. II, 31-69.

[2] Desargues, G. (1981) Brouillon project d'une atteint aux événements des rencontres d'un con avec un plan, in: Taton, R. *L'œuvre mathématique de G. Desargues*, Presses Universitaires de France, Paris.

[9] Si veda a questo proposito Catastini [15].

[10] Si veda Catastini [16].

[3] Catastini, L. (2004) Il Giardino di Desargues, *La Matematica nella Società e nella Cultura*, Bollettino UMI (8), 7-A, 321-345.

[4] De Finetti, B. (2005) *Matematica logico intuitiva*, Giuffrè, Milano.

[5] Rizzolatti, G., Fadiga, L., Gallese, V., Fogassi, L. (1996) Premotor cortex and the recognition of motor actions, *Cognitive Brain Research* 3.

[6] Barsalou, L. W. (1999) Perceptual symbol systems, *Behav. Brain Sci.* 22: 577-600.

[7] Grush, R. (2004) The emulation theory of representation: motor control, imagery, and perception, *Behav. Brain Sci.* 27(3): 377-96.

[8] Berthoz, A. (1997) *Le sens du mouvement*, Éditions Odile Jacob, Paris.

[9] Kosslyn, S. M., Sussman, A. (1994). Roles of imagery in perception: Or, there is no such thing as immaculate perception. In Gazzaniga, M. (ed.) *The cognitive neurosciences*, MIT Press, Cambridge MA, 1035-1042.

[10] Catastini, L., Ghione, F. (2004) *Le geometrie della visione*, Springer, Milano.

[11] Carlevaris, L. (2003) *Il mosaico della scienza prospettica: Una tessera romana. La sala delle maschere*, Tesi di Dottorato, Università di Roma La Sapienza.

[12] Catastini, L. (2001)Neuroscienze, apprendimento e didattica della matematica, *Progetto Alice*, Vol. II, n.4; n. 6.

[13] Lucrezio, (1992) *De rerum natura,* a cura di G. Milanese, Mondadori, Milano, Libro IV, 426-431.

[14] Catastini, L., Ghione F. (2005) *Nella mente di Desargues tra involuzioni e geometria dinamica, la Matematica nella Società e nella Guerra*, Bollettino UMI (8), 8-A, Aprile 2005, 126-147

[15] Catastini, L. (1990) *Il pensiero allo specchio*, La Nuova Italia, Firenze.

[16] Catastini, L. (2003) L'arco di pietre, *Punti critici* 8, 25-52.

Capitolo 5
L'omologia e Piero della Francesca

di *Grazia Indovina*

1. Introduzione e contesto didattico

La seguente proposta didattica si è sviluppata nell'ambito del sottoprogetto "Comunicare la Matematica" del Progetto Nazionale Lauree Scientifiche. Nasce dalla collaborazione tra docenti dell'Università di Palermo e insegnanti di alcune scuole superiori sia di Palermo sia della provincia ed è coordinato dal prof. Aldo Brigaglia dell'Università di Palermo.

Obiettivo principale del progetto "Comunicare la Matematica" è quello di portare gli studenti delle classi superiori a conoscere ed esplorare la matematica mediante percorsi didattici che pongano in risalto l'aspetto pratico e concreto di una disciplina spesso considerata erroneamente attività puramente astratta dell'intelletto umano, dimenticando le importanti applicazioni pratiche nelle scienze di base e applicate, nella moderna industria del software e anche nella natura e nell'arte.

Il progetto nasce quindi con lo scopo di rinnovare negli studenti un sentimento di passione per questa disciplina, la Matematica, dalle mille sfaccettature teoriche, filosofiche e pratiche.

Il tema "La geometria della visione: storia, arte e applicazioni al computer", all'interno del quale si è formata la proposta, s'inserisce nel progetto assieme ad altri temi. La geometria di cui ci occupiamo è la geometria delle trasformazioni, e il problema affrontato è quello della rappresentazione visiva in due dimensioni dello spazio tridimensionale.

Lo studio della prospettiva e delle trasformazioni proiettive, che ne costituiscono il risvolto matematicamente più significativo, hanno oggi un'importanza crescente per esempio nell'ambito della grafica vettoriale e nello studio dei software di animazione al computer. Inoltre i mezzi messi a disposizione dagli strumenti informatici, in particolare quelli relativi alla geometria dinamica, hanno permesso di affiancare e in buona parte sostituire i faticosi calcoli con l'intuizione visiva e ciò permette di trasferire questa parte della matematica a livello delle nostre scuole superiori, come dimostrano numerose esperienze didattiche svoltesi in tutta Italia.

Inoltre i legami di questa geometria con profondi problemi filosofici (come la natura dell'infinito in geometria), con affascinanti percorsi artistici, come quello di Piero della Francesca, con una storia che può farsi risalire all'età classica greca, con problemi attuali relativi alla moderna industria del software (si pensi agli effetti speciali nel cinema o ai videogiochi), rendono questo ramo della matematica adatto sia per percorsi multidisciplinari, sia per un primo sguardo sulle applicazioni più sofisticate della computer grafica. In quest'ottica lo strumento informatico può divenire un potente mezzo per dotare i ragazzi di ulteriori strumenti di comprensione e per motivarli nello studio.

Il percorso didattico è stato proposto in orario extra-scolastico a classi di circa venti allievi di terzo o quarto liceo, appositamente formate negli anni 2006-07, 2007-08, 2008-09. Gli allievi in tutti e tre gli anni di sperimentazione provenivano da scuole di diversa tipologia, e, più precisamente, il primo e il terzo anno provenivano da un Liceo classico e da un Liceo scientifico, il secondo anno da un Liceo scientifico e da un Istituto socio-psico-pedagogico. La risposta degli allievi è stata sempre positiva e non priva di curiosità. L'appartenenza a scuole diverse ha generato un minimo di competizione che ha provocato un maggiore impegno da parte di tutti.

L'attività vera e propria inizia dopo una fase (circa dieci ore) durante la quale gli alunni hanno imparato a utilizzare un software di geometria dinamica (ci siamo serviti del Cabri II plus) attraverso attività nell'ambito delle Isometrie (si veda per esempio il Capitolo 3 *Esempi di impiego della tassellazione del piano nelle arti figurative* di Michele Cascino) e delle Similitudini.

L'idea è quella di far scoprire agli allievi lo stretto legame che intercorre tra l'impianto prospettico di Piero della Francesca e la moderna omologia: una trasformazione del piano proiettivo reale in se stesso. Inoltre l'esigenza di rappresentare sul piano del quadro la realtà tridimensionale fa sì che i ragazzi accettino il fatto che vengano aggiunti al piano euclideo i punti all'infinito.

Le attività laboratoriali, suddivise in quattro incontri di tre ore, sono sempre state precedute da una breve introduzione generale, per inquadrare il problema affrontato, e da una breve presentazione delle schede di lavoro.

Assieme alle schede viene fornita all'allievo una *barra dell'omologia* (costruita con Cabri o con Geogebra) e un opuscoletto in cui vengono elencate le proprietà dell'omologia e le costruzioni dinamiche che sono servite a definire la *barra dell'omologia*. Questo materiale si trova nel CD allegato al libro: *Capitolo V/Schede/Omologia e Cabri.pdf*, *Capitolo V/Schede/Barra dell'omologia.gbg* e *Capitolo V/Schede/Barra dell'omologia.men*.

Nella scheda n. 1 (primo incontro) lo studente viene guidato a scoprire le proprietà dell'omologia e il teorema di Desargues, *Capitolo V/Schede/Scheda1.pdf*.

Nella scheda n. 2 (secondo incontro) lo studente esplorerà l'impianto prospettico di Piero della Francesca e afferrerà lo stretto legame che c'è tra questo e l'omologia, *Capitolo V/Schede/Scheda2.pdf*. Alcuni quadri, *Capitolo V/Quadri*, permettono di importare l'immagine in una pagina di Cabri (o Geogebra) e studiarne la struttura prospettica. A questa scheda ne abbiamo aggiunto un'altra con la soluzione degli esercizi, *Capitolo V/Schede/Scheda2Soluzioni.pdf*.

Nella scheda n. 3 (terzo incontro) si passa alla realizzazione prospettica di semplici figure come per esempio quella di un cubo, *Capitolo V/Schede/Scheda3.pdf*.

Viene anche curata l'animazione delle figure e in *Capitolo V/Animazioni 3D* si trovano delle animazioni realizzate con Cabri3D.

Durante l'ultimo incontro gli studenti hanno realizzato lavori personali come applicazione di ciò che avevano imparato negli incontri precedenti.

2. La prospettiva

La prospettiva, mezzo rigoroso e scientifico per imprigionare in un dipinto la realtà con i suoi volumi e i suoi spazi, è stata, nel Rinascimento, un importante punto di incontro tra teoria e pratica, tra arti figurative e matematica.

La tecnica, che si basa sul concetto di proiezione di un oggetto osservato da un punto (l'occhio) su un piano (il quadro del dipinto), costruisce la rappresentazione secondo precise regole matematiche legate ai rapporti che collegano tra loro l'oggetto, il quadro e l'osservatore.

La concettualizzazione matematica dei procedimenti prospettici ha portato alla nascita della Geometria Proiettiva, settore della Geometria che studia le proprietà delle figure invarianti rispetto alle operazioni di proiezione (da un punto) e di sezione (con un piano).

La prima teorizzazione della prospettiva è dovuta a Leon Battista Alberti che nel suo *De Pictura* (1436), definì ampiamente una pratica della prospettiva lineare.

Egli immaginava il quadro come "una finestra aperta nello spazio" il cui vetro altro non era che la sezione della "piramide visiva " culminante nel punto di vista dove è posto l'occhio. Egli affermava che tutte le linee dello spazio perpendicolari al piano del quadro (detto anche da Piero della Francesca "piano degradato") dovevano concorrere a un unico punto, il "punto centrico" oggi detto anche *punto di fuga* che corrisponde alla proiezione ortogonale del punto di vista sul quadro.

Per rendere più chiaro questo concetto dobbiamo pensare al classico esempio dei binari della ferrovia. Sappiamo che essi corrono paralleli, ma la nostra visione in lontananza li vede convergere in un unico punto. Se i binari corrono perpendicolarmente al piano del dipinto, il punto in cui vediamo convergere le linee dei binari viene chiamato appunto *punto di fuga* o *punto centrico*.

In Fig. 1 il punto di fuga è P.

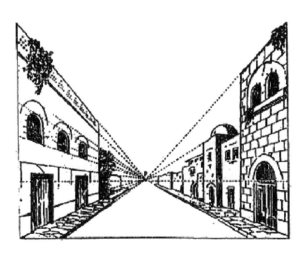

◀ **Figura 1**
Veduta prospettica

Alberti chiede, nell'azione pittorica, di piastrellare il piano di terra con qua-
drati tutti uguali tra loro, in modo che attraverso questi quadrati sia possibile
individuare in pianta la posizione di un oggetto rispetto a un altro, le recipro-
che distanze e grandezze, contando semplicemente il numero di 'mattonelle'.

Sul piano poi si alza una linea verticale con la quale misurare le altezze di
un oggetto rispetto al piano orizzontale. Questo è lo spazio che Alberti rap-
presenta prospetticamente sul piano del quadro.

Piero della Francesca aggiunge una costruzione geometrica di grande inte-
resse e modernità sia da un punto di vista pratico che da un punto di vista mate-
matico, poiché da quel metodo nasce il concetto di trasformazione proiettiva e
di *omologia*. Nel Capitolo 4 *La geometria della visione*, queste costruzioni sono
trattate in modo esauriente e presentate in modo didatticamente accurato.

3. L'impianto prospettico e i punti all'infinito

Immaginiamo due piani ortogonali: uno (orizzontale) il piano di terra, l'altro
(verticale) il piano del quadro (o piano degradato).

Chiamiamo linea di terra la retta di intersezione dei due piani.

Pensiamo gli occhi del pittore (punto di vista) come un unico punto da cui
escono le rette (raggi visivi) che proiettano i punti del piano di terra sul piano
del quadro.

Più precisamente fissato un punto T' del piano di terra la retta (raggio visi-
vo) per T' e per il punto di vista interseca il piano del quadro in un punto T
che sarà l'immagine di T'.

Se un punto del piano di terra descrive una retta, il punto corrispondente
descriverà una retta nel piano del quadro. La retta del piano di terra e la sua
immagine nel piano del quadro s'incontreranno sulla linea di terra. Nel CD alle-
gato al libro *Capitolo V/Animazioni 3D*, si trovano le animazioni realizzate con
Cabri3D, che abbiamo usato per illustrare la costruzione di Piero della Francesca.

Nella figura seguente, dove V è il punto di vista e il triangolo RST è l'im-
magine del triangolo R'S'T', vengono chiarite visivamente alcune proprietà
iniziali della corrispondenza tra i due piani sopra definita.

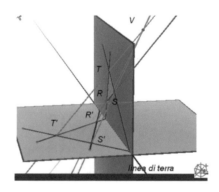

Sorgono spontanee alcune domande: dove si trovano, sul piano del quadro, i punti corrispondenti ai punti della retta parallela alla linea di terra che passa sotto i piedi del pittore? A quale punto corrisponde il punto F del piano del quadro che si trova sul raggio visivo ortogonale al quadro? E a quali punti corrispondono i punti della retta sul piano del quadro parallela alla linea di terra e passante per F?

Intuitivamente la risposta è che si tratta di punti infinitamente lontani.

Risulta allora quasi naturale, come risposta a tali domande e per rendere la corrispondenza tra i due piani biunivoca senza eccezioni, estendere sia il piano di terra sia il piano del quadro introducendo in essi una retta di punti all'infinito detti anche punti impropri.

Più precisamente si conviene di aggiungere a ogni retta un punto comune a essa e a tutte le sue parallele. Tale punto viene detto punto all'infinito della retta (e di tutte le sue parallele). In altre parole conveniamo che due rette complanari s'incontrano sempre in un punto, al finito se sono incidenti, all'infinito se sono parallele. Chiameremo retta all'infinito (o retta impropria) del piano l'insieme di tutti i suoi punti all'infinito. Il piano esteso con l'aggiunta dei suoi punti all'infinito si chiama piano proiettivo. La sua costruzione e una sua presentazione didattica dettagliata viene proposta in questo libro nel laboratorio *La geometria della visione* al Capitolo 4.

Tornando alla proiezione del piano di terra sul piano del quadro, chiamiamo *punto di fuga* il punto F ottenuto proiettando ortogonalmente sul quadro la posizione dell'occhio e *linea dell'orizzonte* la retta per F parallela alla linea di terra. Le immagini di tutte le rette del piano di terra perpendicolari alla linea di terra s'incontreranno nel punto di fuga che sarà quindi l'immagine del punto all'infinito di tali rette. Rette parallele non perpendicolari alla linea di terra avranno immagini che s'incontrano in un punto della linea dell'orizzonte. In particolare le immagini delle rette inclinate di 45° rispetto alla linea di terra e parallele tra di loro s'incontreranno in un punto D che prende il nome di *punto di distanza*.

La distanza FD è uguale alla distanza del punto di vista (occhio del pittore) dal piano del quadro. Non è difficile dimostrare quest'affermazione che si trova comunque trattata in tutti i dettagli nel laboratorio *La geometria della visione*. FD rappresenta anche la distanza ottimale dalla quale guardare il quadro.

Nella figura seguente che si trova realizzata con Cabri3D nel CD allegato al libro *Capitolo V/Animazioni 3D*, abbiamo realizzato una pavimentazione del piano di terra che viene proiettata, dal punto di vista V, sul piano del quadro, F è il punto di fuga e D è il punto di distanza.

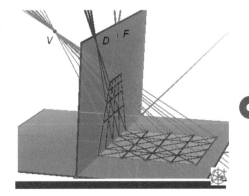

Il teorema di Desargues

La considerazione dei punti all'infinito permette di trattare le proiezioni centrali di un piano su un'altro, come quelle relative alla rappresentazione prospettica, in modo molto più agile e formalmente senza eccezioni, dato che nel nuovo ambiente, ampliato coi punti all'infinito, due rette in uno stesso piano s'incontrano sempre (al finito o all'infinito) in un punto, nello stesso modo si comportano una retta e un piano nello spazio tridimensionale o due piani i quali hanno sempre una retta in comune eventualmente, se i piani sono paralleli, formata tutta da punti all'infinito. Questa formidabile estensione del piano e dello spazio con l'aggiunta di questi nuovi punti all'infinito è descritta dettagliatamente nel laboratorio *La geometria della visione*.

All'interno di questo nuovo ambiente e servendosi solo dei postulati grafici che riguardano il mutuo rapporto tra rette e piani è possibile dimostrare un teorema a fondamento di tutta questa materia dovuto a Desargues, il padre della geometria proiettiva che ci sarà di grande utilità nel seguito.

Cominciamo con una definizione.

Definizione di triangoli omologici
Due triangoli si dicono omologici se è possibile associare i vertici dell'uno a quelli dell'altro, A ad A', B a B', C a C' in modo che le rette AA', BB', CC' siano convergenti in un punto O.

Poiché un triangolo è definito da tre punti (i suoi vertici) A, B, C non allineati, questi individuano univocamente un piano, il piano nel quale esso è tracciato. Sia dunque *P* il piano del primo triangolo e *Q* quello del secondo. I due triangoli sono, secondo la nostra definizione, omologici se uno è proiezione dell'altro da un punto O, o allo stesso modo, se sono due sezioni piane diverse di una stessa piramide di vertice in O, o ancora se sono traguardati da un determinato punto di vista in modo che l'uno copra esattamente l'altro. La nozione di triangoli omologici resta valida e di grande interesse anche nel caso che i due piani *P* e *Q* siano sovrapposti.

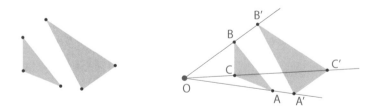

Il teorema di Desargues fornisce un criterio molto semplice per sapere se due triangoli sono o non sono omologici. È facile intuire come questo risultato sia importante nella geometria della visione, se pensiamo che, attraverso i triangoli, possiamo decomporre e studiare figure molto più complesse, come i qua-

drangoli, i poligoni convessi e le curve approssimabili con poligonali. Queste figure possono essere decomposte in triangoli, e, applicando a ciascuna di esse il teorema di Desargues, possiamo stabilire sotto quali condizioni, da un certo punto di vista O, esse appaiono uguali.

Teorema di Desargues

Due triangoli sono omologici se e solo se i lati corrispondenti, se prolungati, s'incontrano in punti allineati.

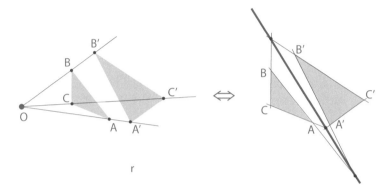

La dimostrazione, se i triangoli siano su piani distinti, è semplice e intuitiva, e costituisce un ottimo esercizio per sviluppare l'immaginazione tridimensionale. La figura animata che proponiamo, nel CD *Capitolo V/Animazioni/ Desargues.html*, permette di modificare i triangoli, il punto O e i punti A,B,C e fa vedere come la considerazione dei punti all'infinito sia essenziale nel considerare questo enunciato nella sua piena generalità.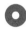

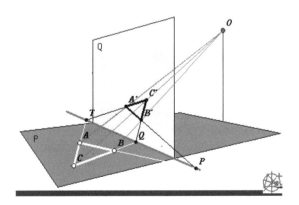

Dimostriamo il teorema nel caso in cui i due triangoli siano su piani diversi.

Supponiamo per ipotesi che i triangoli siano omologici. In questo caso siamo riusciti a ordinare i loro vertici in modo che le rette AA', BB', CC' convergano verso un punto O. Il lato AB del primo triangolo e quello corri-

spondente A'B' del secondo si trovano sul piano contenente la faccia della piramide OAB. Poiché in un piano due rette hanno sempre un punto (eventualmente all'infinito) in comune, esse s'incontrano. Sia P questo punto. Nello stesso modo, ragionando sulle altre facce della piramide, troviamo il punto Q come intersezione di BC e B'C' e il punto T come intersezione di AC e A'C'. Non ci resta che dimostrare che questi tre punti sono allineati. Ma questo si vede facilmente dal momento che il piano *P* che contiene il triangolo ABC, essendo diverso dal piano *Q* che contiene il triangolo A'B'C' dovrà incontrarlo lungo una retta (eventualmente all'infinito). Su questa retta sono situati i tre punti P, Q, T. Infatti P, essendo sul prolungamento del lato AB, si trova sul piano *P* ed essendo anche sul prolungamento del lato A'B' si trova sul piano *Q* e dunque si trova sulla retta di intersezione dei due piani. Analogamente per gli altri due punti.

Supponiamo ora, inversamente, che per ipotesi i vertici dei due triangoli siano stati ordinati in modo che i lati AB e A'B', BC e B'C', CA e C'A' s'incontrino nei punti allineati P, Q, T rispettivamente. Dobbiamo dimostrare che allora le rette AA', BB', CC' sono convergenti. Consideriamo i piani BAPA'B', e BCQC'B'. Questi piani sono diversi perché altrimenti i due triangoli ABC e A'B'C' sarebbero su uno stesso piano, contro l'ipotesi. Se i piani sono diversi essi s'incontrano in una retta: la retta BB' (eventualmente all'infinito). Consideriamo ora il piano ACTC'A'. Questo piano non può passare per la retta BB' comune ai due piani precedenti, perché in questo caso come prima i triangoli sarebbero su uno stesso piano. I tre piani considerati, non avendo una retta in comune s'intersecheranno in un punto: il punto O.

Notiamo come gli ingredienti usati in questa dimostrazione siano solo di natura grafica e non metrica e come si sia fatto un uso continuo dei punti all'infinito che hanno consentito di trattare le intersezioni di rette e piani nello stesso modo se incidenti o paralleli.

Il teorema vale anche nel caso in cui i due triangoli stiano su uno stesso piano, ma la dimostrazione è più complicata e si trova in tutti i dettagli nel libro di Enriques *Lezioni di geometria proiettiva* [1]. Essa si ottiene costruendo fuori dal piano dei due triangoli un terzo triangolo che si proietti da due punti diversi nei due triangoli piani dati e applicando a questi il teorema di Desargues nello spazio. È questo un primo interessante caso nel quale, per dimostrare una proprietà di geometria piana occorra usare una dimensione in più. Sarà questo un nuovo metodo dimostrativo molto usato negli sviluppi successivi della geometria proiettiva e della geometria algebrica.

4. L'idea di Piero della Francesca

Torniamo ora alle idee di Piero della Francesca forti di questo nuovo strumento, di due secoli successivo, che ci aiuterà a capire più in profondità le sue intuizioni.

L'idea di Piero della Francesca è quella di ruotare di 90 gradi il piano del quadro attorno alla linea di terra (nel CD *Capitolo V/Animazioni 3D*), fino a farlo sovrapporre al piano di terra stesso, mantenendo, durante la rotazione, la stessa corrispondenza tra i punti dei due piani. Il teorema di Desargues permette di dimostrare che, durante la rotazione, le rette che congiungono punti corrispondenti continuano a incontrasi tutte in un punto V il quale finirà per definire un punto, che chiamiamo sempre V, alla fine della rotazione. Infatti comunque si scelgano tre punti T', R', S' sul piano di terra e i loro corrispondenti T, R, S sul piano del quadro, i due triangoli hanno i punti di incontro dei lati corrispondenti T'R' e TR, T'S' e TS, R'S' e RS allineati sulla linea di terra e questa condizione resta valida durante la rotazione dato che la rotazione ha come asse questa retta. Il teorema di Desargues ci permette di dedurre che, in queste condizioni, le rette T'T, R'R e S'S passano per uno stesso punto V. Questo punto naturalmente cambia durante la rotazione nella misura in cui cambia la posizione nello spazio del triangolo TRS ma non cambia la convergenza delle tre rette che proiettano un triangolo nell'altro. Per dirla in modo più intuitivo, immaginiamo i due triangoli rigidamente posizionati sui due piani e tre fili rigidi e infiniti che collegano T a T', R a R' e S a S'. Inizialmente i tre fili convergono in V e i due triangoli sono omologici, ma questi triangoli restano omologici qualunque sia la posizione dei due piani durante la rotazione dato che i lati corrispondenti T'R' e TR, T'S' e TS, R'S' e RS s'incontrano in punti fissi, allineati sull'asse di rotazione. Ne segue, per il teorema di Desargues, che i tre fili convergono qualunque sia la posizione dei due piani.

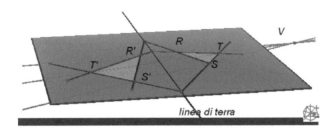

Viene così a stabilirsi una corrispondenza biunivoca tra i punti del piano (completato con i punti all'infinito: piano proiettivo) che fa corrispondere a ogni punto del piano un punto dello stesso piano. In questo modo abbiamo *su uno stesso foglio* la pianta della figura T'R'S' e la sua immagine prospettica TRS e una corrispondenza che ci permette di costruire, punto per punto, l'immagine prospettica di una qualunque figura.

Piero non costruisce la corrispondenza usando il punto V che non conosce e che non immagina neppure, né conosce il teorema di Desargues di due secoli posteriore, ma costruisce, come vedremo, la corrispondenza usando proprietà geometriche più semplici e alla sua portata.

◀ **Figura 2** Illustrazioni da
De Prospectiva Pingendi
di Piero della Francesca in [2],
Libro I, 15 e Libro I, 17

Osserviamo intanto che la corrispondenza ottenuta in questo modo a partire
da una proiezione centrale di un piano nell'altro, e ruotando uno dei due piani
fino a farlo sovrapporre all'altro ha le seguenti caratteristiche che si possono
intuire da un'osservazione attenta di questa costruzione:

· punti allineati si trasformano in punti allineati;
· i punti della linea di terra coincidono con il proprio corrispondente e sono
 quindi punti fissi della trasformazione;
· rette corrispondenti s'incontrano in un punto fisso sulla linea di terra, in
 particolare rette parallele alla linea di terra (che la incontrano quindi all'in-
 finito) si trasformano in rette parallele alla linea di terra;
· punti corrispondenti sono allineati con il punto V.

Chiameremo questa corrispondenza *omologia* di *centro* V e *asse* la linea di terra.

5. L'omologia nella matematica di oggi

Da un punto di vista formale l'omologia può essere definita e studiata nel con-
testo della geometria proiettiva. Chiameremo *piano proiettivo* il piano eucli-
deo completato con i punti della retta all'infinito. I punti all'infinito del piano
proiettivo si dicono anche *punti impropri*, la retta all'infinito si dice anche
retta impropria.

Dati due piani proiettivi α e β, definiamo *trasformazione proiettiva*, o *proiet-
tività*, di α in β ogni corrispondenza biunivoca che conservi l'allineamento.

Una proiettività di un piano proiettivo in sé si dice *omologia* se ha una retta di
punti fissi, detta *asse dell'omologia*, e un punto fisso, detto *centro dell'omologia*.

Se il centro appartiene all'asse l'omologia è detta *speciale*.

Vediamo ora alcune proprietà dell'omologia che verranno utilizzate nelle
esercitazioni al computer che si trovano nel CD e che sono servite per costrui-
re la Barra dell'omologia, *Capitolo V/Schede/Barra dell'omologia*, con un
software di geometria dinamica come Cabri o Geogebra.

5.1. Punti corrispondenti sono allineati con il centro dell'omologia

Se infatti A è un punto generico del piano e P il centro dell'omologia, allora la retta *r*, che congiunge A con P, interseca l'asse in un punto T. Quindi possiamo pensare la retta *r* formata da tutti i punti del piano allineati con P e T. Se ora trasformiamo con l'omologia i punti di questa retta troviamo (dato che l'omologia conserva l'allineamento) punti allineati con il trasformato di P e il trasformato di T. Ma questi due punti sono fissi e dunque la retta *r* si trasforma in se stessa. In particolare il trasformato A' di A sarà sulla retta PT.

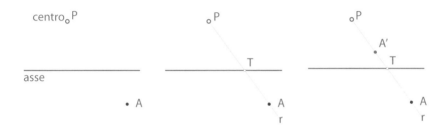

ATTENZIONE. La retta *r* si trasforma in se stessa ma non punto per punto: solo i punti P e T restano fissi mentre gli altri punti di *r* cambiano posizione pur restando sulla retta *r*.

5.2. Rette corrispondenti s'incontrano in un punto dell'asse

Infatti ogni retta incontra in un punto T l'asse dell'omologia (dato che due rette s'incontrano sempre in un punto), e dato che questo punto è fisso, anche la trasformata di tale retta, che è una retta perché punti allineati si trasformano in punti allineati, passerà per T.

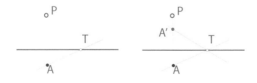

Nella figura P è il centro dell'omologia, A' è l'omologo di A e la retta A'T è l'omologa della retta AT.

ATTENZIONE. Se A' è l'omologo, o corrispondente, di A rispetto all'omologia in generale non è vero che A è l'omologo di A' rispetto alla stessa omologia.

5.3. Una retta parallela all'asse si trasforma in una retta parallela all'asse

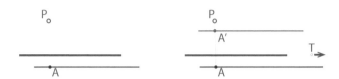

Infatti in questo caso il punto T è il punto all'infinito dell'asse e le due rette AT e A'T risultano parallele.

Teorema di costruzione dell'omologia
Dati in un piano proiettivo una retta a e tre punti allineati P, A, A' esterni alla retta, esiste una e una sola omologia che ha come asse la retta a come centro il punto P e che trasforma A in A'.

Per dimostrare questo teorema dobbiamo definire innanzi tutto, a partire dai dati (cioè da una retta *a* un punto P e una coppia A e A' di punti allineati con P) una corrispondenza del piano proiettivo in se stesso, verificare che trasforma A in A', che è biunivoca, che conserva l'allineamento e che ogni altra corrispondenza con queste proprietà è identica, punto per punto, a quella che abbiamo definito. Diamo qua la costruzione della corrispondenza e un'idea di come si dimostrano questi fatti.
 Dato un *generico* punto X del piano proiettivo costruiamo:

- la retta AX;
- il punto T dove AX incontra l'asse *a*;
- la retta A'T;
- la retta XP;
- il punto X' dato dall'intersezione di A'T e XP.

Al punto X associamo il punto X' così costruito.
 Osserviamo che la costruzione cade in difetto se il punto X si trova sulla retta AA' perché in questo caso le rette PX e A'T coincidono con la retta AA' e non definiscono un punto come loro intersezione, tuttavia possiamo aggirare l'ostacolo considerando un ulteriore punto B che non appartenga alla retta AP e costruire, come abbiamo fatto per X, il suo corrispondente B'. Ora preso un

punto X sulla retta AP, possiamo costruire il suo corrispondente X' utilizzando B e B' al posto di A e A'. Naturalmente occorrerà dimostrare che il punto X' così costruito non dipende dalla scelta di B.

Notiamo che non abbiamo altre scelte possibili per il punto X'. Infatti, dato che il punto X appartiene alla retta AX che è uguale alla retta AT, il punto X' deve allinearsi con A' e con T. D'altra parte per la proprietà 1 il punto X' deve essere allineato con X e P dunque deve trovarsi sulla retta XP. Poiché due rette A'T e XP hanno nel piano proiettivo un punto comune (eventualmente all'infinito) il punto X' è univocamente calcolabile a partire dai dati. Questo dimostra che, se un'omologia esiste, deve essere necessariamente questa e solo questa.

Per vedere che l'omologia esiste basta vedere che la corrispondenza X – X' che abbiamo appena definita ha tutte le proprietà dell'omologia.

Mostriamo che questa corrispondenza conserva l'allineamento.

Per questo basta dimostrare che se X,Y,T (T sull'asse) sono tre punti allineati allora anche X' e Y' si allineano con T. Cominciamo col costruire i punti X' e Y' con la regola precedente. Abbiamo due triangoli AXY e A'X'Y' che sono omologici dato che i punti corrispondenti sono allineati col centro P.

Possiamo allora applicare il teorema di Desargues e troviamo che i lati XY e X'Y' s'intersecano sulla retta dove s'intersecano gli altri due cioè sull'asse. Poiché la retta XY incontra l'asse in T anche la retta X'Y' dovrà passare per T.

Non è difficile vedere che se X è un punto dell'asse, allora X'=X. In questo caso infatti X=T e la retta A'T=A'X e A'X incontra PX in X.

È anche facile vedere che P è un punto fisso dato che presi due punti generici A e B, P si trova sulle rette AA' a BB' e dato che queste rette si trasformano in se stesse, anche il trasformato P' si trova su queste due rette ma due rette distinte hanno un solo punto comune dunque P=P'.

Per dimostrare infine che la corrispondenza che abbiamo definito è biunivoca basta vedere che è invertibile. La cosa è facile dato che cambiando il ruolo di A con quello di A' si vede immediatamente che il punto X' si trasforma nel punto X.

Abbiamo così definito, a partire da *a*, e da tre punti allineati P, A e A' una corrispondenza biunivoca del piano in se stesso che fissa la retta *a* punto per punto, che fissa il punto P e che conserva l'allineamento. Inoltre una corrispondenza con queste proprietà è necessariamente quella che abbiamo definito.

6. L'omologia di Piero della Francesca

Una conseguenza del teorema precedente, che corrisponde più da vicino al procedimento di Piero della Francesca e che potremmo attribuire a lui è la seguente riformulazione.

Teorema di Piero
Dati in un piano proiettivo una retta a *e due coppie di punti* I, I' *e* C, C' *tali che le rette* IC, I'C' *e* a *siano convergenti, allora esiste un'unica omologia che ha* a *come asse, che trasforma* I *in* I' *e* C *in* C'.

Possiamo infatti prendere il punto P comune alle rette I I' e CC' e costruire l'unica omologia che ha P come centro, *a* come asse e trasforma I in I'. Tale omologia manda C in C' dato che l'immagine di C si ottiene come abbiamo visto, intersecando PC con TI'.

Alternativamente, dati *a*, I I', C C', possiamo costruire l'immagine di un generico punto X del piano senza far intervenire il centro P, che Piero non conosceva, seguendo direttamente la sua costruzione.

Possiamo presentare il punto X come intersezione delle rette IS e CR (R e S sull'asse *a*) e quindi X' si otterrà intersecando I'S con C'R. Naturalmente i due triangoli ICX e I'C'X' sono, per il teorema di Desargues, omologici e quindi le rette I I', CC' e XX' passano tutte per uno stesso punto P, il centro appunto dell'omologia.

In definitiva, dati AB, A'B' e l'asse possiamo costruire l'immagine, tramite l'omologia, di una qualunque figura.

Piero costruisce con questo metodo l'immagine prospettica di una griglia fitta quanto si vuole all'interno della quale può poi posizionare una qualunque figura. Il piano di terra diventa un oggetto matematico, un piano coordinato geometrico i cui punti sono individuati dalle maglie della griglia e la trasformazione omologica permette a Piero di trasformare quest'oggetto indipendentemente da ciò che contiene, trasformando, con una stessa regola precisa, tutti suoi punti. I dati iniziali sono la linea di terra che gioca il ruolo di asse dell'omologia e le due coppie di punti I C e I'C' scelti nel modo seguente:

- l'asse *a* dell'omologia è la linea di terra;
- il punto I è il punto all'infinito della direzione ortogonale ad *a*;
- il punto C è uno dei vertici del quadrato da proiettare;
- il punto I' è il punto di fuga;
- il punto C' è il punto che determina la profondità dello scorcio (la retta IC è la retta per C perpendicolare ad *a*).

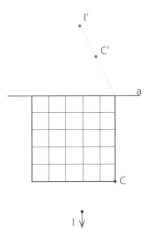

Seguendo la costruzione precedente, a partire da questi dati, possiamo trasformare i punti sulla diagonale e di conseguenza tutti gli altri realizzando lo scorcio delle griglia. Dopo aver costruito l'immagine dei punti sulla diagonale, dato che le rette parallele ad *a* si trasformano in rette

parallele ad *a*, possiamo costruire le immagini delle rette orizzontali e quindi l'immagine del quadrato ABCD e della griglia che contiene che possiamo fare fitta quanto vogliamo.

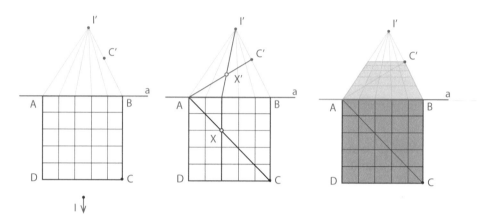

Piero ha anche elaborato un secondo metodo meno diretto, ma capace di costruire a partire dagli stessi dati l'immagine prospettica di un qualunque punto del piano di terra senza dover ricorrere alla griglia. Anche questo metodo si basa sul fatto che i punti sulla diagonale possono essere trasformati a partire dai dati.

La figura seguente illustra questa costruzione.

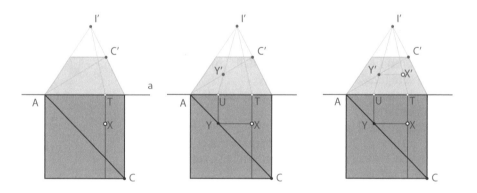

- Si costruisce la linea di profondità passante per X (è la retta TI).
- Si trasforma questa retta (è la retta TI').
- Si traccia la parallela per X alla linea di terra la quale incontra la diagonale in Y.
- Si trasforma Y che, essendo sulla diagonale, si ottiene intersecando AC' con UI'.
- Si traccia la parallela per Y' alla linea di terra e s'interseca con TI'.

▲ **Figura 3** Illustrazioni da *De Prospectiva Pingendi* in [2], Libro I, 18, Libro I, 19, Libro I, 25

Con Cabri o Geogebra possiamo costruire una macro che ci permette di vedere concretamente come si trasforma una figura a partire da questi dati seguendo la costruzione di Piero.

Resta il problema di vedere come vengono determinati i punti I' e C' a partire dalla posizione dell'occhio. Questo è forse il risultato più importante di Piero: il teorema XIII del suo *De Prospectiva Pingendi*.

◀ **Figura 5.26** Illustrazione da *De Prospectiva Pingendi* in [2], Libro I, 13: *Il piano del quadro in quadro reducere*

Questo teorema insegna a costruire l'immagine prospettica di un quadrato orizzontale posto dinanzi all'occhio, occhio che si suppone a una certa distanza dal quadro dove avviene la "degradazione" e a una certa altezza dal piano di base orizzontale dove è posto il quadrato. Il quadrato si proietta in un trapezio del quale Piero indica come tracciare l'altezza e le basi. La costruzione è molto importante perché mette chiaramente in relazione la forma del trapezio e quindi la posizione del punto B' con la posizione dell'occhio e perché successivamente, sarà solo a partire da questo che l'intera proiezione sarà determinata punto per punto senza più bisogno di ricorrere al centro di proiezione e al contesto spaziale, ma riducendo tutta la costruzione sul piano del quadro.

○ Nel CD *Capitolo V/ Animazioni /Piero.html,* si trova un'animazione che descrive questa situazione.

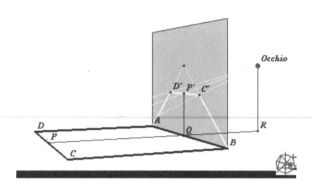

Con riferimento a quest'animazione, indicando con O la posizione dell'occhio, abbiamo che QR è la distanza dell'occhio dal quadro e RO è la sua altezza. Si tratta, in funzione di questi dati, di calcolare l'altezza del trapezio.

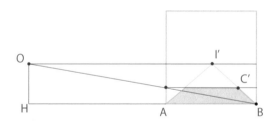

Ecco la costruzione di Piero: RA è la distanza dell'occhio dal quadro e RO la sua altezza. La figura indica come viene costruito il punto C' e quindi l'altezza del trapezio. Piero dimostra rigorosamente, considerando una serie di triangoli simili e riferendosi alla situazione tridimensionale, che la costruzione è corretta. Si veda per esempio Catastini-Ghione, *Le geometrie della visione* [2].

Risulterà didatticamente utile abituare gli allievi a riconoscere la forma del trapezio, e quindi la posizione del punto C', a partire dalla posizione dell'occhio e viceversa. In questo modo Piero fornisce ai pittori uno strumento geometrico potente che permette di simulare la riuscita prospettica di una scena e modificarla secondo le esigenze estetiche dell'opera.

 Per esempio nella *Flagellazione di Cristo* (Fig. 5), (nel CD *Capitolo V/Quadri/Flagellazione.jpg*) il punto centrico I' dove confluiscono le linee di profondità è posto all'altezza delle ginocchia dei personaggi dando l'impressione straniante di vedere la scena come fosse rialzata, sospesa nell'aria.

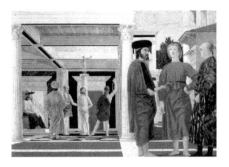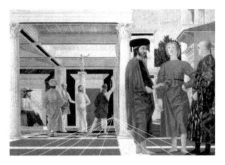

▲ **Figura 5** A sinistra: Piero della Francesca, *Flagellazione di Cristo*, 1459 ca, Galleria Nazionale delle Marche, Urbino. A destra: studio prospettico della *Flagellazione* in [2]

Con software di geometria dinamica sarà possibile definire una macro omologia di Piero della Francesca che, a partire dal quadrato e dal trapezio, restituirà per ogni punto il suo omologo.

Piero della Francesca nei suoi tre libri del *De Prospectiva Pingendi* applica la teoria per risolvere una serie di problemi pratici via via più complessi, il tutto improntato a un rigore matematico che fa distinguere Piero della Francesca rispetto all'empirico Alberti.

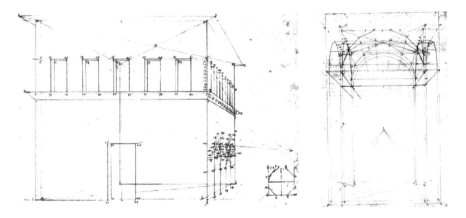

▲ **Figura 6** *De Prospectiva Pingendi* in [2], Libro II, 9, Libro II, 11

Le proprietà dell'omologia di Piero della Francesca consentono inoltre la cosiddetta *restituzione prospettica*, ovvero la ricostruzione della vera forma della scena rappresentata. Si tratta di operare in modo inverso rispetto a quello del pittore cioè di ricostruire lo spazio che ha suggerito la scena all'artista.

Un'interessante restituzione prospettica si può osservare nella sezione della Mostra Matemilano (*http://matemilano.mat.unimi.it*).

Si tratta di un esperimento virtuale che permette al visitatore di "entrare" nella scena in cui è ambientata la *Pala Montefeltro* di Piero della Francesca, un dipinto, ora conservato alla Pinacoteca di Brera, che è considerato uno dei più importanti esempi di ricostruzione prospettica.

Nel CD si trovano delle schede didattiche che hanno l'obiettivo di condurre gli allievi a scoprire, utilizzando software di geometria dinamica, le regole dell'impianto prospettico di Piero della Francesca e il concetto di omologia. Nella scheda n. 3 gli studenti vengono guidati, con l'uso di Cabri, alla realizzazione prospettica di un cubo che sarà possibile animare e muovere. Infine la scheda *Capitolo V/Schede/Scheda4.pdf*, realizza la costruzione prospettica di un parallelepipedo poggiato sul piano di terra in una posizione (x,y) che può essere modificata agendo col mouse, come può essere modificata la sua altezza z. Questo, in definitiva, realizza, in funzione della posizione dell'occhio, la trasformazione prospettica di un qualunque punto P(x,y,z) dello spazio e quindi di un qualunque oggetto definito da punti, sul piano del quadro.

Bibliografia

[1] Enriques, F. (1926) *Lezioni di Geometria proiettiva*, Zanichelli, Bologna.
[2] Catastini, L., Ghione, F. (2004) *Le Geometrie della Visione* Springer, Milano.

Segnaliamo inoltre:
Alberti, L.B. (1950) *Della Pittura*, edizione critica a cura di Luigi Mallè, Sansoni, Firenze.
Bagni T., D'Amore B. (1994) *Alle radici storiche della prospettiva*, Franco Angeli, Milano.
Brigaglia, A., Indovina, G. (2003) *Stelle, Girandole e altri oggetti matematici*, Zanichelli-Decibel, Bologna.
Castelnuovo, G. (1905) *Lezioni di geometria analitica e proiettiva*, Dante Alighieri, Venezia.
Emmer, M. (1991) *La perfezione visibile*, Edizione Theoria, Roma.
Euclide (1557) *Euclidis Optica & Catoptrica*, edizione greca di Ioannis Penae, Wechel Parigi.
Euclide (1573) *La prospettiva di Euclide*, tradotta da Egnazio Danti, Giunti, Firenze.
Federici Vescovini G. (1961) Le questioni di 'Perspectiva' di Biagio Pelacani da Parma, in: *Rinascimento* XII(1), Sansoni, Firenze.
Frajese, A. (1940) Alle origini della geometria proiettiva, *Bollettino UMI* 2(2).
Freguglia, P. (1982) *Fondamenti storici della geometria*, Feltrinelli, Milano.

▶

Freguglia, P. (1997) I trattati di prospettiva nell'età rinascimentale, in *Arte e Matematica: un binomio sorprendente*, Convegno Nazionale nella città di Vasto.

Ghione, F. (2005) Breve introduzione sul contenuto matematico del "De Prospectiva Pingendi" di Piero della Francesca, in: Piero della Francesca, *De prospectiva pingendi*, edizione critica a cura di Nicco-Fasola, note di E. Battisti e F. Ghione, Le Lettere, Firenze.

Iacopino, M.C. (2004) *Prospettiva: indagini geometriche e costruzioni con Cabri-Géomètre II*, Tesi di Laurea Università della Calabria. Relatore: Margherita D'Aprile.

Kline, M. (1991) *Storia del pensiero matematico*, Vol. I-II, Einaudi, Torino.

Leonardo da Vinci *Trattato della Pittura* dal Codice Urbinate Vaticano, Le Bibliophile-Neuchatel.

Pellegrino, C. (1999) *Prospettiva: il punto di vista della geometria*, Pitagora, Bologna.

Piero della Francesca (2005) *De prospectiva pingendi*, edizione critica a cura di Nicco-Fasola, note di E. Battisti e F. Ghione, Le Lettere, Firenze.

Severi, F. (1921) *Geometria Proiettiva*, Lytotipo, Padova.

Speranza, F. (1994) Alcuni nodi concettuali a proposito dello spazio, in *Educazione Matematica* 5.IV, A.1, 95-115.

Speranza, F. (1997) *Dallo spazio alla geometria*, Atti del 2° Internuclei per la scuola dell'obbligo, Dipartimento di Matematica, Università di Parma.

Speranza, F., Vighi P. (1997) Spazio dell'arte, spazio della matematica, in *Arte e Matematica: un binomio sorprendente*, Convegno Nazionale nella città di Vasto.

Staudt, C.G.C.V. (1889) *Geometria di Posizione*, Fratelli Bocca, Napoli.

Siti web

http://math.unipa.it/~grim/prospettiva.pdf
http://www.italica.rai.it/rinascimento/categorie/prospettiva.htm
http://www.treccani.it/site/Scuola/Zoom/prospettiva/
http://matemilano.mat.unimi.it

Capitolo 6
Matematica: anima segreta dell'arte

di *Nadia Garuti, Margherita Pivetti, Ennio Quattrini* e *Daniele Tettamanzi*
Liceo Scientifico Statale "Manfredo Fanti", Carpi (Modena)

1. Un'importante esperienza tra matematica e arte

L'insegnamento della matematica nelle scuole superiori mette spesso i docenti nella condizione di percepire il pericolo che le attività e gli obblighi scolastici oscurino la vera natura di questa disciplina; essi rischiano così di essere tra i principali responsabili di quella diffusa opinione per cui la matematica è solo una materia arida, piena di calcoli complicati, un insieme di astratte e noiose regole. Ma così come la musica e la letteratura non si riducono rispettivamente al solfeggio e alle regole della grammatica e della retorica, la matematica è molto di più delle tecniche e delle regole di calcolo che si apprendono a scuola. Partendo da queste considerazioni è sorta in noi l'esigenza di ricordare agli altri insegnanti, ai mass-media ma, soprattutto, agli studenti, che la matematica è un elemento essenziale di tutta la nostra cultura, non solo di quella scientifica. È stato, quindi, approfondito il suo legame con una disciplina solitamente percepita agli antipodi, l'*arte*, ed è nata così una mostra che tenta di rendere meno oscuro il legame tra questi due modi di percepire la realtà. Abbiamo cercato di infrangere i luoghi comuni sulla matematica facendone riscoprire il fascino irresistibile che contagia la vita dell'uomo anche nelle arti, mostrando che essa può intervenire nei capolavori di alcuni artisti come una sorta di anima invisibile. Da questo deriva il titolo della mostra: *Matematica: anima segreta dell'arte*. Alla sua realizzazione hanno collaborato anche la prof.ssa Maria Cristina Castellazzi, che ha preparato i poster sulla "poesia visiva", il prof. Aldo Meschiari, che ha predisposto il pannello sulle "Città invisibili" e il prof. Paolo dall'Olio che ha realizzato un'opera dal titolo "Il ragno", che è stata donata alla scuola e fa parte della mostra. Con il contributo del Dipartimento di Matematica dell'Università di Modena e Reggio Emilia, nell'ambito del Progetto Lauree Scientifiche *Orientamento e formazione degli insegnanti: MATEMATICA*, abbiamo inoltre realizzato un CD-rom che riprende tutti i contenuti della mostra affinché l'iniziativa possa avere una più ampia diffusione soprattutto nelle scuole.

2. La mostra

I temi trattati nella mostra e che sono contenuti all'interno del CD-rom sono suddivisi in quindici sezioni: in ognuna di esse gli argomenti principali sono riassunti in un pannello esplicativo e trattati nell'esposizione con una serie di opere rappresentative dell'argomento stesso. Ciascun'opera è adeguatamente commentata, al fine di facilitarne la comprensione e il legame con quanto descritto nel pannello introduttivo.

Le sezioni della mostra sono le seguenti:
- introduzione alla mostra;
- stregati dai numeri;
- le forme della perfezione;
- la divina proporzione;
- le forme geometriche;
- incastri perfetti;
- la forma delle nuvole;
- infinito;
- la prospettiva;
- l'anamorfosi;
- le figure impossibili;
- strani nuovi mondi;
- poesia visiva;
- città invisibili;
- la matematica in una bolla;
- $\sqrt[4]{Bang} \times (Gulp)^3$

Per la realizzazione delle sezioni ci siamo avvalsi di un'ampia bibliografia. La preparazione della quasi totalità dei pannelli e la scelta di tutte le opere significative da esporre, con relativa didascalia, è stata effettuata da noi insegnanti; fa eccezione solo l'ultima sezione in cui abbiamo deciso di coinvolgere gli alunni di una terza classe del liceo scientifico tecnologico nello studio del ruolo della matematica nei fumetti. Questa particolare forma artistica, molto apprezzata dagli studenti perché sincronizzata sul loro linguaggio, affronta piacevolmente anche argomenti non sempre amati dagli adolescenti. Oltre ad analizzare il rapporto tra matematica e fumetti, i ragazzi hanno ideato e realizzato una storia a fumetti collegata alla congettura di Goldbach.

3. Stregati dai numeri

I numeri sono stati frequentemente scelti come soggetti per l'arte figurativa. Essendo enti astratti, essi non sono stati raffigurati direttamente, ma attraverso le loro rappresentazioni nel sistema decimale. Anche se non mancano esempi di raffigurazione dei numeri in opere rinascimentali (si veda Albrecht Dürer, *Melenconia I*, 1514, dove su una parete del palazzo alle spalle della donna che rappresenta

▸ **Figura 1** Giacomo Balla, *Numeri innamorati*, 1920, olio su tela, 77x55cm, MART, Rovereto, collezione VAF-Stiftung © Archivio Fotografico Mart

la Melanconia è scolpito un quadrato magico perfetto basato sul numero 34) è soprattutto nel Novecento che i numeri diventano un soggetto affascinante, per artisti come Giacomo Balla, Salvador Dalì, Jasper Johns, Tobia Ravà, Nespolo e altri.

4. Le forme della perfezione

"Non accorderemo a nessuno che vi siano corpi nell'universo più belli di questi". Così scrive Platone (427-347 a.C.) nel dialogo *Timeo* riferendosi ai cinque poliedri regolari dello spazio: tetraedro, cubo (o esaedro), ottaedro, dodecaedro e icosaedro. Essi hanno esercitato una grande attrazione su matematici e artisti di ogni epoca. Furono soprattutto gli artisti del Rinascimento italiano che rimasero affascinati da questi oggetti.

Più recentemente Escher ha dimostrato grande interesse verso semplici figure spaziali geometriche, come i poliedri regolari. L'origine di questo interesse risiede nell'ammirazione di Escher per le forme cristalline esistenti in natura. In *Stelle* (1948) Escher costruisce un piccolo universo riempito di solidi regolari di tre tipi: semplici (cubi, ottaedri, dodecaedri), doppi (cioè formati da due solidi regolari che si compenetrano) e tripli (cioè ottenuti dalla compenetrazione di tre solidi platonici).

▸ **Figura 2** Maurits Cornelis Escher, *Stars*, 1948, silografia su legno di testa, 32x26cm © 2010 The Escher Company-Holland. All rights reserved. *www.mcescher.com*

5. La divina proporzione

Per secoli la sezione aurea è stata il criterio di bellezza per antonomasia sia nel campo della pittura sia dell'architettura. Se il mito della sezione aurea nasce nell'antica Grecia (dove la ritroviamo come criterio di costruzione di templi, statue e addirittura anfore) è nel Rinascimento che si ha il vero trionfo della sezione aurea (o divina proporzione). Quasi tutti i maggiori artisti di questo periodo

▲ **Figura 3** Sandro Botticelli, *Nascita di Venere*, 1485 ca, tempera su tela, 172,5x278,5cm, Galleria degli Uffizi, Firenze per gentile concessione del Ministero per i Beni e le Attività Culturali, Soprintendenza Speciale per il Polo Museale Fiorentino

usano la divina proporzione (e le sue derivazioni come il pentagono stella-
to, la spirale aurea, ecc.) nella progettazione e nella realizzazione dei loro
maggiori capolavori.

6. Le forme geometriche

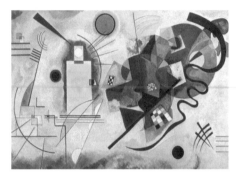

Cerchi, triangoli, quadrati, pentago-
ni… sono stati ovviamente soggetti
privilegiati dall'arte in tutti i tempi e
in tutte le culture, nella pittura come
nell'architettura. Essi sono gli ele-
menti fondamentali che gli artisti
hanno usato per rappresentare la
realtà nelle loro opere. Ma è soprat-
tutto nel Novecento che le figure
geometriche diventano soggetto
delle opere dei pittori. Il maggiore
esponente di questa visione è sicura-
mente Wassily Kandinsky secondo il
quale bisogna abbandonare comple-

▲ **Figura 4** Wassily Kandisky, *Giallo rosso blu*,
1925, olio su tela, 127x200cm, Musée
Nationale d'Art Moderne. Centre Georges
Pompidou, Parigi

tamente l'imitazione, più o meno concreta, della natura e dell'uomo e dedicar-
si alla rappresentazione più o meno geometrica del mondo delle idee. Le opere
devono raffigurare un mondo spirituale in cui le forme pure hanno preso il
posto degli oggetti per la loro capacità di rappresentare il mondo delle idee a
causa della loro regolarità, ma anche per i particolari significati simbolici loro
attribuiti.

Lo sviluppo della Topologia offrirà agli artisti del Novecento (Salvador
Dalì, Max Bill, M. C. Escher) nuove figure da inserire nelle loro opere.

7. Incastri perfetti

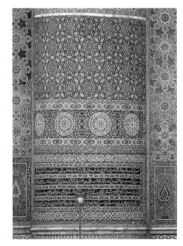

Il concetto di simmetria è fondamentale
nella scienza e nell'arte. La natura presenta
molte regolarità profonde basate sulla sim-
metria e la comprensione di tali regolarità ha
rappresentato un mezzo fondamentale per
l'avanzamento della scienza. Nel mondo del-
l'arte la ripetitività simmetrica di elementi

▶ **Figura 5** Particolare di un mosaico dell'Alhambra,
1390 ca, Granada (Spagna).
© Howard Davis / Artifice Images

costituisce un modello seguito fin dalle prime manifestazioni artistiche. La tassellazione del piano, ossia l'uso di un insieme di forme chiuse che ricoprono il piano completamente senza sovrapporsi e senza lasciare spazi vuoti, come in un gigantesco puzzle, ha attratto l'interesse dei matematici, in quanto la teoria delle tassellazioni può essere messa in relazione con quella delle isometrie.

8. La forma delle nuvole

Nel corso del XX secolo ci si accorse di non poter descrivere le forme della natura utilizzando unicamente le figure messe a disposizione dalla geometria euclidea. A questo proposito scrive il matematico Mandelbrot in un suo libro: "le nuvole non sono sfere, le montagne non sono coni, le coste non sono circoli e gli argini non sono regolari".

▲ **Figura 6** Jackson Pollock, *Number 32*, 1950, smalto su tela, 269x457cm, Kunst Sammlung Nordrhein Westfalen, Düsseldorf

Proprio nel tentativo di descrivere la forma di una nuvola oppure di un fiocco di neve o ancora le frastagliate coste di un'isola, furono introdotte nuove forme geometriche cui Mandelbrot diede il nome di frattali, dal latino *fractus* cioè "frammentato", "rotto", "frastagliato". La geometria frattale vuole presentarsi come la geometria più adatta per descrivere le forme della natura. Proprio questo fatto e la capacità dei frattali di generare figure complesse hanno spinto numerosi artisti a intraprendere la strada della Computer Art con esiti a volte molto interessanti.

9. Infinito

Il concetto d'infinito ha sempre destato un grande interesse tra filosofi, scienziati e artisti ma esso si è spesso rivelato sfuggente e il tentativo di catturarlo infruttuoso. L'infinito possiamo soltanto "immaginarlo" e mai sperimentarlo. Il concetto permea il pensiero umano, eppure sfugge alla comprensione; s'invoca per rispondere a domande altrimenti prive di risposte. Solo la matematica, grazie all'opera di Cantor, è riuscita a imbri-

▲ **Figura 7** Maurits Cornelis Escher, *Circle Limit III*, 1959, silografia da cinque piastre, diametro 41,5 cm

gliarlo dandogli dignità scientifica. Nell'arte è soprattutto Escher che raccoglie la sfida. Egli studia e inventa simmetrie di vario tipo, cercando di utilizzare la divisione del piano come mezzo per catturare e fermare il concetto d'infinito, realizzando opere in cui la tassellazione può continuare indefinitamente.

10. La prospettiva

La prospettiva è la rappresentazione dello spazio tridimensionale su una superficie piana o curva in modo da ottenere un'immagine corrispondente a quella della visione. Il problema della trasposizione della realtà tridimensionale su un piano era già presente nell'antichità e risolto presso greci e romani con metodi intuitivi (che si ritrovano successivamente anche in opere dei secoli XIII-XIV). Sarà ancora una volta il Rinascimento a dare a tale problema una rigorosa connotazione geometrico-matematica grazie all'opera di grandi artisti quali Masaccio, Brunelleschi, Alberti, Piero della Francesca, Dürer e molti altri. Si può senz'altro affermare che la prospettiva rinascimentale, organizzata in uno schema geometrico, costituisce una fusione tra scienza e arte come mai era successo prima.

▶ **Figura 8** Piero della Francesca, *Flagellazione di Cristo*, 1459 ca, tempera su tavola, 58,4x81,5cm, Galleria Nazionale delle Marche, Urbino, per concessione del Ministero per i Beni e le Attività Culturali, Soprintendenza per i Beni Storici Artistici e Etnoantropologici delle Marche-Urbino

11. L'anamorfosi

L'anamorfosi è un artificio pittorico consistente nella deformazione delle immagini, usato a partire dal Rinascimento e sviluppatosi soprattutto nel tardo Barocco, per inserire

▶ **Figura 9** Hans Holbein il Giovane, *Jean de Dinteville e Georges de Selve (Gli ambasciatori)*, 1533, olio su quercia, 207x209cm, National Gallery, Londra
© The National Gallery 2010

in una composizione figure deformate da uno specchio non piano oppure non percepibili se non da un dato punto di vista non frontale.

12. Le figure impossibili

La geometria e le sue regole, applicate al disegno, permettono di rappresentare quello che si vede in modo tale che il cervello lo ritenga simile alla realtà. Questo metodo consente anche di "ingannare" l'occhio e di rappresentare oggetti o spazi in false prospettive e renderli "impossibili". Una figura impossibile è quindi un disegno che rappresenta qualcosa che non può esistere nel mondo reale ma costruito in maniera tale che il cervello, almeno per un attimo, lo ritiene simile alla realtà.

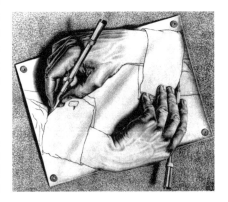

▸ **Figura 10** Maurits Cornelis Escher, *Drawing Hands*, 1948, litografia, 28,5x34cm

13. Strani nuovi mondi

Nella prima metà dell'Ottocento la geometria venne travolta da profonde rivoluzioni che sconvolsero il millenario equilibrio instaurato da Euclide. Il più immediato di tali sconvolgimenti ottocenteschi fu la scoperta della possibilità di aggiungere nuove dimensioni alle tre note. Grazie alle intuizioni di matematici come Riemann, la matematica libera l'uomo dagli angusti limiti delle tre dimensioni, permettendogli di pensare a mondi con 1, 2, 3, 4 o addirittura infinite dimensioni. All'inizio del

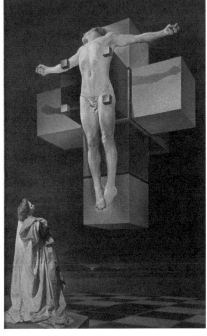

▸ **Figura 11** Salvador Dalì, *Crucifixion (Corpus Hypercubus)*, 1954, olio su tela, 58,4x73,7cm, Metropolitan Museum of Art, New York © Foto Scala Firenze

XX secolo Einstein introduce il tempo come quarta dimensione. Con Einstein il tempo non è più qualcosa di separato dallo spazio ma è a esso legato in maniera indissolubile, giungendo a parlare di spazio-tempo. Le scoperte della matematica e della fisica faticarono molto a passare dalla scienza all'arte, soprattutto a quella figurativa. Gli artisti del primo Novecento, sempre alla ricerca di nuovi modi espressivi, riuscirono però a portare tali scoperte nell'arte dando vita a una rivoluzione figurativa che ha sconvolto, grazie a movimenti artistici come il cubismo e il futurismo o ad artisti quali Salvador Dalì e Attilio Pierelli, il millenario equilibrio instaurato dall'arte greca.

14. Poesia visiva

Una poesia visiva è un componimento letterario la cui scrittura contiene valori di poesia apprezzabili attraverso la vista più che attraverso la lettura. I versi della poesia, abbandonato il tradizionale allineamento, vengono ordinati dall'autore sul bianco della pagina in modo da riempire, con le loro varie lunghezze e disposizioni, il profilo di una figura accordabile con l'argomento trattato. In questa sezione vengono presentati diversi esempi relativi alle varie espressioni di poesia visiva nel corso

▲ **Figura 12** Onorato Tiranti, *Il labirinto dei groppi*, calligrafia in forma di nodo/labirinto, 1665

dei secoli: poesia visiva nell'antica Grecia, poesia figurata tardo antica e medioevale, poesia artificiosa nel Cinque e Seicento, estetica tipografica nella poesia dell'epoca moderna (Stefane Mallarmé, G. Apollinaire, F.T. Marinetti).

15. Città invisibili

Il capolavoro di Italo Calvino rappresenta in modo egregio il rapporto tra matematica e letteratura, o meglio il rapporto tra istanza razionalizzante e geometrica (Kublai Kan) e istanza vitale che sfugge a questo tentativo di comprensione matematica (Marco Polo). Tutto il libro è gioca-

▶ **Figura 13** Colleen Corradi Brannigan, *Fedora,* da *Le Città Invisibili di Italo Calvino,* 2003, tecnica mista, 100x100cm, per gentile concessione dell'artista

to tra il bisogno di irretire il mondo in uno schema perfetto e il continuo sfuggire del mondo stesso, delle cose a questo tentativo. Calvino scrive:

> Un simbolo più complesso, che mi ha dato le maggiori possibilità di esprimere la tensione tra razionalità geometrica e groviglio delle esistenze umane è quello delle città. Nelle Città invisibili ogni concetto e ogni valore si rivela duplice: anche l'esattezza. Kublai Khan a un certo momento impersona la tendenza razionalizzatrice, geometrizzante o algebrizzante dell'intelletto e riduce la conoscenza alla combinatoria dei pezzi di scacchi d'una scacchiera.

16. La matematica in una bolla

▲ **Figura 14** *Beijing National Aquatics Center* (piscina olimpica), veduta della facciata esterna, 2003-2008, Pechino, Villaggio olimpico, per gentile concessione di PTW Architecture, Sydney (Australia)

Un fascino magico è esercitato dalle bolle di sapone colorate che volano nel vento. La loro bellezza e la loro fragilità, quasi metafora della caducità delle cose umane e della vita stessa, ha destato l'interesse di molti artisti. Tuttavia dietro queste figure così evanescenti e affascinanti si nascondono problemi matematici profondi, così come applicazioni pratiche in architettura, in fisica e in chimica. Matematicamente le bolle sono legate al problema delle superfici minime e sono inoltre in grado di dare risposte semplici a problemi complessi come quello del commesso viaggiatore.

17. $\sqrt[4]{Bang} \times (Gulp)^3$

Raccontare matematica nei fumetti non è facile, in quanto è un'operazione che nasconde numerose insidie. Nonostante tali difficoltà, la matematica è capace di esercitare un certo fascino anche in questo particolare tipo di arte.

Negli ultimi anni, nel panorama del fumetto italiano, alcune tra le più note collane di fumetti (Dylan Dog, Nathan Never, Martin Mystère solo per citare alcuni esempi) hanno presentato storie legate in qualche modo alla matematica, grazie anche alle idee di autori come Marco Abate, che è scrittore di fumetti, oltre che professore di matematica all'Università di Pisa.

◄ **Figura 14** Copertina di *Martin Mystère. Detective dell'impossibile*, collana "I padroni del caos", mensile n° 255, giugno 2003 © 2010 Sergio Bonelli Editore. Disegni di Giancarlo Alessandrini

18. Confronti tra sezioni

Le opere sono state classificate all'interno delle quindici sezioni, tuttavia molte di esse potrebbero essere riconducibili a due o più sezioni.

È possibile inoltre una lettura trasversale delle opere studiando come rappresentazioni degli stessi soggetti si evolvono nel tempo grazie anche all'evoluzione della matematica.

Si può, per esempio, osservare come è stata rappresentata la figura umana nel corso degli anni attraverso le opere sul tema di tre grandi artisti: Leonardo da Vinci con *Ritratto di Monna Lisa* (1503-1506), Pablo Picasso con *Ritratto di Ambrosie Vollard* (1910) e Salvador Dalì con *Contorsione topologica di una figura femminile* (1983). Per quanto concerne il tema della "Crocifissione di Gesù" si possono mettere a confronto il *Crocifisso* duecentesco di Giunta Pisano (1230), *La Trinità* di Masaccio, (1426 ca) e l'opera di Salvador Dalì, *Crucifixion* (*Corpus Hypercubus*) (1954).

Anche nell'architettura ci sono esempi significativi al riguardo, basta confrontare il Partenone (V sec. a.C.) con il Guggenheim Museum di Bilbao (1997) e la Piscina olimpica di Pechino (2008).

19. Esperienza con i ragazzi

Lavorando nella scuola abbiamo cercato di coinvolgere anche una classe di studenti nella realizzazione di una sezione della mostra, scegliendo per loro il tema *matematica e fumetti*, in quanto questa moderna forma d'arte è molto apprezzata dai ragazzi e poteva più di altre stimolare il loro interesse e la loro partecipazione.

In una prima fase, i ragazzi hanno letto fumetti delle più note collane italiane e li hanno analizzati. Un primo aspetto che è stato preso in considerazione è

il ruolo svolto dalla matematica all'interno della storia. Il secondo aspetto che è stato analizzato riguarda l'argomento inserito nella storia. Infine gli studenti hanno valutato come viene presentata la figura del matematico. Secondo una consolidata tradizione, la figura dello scienziato in generale e del matematico in particolare, è fortemente stereotipata: dedito fino all'ossessione alle sue ricerche, eccentrico in maniera irrimediabile (se non pazzo schizofrenico!), completamente isolato e distaccato dal mondo. I fumetti non si sottraggono a questo cliché, specialmente quando la matematica è usata per costruire un'atmosfera particolare. Questa tendenza si ritrova, in alcuni casi, anche quando si fa riferimento a matematici realmente esistiti. Non mancano apprezzabili tentativi di scrivere storie con personaggi matematici realistici, ossia persone normali! Gli elementi emersi sono stati tenuti in considerazione per la seconda fase dell'attività: la realizzazione di un fumetto con soggetto matematico (la congettura di Goldbach), scritto e disegnato dagli studenti. L'idea è stata quella di creare una storia piena di suggestioni matematiche, ma legata al mondo dei ragazzi. Con molta fantasia sceneggiatori e disegnatori sono riusciti a inserire all'interno del fumetto molti degli elementi (ipercubo, nastro di Möbius, figure impossibili ecc.) che avevano imparato a conoscere attraverso la mostra, le conferenze e la lettura dei fumetti. Man mano che la storia prendeva forma e gli elementi matematici inseriti nel fumetto aumentavano, è nata l'idea di creare una sorta di gioco che stimolasse le conoscenze del lettore: si tratta di rintracciare tutti gli elementi matematici (simboli, numeri, personaggi) nascosti nel fumetto e di risolvere alcuni problemi presenti nella storia e non risolti.

Gli alunni della classe coinvolta nella realizzazione della sezione sui fumetti si sono entusiasmati al lavoro e hanno mostrato di avere acquisito in modo quasi spontaneo (e comunque senza *lezioni frontali*) una buona padronanza su argomenti di matematica che non fanno parte dei programmi tradizionali e di saperli riconoscere nel mondo che li circonda (per esempio, nella sigla di un cartone animato).

20. Considerazioni conclusive

Fin dall'inizio era ben chiaro che la mostra non poteva avere la pretesa di migliorare il profitto degli studenti nella materia, il nostro scopo era piuttosto quello di cercare di avvicinarli maggiormente alla matematica anche attraverso una disciplina in cui l'estro sembra predominante. Abbiamo voluto pertanto enfatizzare l'importanza che la matematica ha nella cultura moderna andando a cogliere i legami che ha con una disciplina apparentemente molto distante. Essa serve allo studioso di scienze fisiche e sociali, al filosofo e al logico, influenza le dottrine di statisti e teologi, soddisfa la curiosità dell'uomo che scruta il cielo, di quello che medita sulla dolcezza dei suoni musicali e modifica la prospettiva dell'artista.

Un primo aspetto che emerge dai risultati di questo lavoro è la voglia, espressa da molti, di conoscere la matematica partendo da un approccio diverso da quello tradizionale.

Un secondo aspetto riguarda i risultati conseguiti con gli studenti: l'entusiasmo mostrato dai ragazzi che hanno realizzato il fumetto sulla congettura di Goldbach suggerisce le potenzialità del fumetto come modalità di approccio non usuale alla matematica, ma che parla il loro linguaggio e che potrebbe essere utilizzato anche per affrontare argomenti più "canonici".

Quest'esperienza ha avuto ricadute su insegnanti e studenti: ci sono stati infatti docenti che hanno concretizzato nelle loro programmazioni didattiche annuali gli spunti che la mostra suggerisce, inoltre diversi allievi frequentanti le classi finali, nei loro lavori interdisciplinari da presentare all'esame di stato, hanno affrontato temi inerenti la relazione tra matematica e arte dimostrando spesso un interesse e una capacità di elaborazione che sono andati ben al di là di quanto emerso durante le lezioni tradizionali di matematica.

Chi desidera ricevere gratuitamente il CD: *Matematica: anima segreta dell'arte* può farne richiesta a:

Nadia Garuti, Margherita Pivetti, Ennio Quattrini, Daniele Tettamanzi
Liceo Scientifico Statale "Manfredo Fanti", Carpi (Modena).
Indirizzo di posta elettronica: *matematicarte@liceofanti.it*.

oppure a:

Franca Cattelani
Dipartimento di Matematica Pura e Applicata "G. Vitali", Università di Modena e Reggio Emilia.
Indirizzo di posta elettronica: *franca.cattelani@unimore.it*.

Printed in the United States
By Bookmasters